Picturing Apollo 11

UNIVERSITY PRESS OF FLORIDA

Florida A&M University, Tallahassee
Florida Atlantic University, Boca Raton
Florida Gulf Coast University, Ft. Myers
Florida International University, Miami
Florida State University, Tallahassee
New College of Florida, Sarasota
University of Central Florida, Orlando
University of Florida, Gainesville
University of North Florida, Jacksonville
University of South Florida, Tampa
University of West Florida, Pensacola

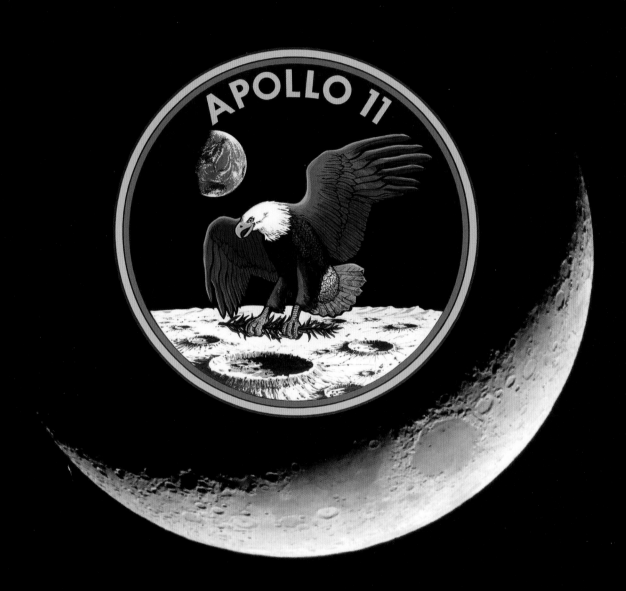

Picturing Apollo 11

Rare Views and Undiscovered Moments

J. L. PICKERING AND JOHN BISNEY

University Press of Florida

Gainesville · Tallahassee · Tampa · Boca Raton

Pensacola · Orlando · Miami · Jacksonville · Ft. Myers · Sarasota

Library of Congress Control Number: 2018941282
ISBN 978-0-8130-5617-3

The University Press of Florida is the scholarly publishing agency for the State University System of Florida, comprising Florida A&M University, Florida Atlantic University, Florida Gulf Coast University, Florida International University, Florida State University, New College of Florida, University of Central Florida, University of Florida, University of North Florida, University of South Florida, and University of West Florida.

University Press of Florida
2046 NE Waldo Road
Suite 2100
Gainesville, FL 32609
http://upress.ufl.edu

CONTENTS

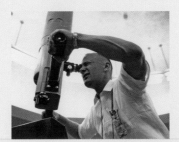
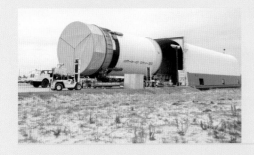
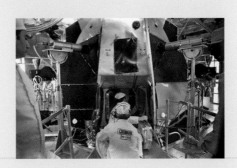
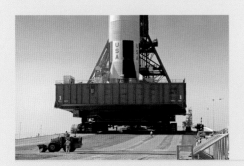

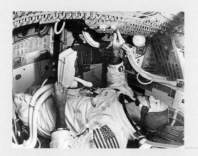

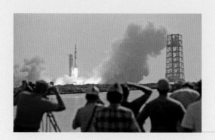

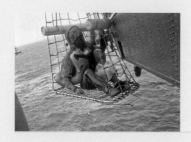

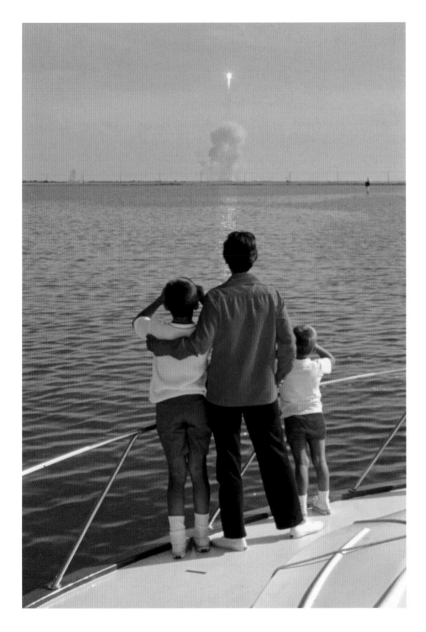

Rick Armstrong (*left*), with mother Jan and brother Mark, watch the Apollo 11 launch from a boat rented for them by *Life* magazine. (Photo by Vernon Merritt III, from the LIFE Collection)

In some ways, it's hard to believe that half a century has passed since my father and Buzz Aldrin "first set foot upon the moon." At the time I was twelve years old, and Dad had been a test pilot or an astronaut all my life, so despite the worldwide attention, the events of July 1969 just seemed pretty normal to me.

On launch day I was in a boat with my mom and my brother Mark on the Banana River, which was somewhat to the south of the launch pad. At that angle our initial view of the lift-off was obscured by billowing exhaust from the five F-1 engines of the Saturn V rocket.

I could hear and feel that something was happening, but it seemed like a long time before the top of the Saturn V came into view. Despite the incredible power of the rocket, I don't think I was really worried, but I was anxious to see it! I also don't remember ever being scared during the flight, because I felt like if anything went wrong they would figure out how to fix it.

Over the years I often relied on Dad for advice—he was a great sounding board. He was very knowledgeable on a wide variety of subjects, and he always seemed to be in the middle of a book. He had an encyclopedic

knowledge of airplanes. I remember walking around the Oshkosh Air Show field once, and he knew the details about every single plane I pointed to, including the experimental home-built ones. For as long as I can remember, whenever a plane flew over, Dad would look up and he would know what it was. He was also a pretty funny guy, and he loved golf—whether he was watching it, playing it, or talking about it.

In the aftermath of the Apollo program I was certain we would have bases on the Moon and would have visited Mars by now, and I know I was not alone in that. I looked in my daughter's high school history book last year, however, and there was exactly one paragraph about the entire space program. To borrow a quote from a favorite movie of mine: "Inconceivable!"

I think there are several legacies from the Apollo program. One is knowing that amazing things can be accomplished by a team of people that are dedicated to a goal. Another is the inspiration the space program provided to people all over the world. I frequently hear from people who say something to the effect of "I'm doing what I'm doing because of what your dad and the other astronauts did." Invariably, what they are doing is most impressive in their own right. Providing young people with inspiration to do great things—what better legacy could there be than that?

Rick Armstrong
September 2018

The story of the first time humans landed on and explored our Moon has been told many times—by the Apollo 11 astronauts, by mission controllers, by NASA officials and historians. Yet we believe this book will help to fill in visually the events surrounding this landmark in exploration, since a large percentage of the images you see (except for in-flight photography) have never been published previously.

Although we set the stage for the mission with background information on Neil Armstrong, Buzz Aldrin, and Mike Collins, our primary focus is January through August 1969. We take the reader through crew training, including geology field trips and lunar surface simulations. You see the arrival, processing, and assembly of the huge Saturn V booster and the two Apollo spacecraft at the launch site, Florida's John F. Kennedy Space Center.

Our coverage proceeds chronologically through launch preparations, launch vehicle rollout, and testing. Interest was quickly building during May and June, as Apollo 10's three astronauts successfully conducted a dress rehearsal in lunar orbit for the first landing.

On launch day, July 16, 1969, more than one million people were watching along Florida's Space Coast. The broadcast coverage on the three national TV and radio networks was extensive. I was fifteen years old, living in St. Petersburg, Florida, and as an enthusiast with a local Apollo contractor connection, was fortunate enough to watch the liftoff from just inside the south gate to Cape Canaveral, about twelve miles away.

The weeks surrounding the flight were filled with other news: actress Judy Garland died of a drug overdose in her London home. The first U.S. troop withdrawals from Vietnam began, and the Stonewall riots in New York City marked the start of the modern gay rights movement in the United States.

The day before the landing Senator Ted Kennedy drove off a bridge on his way home from a party on Chappaquiddick Island, Massachusetts. Mary Jo Kopechne, a former campaign aide to his brother, died in the submerged car. John Fairfax landed that same day in Hollywood Beach, Florida, near Miami, becoming the first person to row across an ocean solo, after 180 days spent at sea on board the twenty-five-foot rowboat *Britannia*.

At the top of the charts was "In the Year 2525" by one-hit wonders Zager and Evans. Two other songs in the top twenty touched on the racial and social change of the era: "In the Ghetto" by Elvis and "Black Pearl" by Checkmates Ltd. This awareness was reflected by the Poor People's protest at the launch.

On July 20 at 10:56 p.m. Eastern time an estimated 500 million people worldwide watched Neil Armstrong take his historic first steps on the Moon, the largest television audience for a live broadcast at that time and about 14 percent of the global population.

As J. L. notes in the remarks that follow, all the in-flight photography by the crewmen has been publically available since 1969, so we make no claim of unseen images during the flight itself.

We wrap up with an extensive look at the astronauts' recovery and quarantine with their lunar samples as well as reviewing the parades, tours, anniversaries, and crew reunions that followed.

As with our previous space photo books, we have done our best to identify as many of the people in each image as possible, since they played significant roles in the success of the mission. I hope you enjoy this new look at Apollo 11, fifty years later.

John Bisney
Seminole, Florida

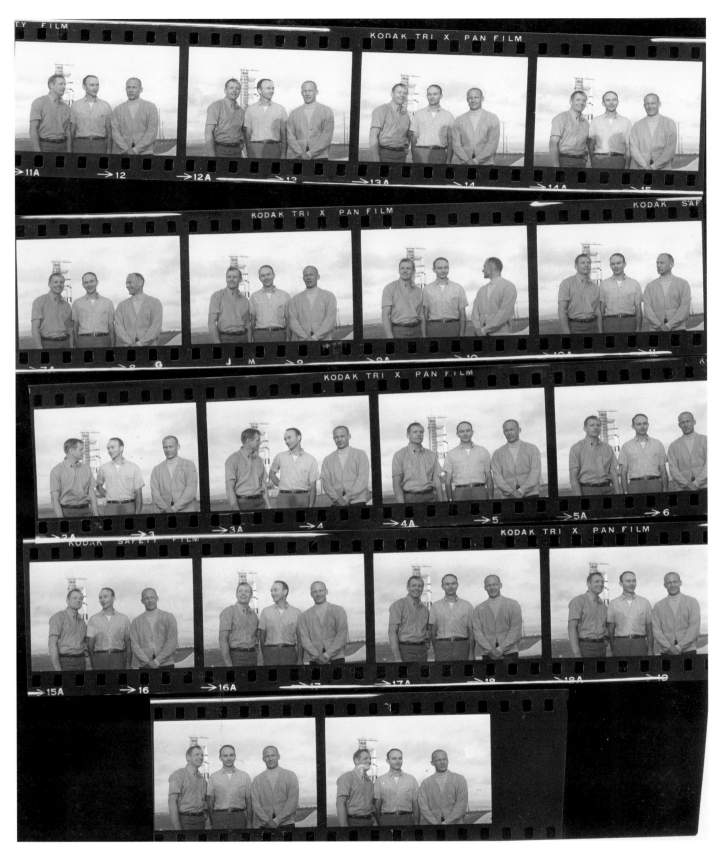

A contact sheet of 35mm film strips of the Apollo 11 crew at Launch Complex 39A after rollout of their Saturn V illustrates both the challenges of selecting the best of rare photos as well as the wealth of images still buried in the archives.

About the Photography

As an eleven-year-old living in Bloomington, Illinois, the year 1969 would be about as good as it gets for those of us closely following the U.S. space program. NASA, in fact, promoted it as "The Year of Apollo." The Apollo Program was in high gear with Apollo 9 in March, Apollo 10 in May, Apollo 11 in July, and Apollo 12 in November. It was a period that saw my Sears Silvertone reel-to-reel tape recorder get quite a workout as my collection of TV network space coverage began to grow.

During 1970–71 I began collecting original NASA prints in earnest. Considerable letter writing (pre-email) and long-distance phone calling allowed me to get acquainted with folks who would help build my collection to its current size. Prints and 35mm slides eventually led to 4×5 negatives and transparencies. The digital era ushered in a whole new level of archiving, allowing me to acquire images from many obscure sources.

When putting a book together, there is a fine line between choosing photos that are of interest as rare or unseen as opposed to using more familiar images that might, in some cases, tell a better story. I have also become aware that photos I consider common are not always viewed that way by others. This applies especially to younger people, who may be seeing the "greatest space hits" for the first time. That being said, this project, like our previous efforts, consists of as many unpublished images as possible, and we hope they give audiences of all ages some new views of the golden era of space flight.

For this Apollo 11 retrospective I assembled a selection of rare images that show the preparation, execution, and follow-up of the mission. The high-profile nature of the first landing of astronauts on the Moon required me to dig deep into federal government archives for new material.

Chapter 1 primarily illustrates the history of the Apollo 11 astronauts. The chapter opens with a rare alternate version of the Group 1 and 2 astronauts together. Also included are images of survival and geology training as well as of Gemini missions flown by Armstrong, Collins, and Aldrin. Chapter 1 closes with relatively rare color images of the astronauts and their families.

Chapter 2 begins with an alternate Apollo 11 crew photo. To the best of my knowledge, from this photo session only two photos have been released that show all three crew members together. When the Media Resource Center at Johnson Space Center (JSC) closed several years ago, it became nearly impossible to discover additional oddball images in the JSC archive.

This chapter also includes images of the Saturn V's arrival and processing at Kennedy Space Center (KSC), all scanned from the original 4×5 color negatives. I am happy that just recently I finally located color images of the S-II stage arrival. I wish I could have acquired some fresher images of Armstrong and Aldrin training outdoors in Texas, but again that was a JSC holding.

Chapter 3 concentrates heavily on spacecraft and launch vehicle checkout at KSC as well as astronaut training at KSC and the Manned Spacecraft Center in Houston. I was extremely happy to locate some long-hidden negatives in the archives that show new views of the Saturn V stages being stacked inside the Vehicle Assembly Building. Some other personal favorites are the new views of the Apollo 11 astronauts in the altitude chamber and of Pad Leader Guenter Wendt. The chapter closes with some wonderful images taken inside the command and lunar modules during checkout at KSC.

In chapter 4 the beauty of the Saturn V rocket is on full display. Our friend Jacques Tiziou, the late French photojournalist, blessed me with a large portion of his personal slides a few years ago. Many images taken by Jacques and his brother Michel are in this chapter, including the wonderful images of Collins, Armstrong, and Aldrin at the pad following the rollout. Jacques

and Michel emphasized the human side in their photography as opposed to the more formal engineering side.

Some of my favorite images in the book are in chapter 5. It was great to have located original negatives of the crewmen inspecting their spacecraft and escape routes at the pad. Some superb images taken at close range by the Tiziou photo team of the Apollo 11 stack at Launch Complex 39A are next, followed by a group of images showing the astronauts arriving at Patrick Air Force Base. The photos perfectly illustrate the casual and cool demeanor of these pilots. This chapter concludes with a selection of images showing Mike Collins training in and out of the command module simulator.

In chapter 6 you can feel the excitement build as the launch date nears. We begin with some unseen images showing the crew suiting up for the countdown demonstration test and some rare color images of the scene inside the firing room at KSC.

Of special note are the scenes inside the white room during the test—I recently purchased a collection of negatives from a retired employee of Technicolor (a former KSC photo contractor). Included was a plain white envelope labeled "Astronauts in white room." Inside were approximately 35 strips of original 35mm color film of the Apollo 11 crew and general activity in the white room.

Also of note are the excellent night views of Apollo 11 at the pad, the scenes around the KSC Visitor Center, and the Space Coast in general. These are all the fine work of the Tiziou photo team.

Chapter 7, launch day, presented a frustrating challenge. Over the last twenty years I have written many e-mails, made many phone calls, followed up on many leads, and conducted extensive research in the KSC and JSC archives. Amazingly, I have yet to locate the original negatives for images that were taken by NASA on the day of the Apollo 11 launch (or for any manned Apollo launch)! Why the KSC photo archives seem void of any launch day material that shows astronaut, launch vehicle, or firing room activity remains a complete mystery.

We nevertheless show you a well-rounded selection of launch day material. Some favorite images for me and for John (who was at the launch) are the Cocoa Beach crowd shots. They show people captivated by the historic moment and coming together for a once in a lifetime event.

Chapter 8 was probably the most difficult. There are no images taken by the astronauts during the mission that have not been released. How could we bring a fresh approach to the Apollo 11 mission without relying on the in-flight images that have been available for fifty years? The solution was to emphasize activities on the ground and to crop the in-flight images for a more up to date look. Fortunately the Tiziou photo team made the trip to Houston during the Apollo 11 mission and captured some great images of the astronauts' families and the area surrounding the Manned Spacecraft Center.

The successful end of the mission and life in the Mobile Quarantine Facility make up chapter 9. I had built up a decent selection of Apollo 11 recovery and post-flight images from the JSC negative files in the 1990s. Although a Navy photographer captured a grainy image of the *Columbia* descending on the main parachutes, unfortunately there are no NASA images. I have also never been able to locate a photo showing a full view of the Apollo 11 command module inside the Lunar Receiving Laboratory. If I ever do, I will include it in an updated edition!

Chapter 10 was an interesting chapter to assemble. It was great to see how the Apollo 11 crew came together every five years and celebrated the accomplishments of the entire NASA team. Although Armstrong, Aldrin, and Collins inevitably grew older by each milestone, they maintained a great bond throughout.

My favorite images in this chapter are from Washington, D.C., in 1994, images taken by Jacques Tiziou and scanned from the original 35mm black and white strips; and color views of Armstrong and Aldrin at KSC in 1999 shot by my other space photographer friends, brothers Tom and Mark Usciak, and scanned from the original color negatives.

The space photo books John and I have assembled are intended to fill voids in photographic history; I hope we have accomplished that again.

J. L. Pickering
Bloomington, Illinois

Three to Get Ready

Apollo 11 was the fifth manned mission of NASA's Moon program, and in early planning was not expected to include the first landing. NASA managers shuffled goals and objectives for each flight as prior missions were completed. Eventually it became clear that this flight would be the one to make history as the first to land.

That's the way the space agency operated: taking small, deliberate steps in a carefully considered order to achieve the intended result. This approach meant that Apollo 11 was built on a foundation of twenty previous U.S. manned flights, starting with Alan Shepard's suborbital mission eight years before, and continuing through a series of ten two-man Gemini missions. Astronauts Neil Armstrong, Mike Collins, and Buzz Aldrin all flew Gemini missions in 1966, but none had any reason to believe he would be part of the Apollo 11 crew.

Armstrong had been an Air Force and later a NASA test pilot and was accepted into NASA's second group of astronauts in 1962. The following year Buzz Aldrin earned a doctor of science degree from MIT. His doctoral thesis was "Line-of-Sight Guidance Techniques for Manned Orbital Rendezvous," the dedication of which read, "In the hopes that this work may in some way contribute to their exploration of space, this is dedicated to the crew members of this country's present and future manned space programs. If only I could join them in their exciting endeavors!"

Aldrin had applied for the second group of astronauts but was rejected because he had never been a test pilot. That requirement was lifted when he reapplied, and he was accepted into the third astronaut class in late 1963, as was Mike Collins, who had been a test pilot. Along with their space-bound colleagues, they underwent preliminary training in such disciplines as geology and jungle and desert survival.

By 1968 NASA had about fifty astronauts available for either flight or science duties during Apollo. Armstrong, Collins, and Aldrin, with their experience in rendezvous and docking during Gemini, were well prepared for the landmark flight. Collins and Aldrin had also ventured outside their spacecraft on their Gemini flights. Fate would soon choose these three men to make the first lunar landing.

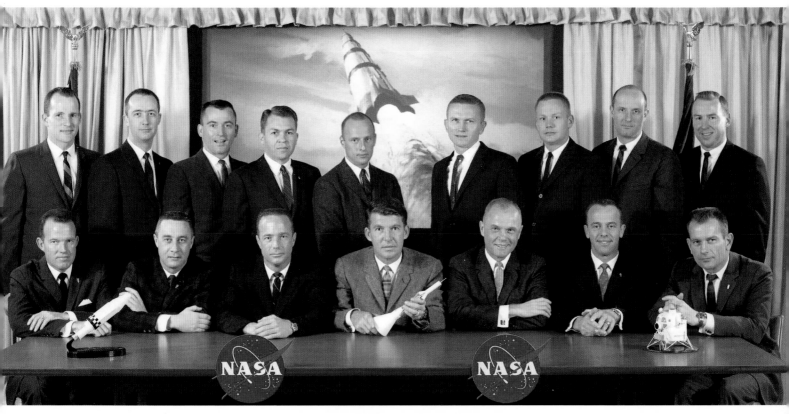

The first and second groups of NASA astronauts pose together in 1963 at the Manned Spacecraft Center in Houston, Texas (renamed the Johnson Space Center in 1973). The "Original Seven" Project Mercury astronauts, announced on April 9, 1959, sit in the lower row (*left to right*): Gordon Cooper, Virgil "Gus" Grissom, Scott Carpenter, Walter Schirra, John Glenn, Alan Shepard, and Deke Slayton. The "New Nine" Group 2 astronauts stand (*left to right*): Edward White, James McDivitt, John Young, Elliot See, Charles Conrad, Frank Borman, Neil Armstrong, Thomas Stafford, and James Lovell. Of these sixteen astronauts Armstrong, Conrad, Shepard, and Young would walk on the Moon. Borman, Lovell, and Stafford would circle it. Behind them is an artist's concept of a Saturn V launch still four years away. (NASA)

Neil Armstrong poses on steps leading to the cockpit of the rocket-powered X-15 research aircraft in 1962, which was carried aloft under the left wing of the B-52 seen in the background. He is flanked by B-52 pilots J.R. Campbell (*left*) and Fitz Fulton. Armstrong piloted seven X-15 missions between 1960 and 1962 before joining NASA. (NASA)

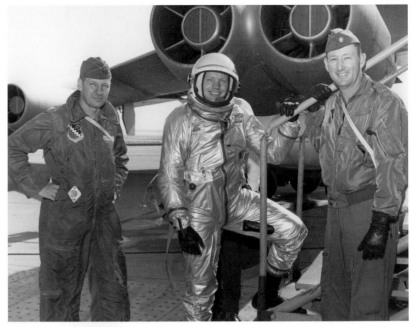

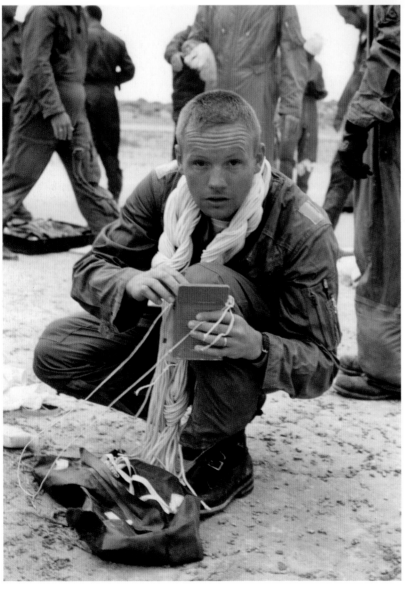

Left: Armstrong, with parachute lines around his neck, undergoes desert survival training at Stead Air Force Base in northwestern Nevada on August 16, 1963. The astronauts were taught how to fabricate clothing and parachutes into survival gear in the unlikely event that their spacecraft landed in a desert. (NASA)

Facing page, bottom: The third group of NASA astronauts poses together at Launch Complex (LC) 19 in April 1964. Astronauts (*beginning third from left*) are Eugene Cernan, Alan Bean, Russell Schweickart, William Anders, Richard Gordon, Walt Cunningham, Buzz Aldrin, Roger Chaffee, C. C. Williams, Donn Eisele, Mike Collins, David Scott, Ted Freeman, and Charles Bassett. Fate would not be kind to Bassett, Chaffee, Freeman, and Williams; all would die before having the chance to fly in space. (NASA)

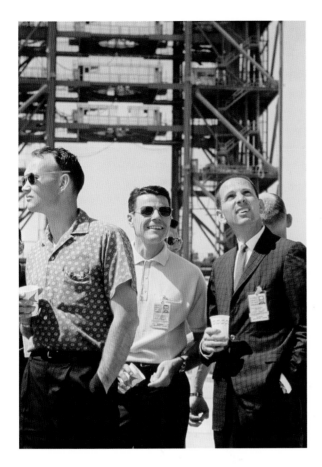

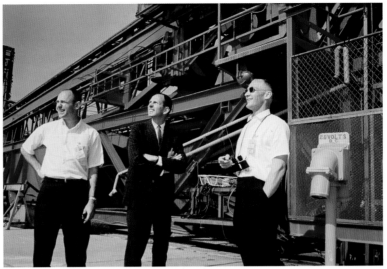

Left: Group 3 NASA astronauts Mike Collins, Charles Bassett, and Ted Freeman take part in an orientation visit to Cape Kennedy, Florida, in April 1964. The astronauts stopped at both Launch Complexes 34 and 37 during the trip. The service structure for LC-34 is in the background. (NASA)

Above: Alan Bean, Ted Freeman, and Buzz Aldrin explore the area around LC-34 in April 1964. The astronauts' visit coincided with the first unmanned Gemini/Titan II launch (Gemini 1) on April 8, 1964, from LC-19. (NASA)

Aldrin looks through a periscope during a tour inside the blockhouse at LC-37. The periscope provided members of the launch team with views outside the windowless structure. (NASA)

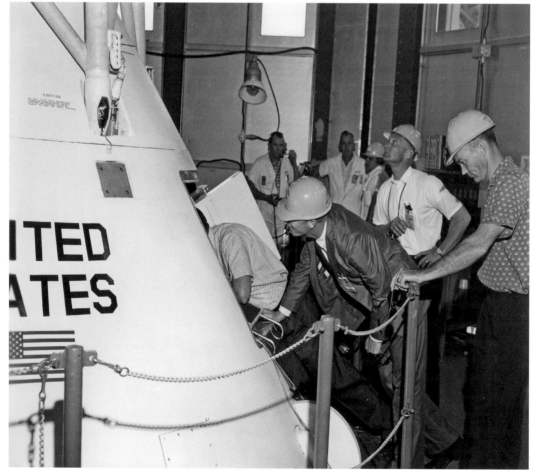

Members of the third astronaut class inspect a boilerplate (nonfunctional) Apollo command module, BP-13, during the visit to LC-37. Schweickart, Aldrin, and Collins wait their turn to peer inside the hatch. BP-13, launched atop a Saturn 1 rocket on May 28, 1964, became the first Apollo spacecraft in Earth orbit. (NASA)

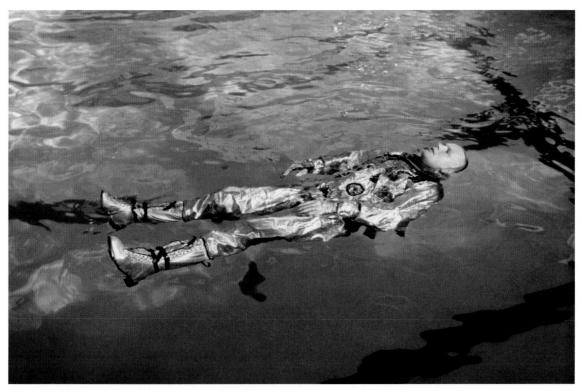

Armstrong appears relaxed while wearing a space suit and floating in a tank in October 1963 during water survival training at the Naval Aircrew Candidate School in Pensacola, Florida. (NASA)

Aldrin takes notes on rock formations during a geology trip to Arizona's Grand Canyon on March 5–6, 1964. Astronauts were sent around the world for geology training in locations including Texas, California, New Mexico, Oregon, Hawaii, Iceland, and Mexico. (NASA)

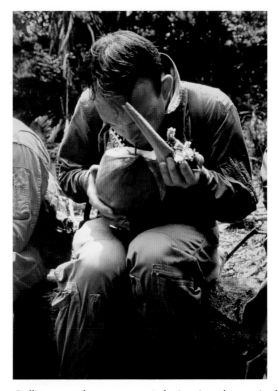

Collins samples a coconut during jungle survival training in the Panama Canal Zone during the week of June 22, 1964. He was one of fifteen astronauts who attended the Tropical Survival School to learn how to survive if their spacecraft happened to land in a jungle. (NASA)

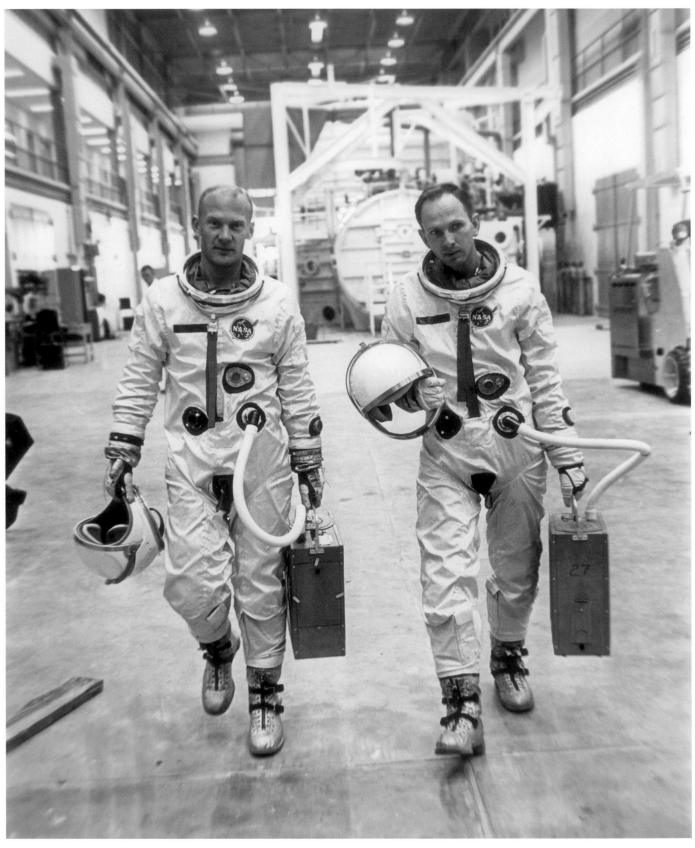

Aldrin (*left*) and Freeman depart after participating in a news media demonstration of the Gemini spacecraft at the Manned Spacecraft Center (MSC) on October 30, 1964. Freeman would die the following day on final approach to Ellington Air Force Base (AFB), Texas, after a routine proficiency training flight. (NASA)

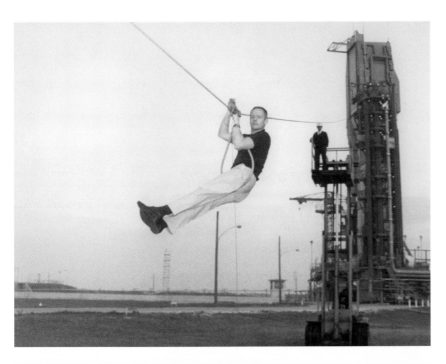

Above: Previously unpublished portrait of Armstrong taken in 1964 at MSC. NASA took various portrait sets of the astronauts, usually with matching backdrops, in both business suits and space suits to satisfy public relations and autograph requests. (NASA)

Left: Armstrong participates in emergency egress slide wire tests at LC-19 on February 21, 1966, while training for Gemini 8. The slide wire was designed for emergency evacuation from the white room surrounding the spacecraft at the top of the LC-19 erector. It took 18 seconds to reach the ground, ending 500 feet from the pad. (NASA)

Below: Gemini 8 is launched atop a Titan II booster from LC-19 on March 16, 1966. Astronauts Armstrong and Scott achieved the first docking of two spacecraft in orbit but suffered the first critical emergency as well. A stuck thruster on the Gemini spacecraft endangered the lives of the astronauts and the mission was quickly aborted. Armstrong was the first civilian to command a U.S. space mission. (NASA)

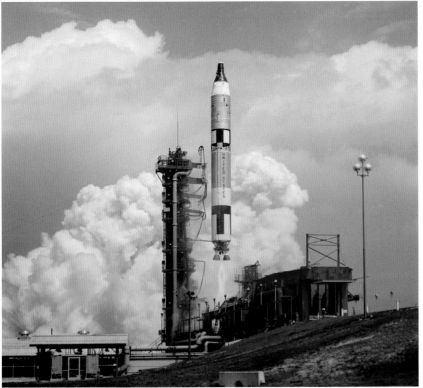

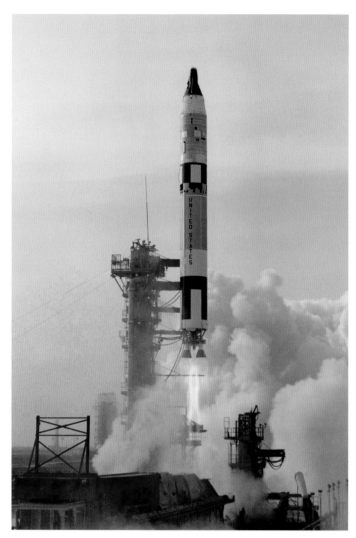

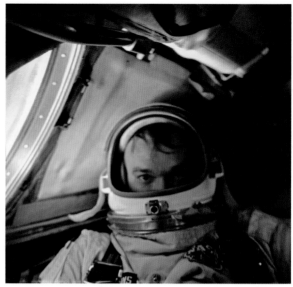

Left: A Titan II booster launches Gemini 10 from LC-19 on July 18, 1966, with astronauts John Young and Mike Collins aboard. Gemini 10 was the first afternoon launch in the Gemini Program. The Titan II was built by the Martin Company and generated 430,000 pounds of thrust at liftoff. (NASA)

Above: Collins is shown in the tight quarters of the Gemini 10 spacecraft. He has just completed a twenty-five-minute "stand-up" extravehicular activity (EVA), remaining mostly inside but with the hatch open. This was one of two EVAs Collins made during the mission. (NASA)

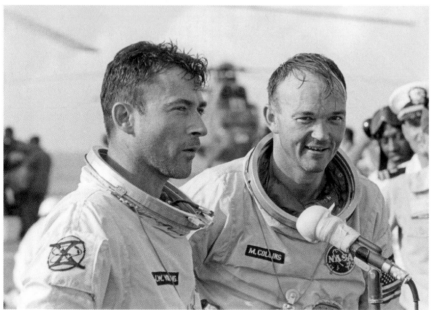

Young (*left*) and Collins speak to well-wishers aboard USS *Guadalcanal* on July 21, 1966, following the Gemini 10 mission. Young would command Apollo 16 to the Moon in 1972 and the first Space Shuttle mission in 1981. (NASA)

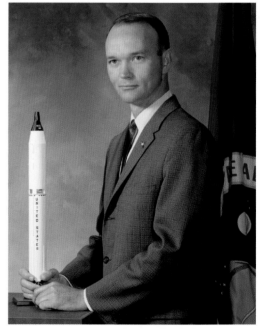

Rarely seen 1964 portrait of Collins with a Martin Co. model of the Gemini-Titan II rocket. (NASA)

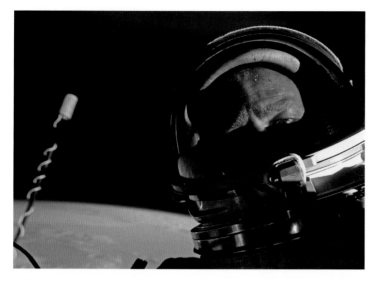

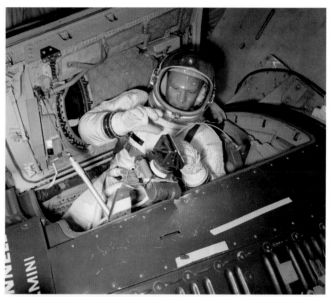

Above: After a string of less than perfect attempts at EVA during the previous three Gemini missions, astronaut Buzz Aldrin pulls off a flawless walk in space during Gemini 12 on November 12, 1966. (NASA)

Right: Aldrin undergoes zero-g training for the final EVA in the Gemini Program, planned for his Gemini 12 mission. Aldrin is in the hatch of a Gemini mockup aboard a modified KC-135A *Stratotanker* aircraft on October 13, 1966. (NASA)

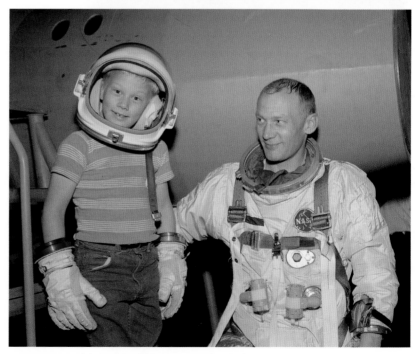

Aldrin speaks with his family aboard USS *Wasp* after the Gemini 12 splashdown on November 15, 1966. (NASA)

Seven year-old Andy Aldrin tries on his father's helmet and gloves in April 1966. Astronaut Aldrin had just finished a training session at MSC as back-up crewman for Gemini 9. (NASA)

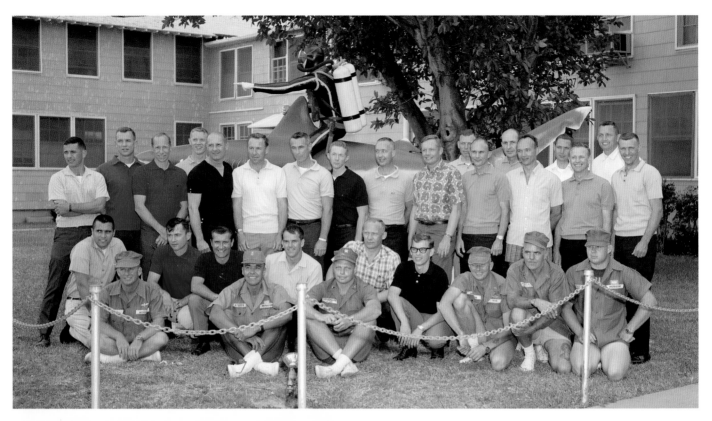

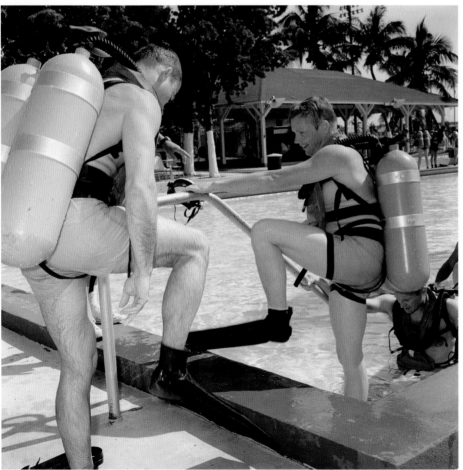

Above: A group of Apollo astronauts spent a week at the Navy Diving School in Key West, Florida, April 7–14, 1967. Standing (*left to right*): Anders, Scott, Alfred Worden, Schweickart, Stafford, Lovell, Cernan, Stuart Roosa, McDivitt, Armstrong, Thomas "Ken" Mattingly, Ed Givens (in back, between Mattingly and Collins), Collins, Gerald Carr, and Joe Engle. Crouching, joined by six Navy divers in olive drab (*left to right*): Harrison "Jack" Schmitt, Young, Gordon, Curt Michel, and Aldrin. (NASA)

Left: Armstrong at the edge of a swimming pool wearing diving equipment at the Navy Diving School. Armstrong and other astronauts learned the basics of underwater operations. Ballasted underwater training was a viable alternative to short duration zero-g airplane parabolic flights. (NASA)

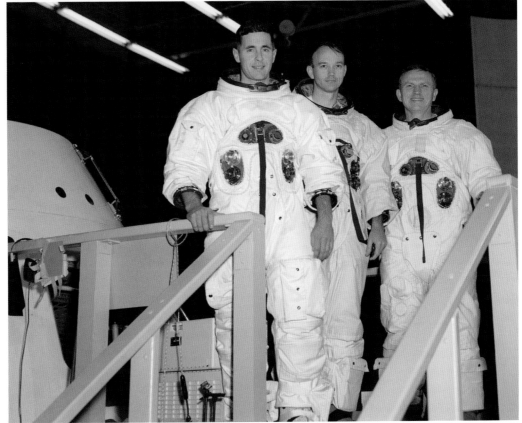

Above: Anders (*left*) and Collins arrive at the Langley Research Center, Virginia, aboard a T-38 jet in January 1967 to train with a lunar module/command module mockup. Collins became a member of the Apollo 11 crew by happenstance after suffering a back injury that required surgery, thus moving him from Apollo 8 to the Apollo 11 crew. (NASA)

Right: Still assigned as the third Apollo crew at the time, Anders, Collins, and Borman (*left to right*) pose together at the North American Aviation plant in Downey, California, in 1967. North American soon merged with Rockwell to form North American Rockwell. (NASA)

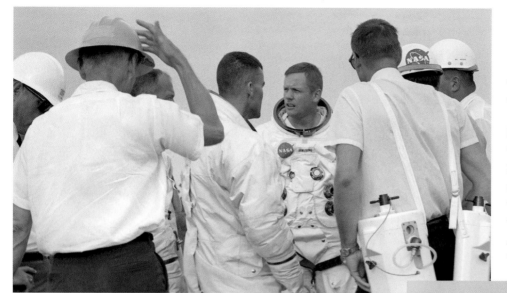

Left: Apollo 8 back-up astronauts Aldrin (partially hidden), Fred Haise, and Armstrong participate in slide wire emergency egress training at LC-39B on October 22, 1968. Haise would also serve as back-up lunar module pilot for Apollo 11, a role he would fully assume aboard the aborted Apollo 13 Moon mission in April 1970. (NASA)

Right: Personnel from NASA and the Bendix Corporation assist Aldrin at the conclusion of slide wire egress training on October 22. Apollo 7 was ending an eleven-day mission in Earth orbit the same day. (NASA)

Below: Apollo 8 back-up commander Armstrong in the suit room at Kennedy Space Center (KSC) on October 23, 1968, before heading back to LC-39A for command module (CM) egress tests. The equipment to the left, built by Hamilton Standard, was used to test space suits from Apollo 7 to the 1975 Apollo-Soyuz Test Project. (NASA)

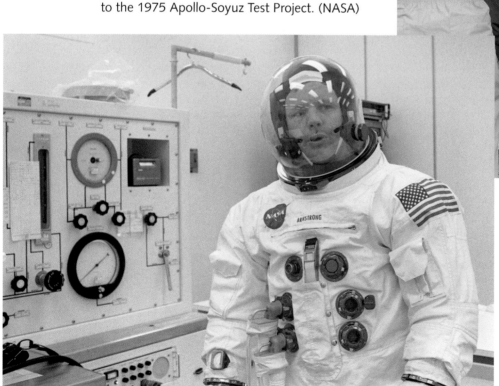

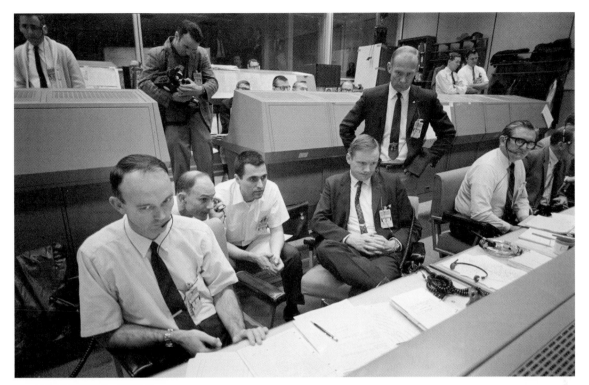

Astronauts Collins, Mattingly, Schmitt, Armstrong, and Aldrin monitor communications at the Mission Control Center (MCC) in Houston, Texas, during Apollo 8's historic first Moon-orbiting manned flight in December 1968. Collins, who served as capsule communicator or "CAPCOM," would be assigned to the Apollo 11 crew with Armstrong and Aldrin a few weeks later. (NASA)

Armstrong (*left*) and Aldrin (*right*) talk with geologist Schmitt in the MCC on December 24, 1968. Schmitt was intimately involved in Apollo crew training with detailed instruction in lunar navigation, geology, and feature recognition. He eventually walked on the Moon as lunar module pilot during Apollo 17 in December 1972. (NASA)

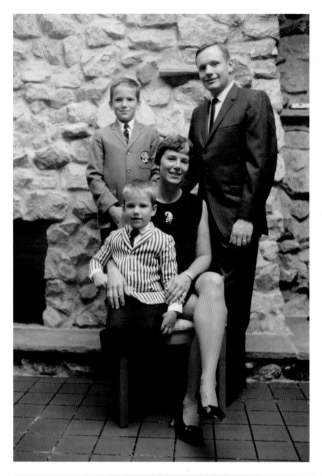

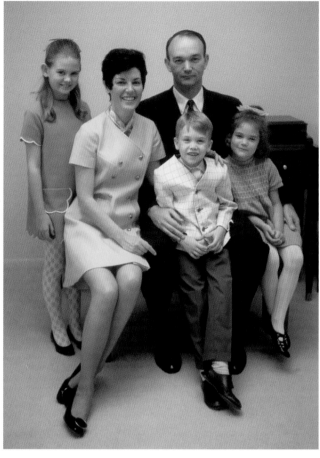

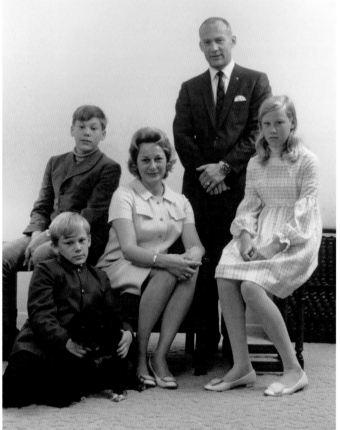

Above, left: Armstrong with his family in 1969 at their home on Woodland Drive in El Lago, Texas, near the Manned Spacecraft Center (MSC) in Houston. Shown are his wife Janet and sons Rick (*standing*) and Eric. (NASA)

Above, right: Collins at his home in Nassau Bay, Texas, in 1969 with his wife Patricia and children Kathleen (*standing*), Michael, and Ann. (NASA)

Left: Aldrin with his wife Joan and children Andrew (*front*), J. Michael, and Janice in 1969 at their home near MSC on Confederate Way in El Lago. (NASA)

Delivering the Team and the Machine

As 1969 dawned, NASA officials formally announced that Armstrong, Aldrin, and Collins would make up the crew of Apollo 11. Their selection was the result of a number of factors involving medical problems, personalities, and office politics that had shuffled flight assignments.

The news meant that the three crewmen would begin mission-specific training for the first manned Moon landing. Armstrong and Aldrin would work from a packed timeline on the lunar surface, with the major goal of setting up a series of experiments to relay data to Earth after their departure. They also spent more time in geology training, the better to assess what samples to bring from the Moon.

While their flight preparations would be unique, the crew was also on a carefully choreographed and complex NASA assembly line. Their flight hardware was scheduled to begin arriving at Kennedy Space Center (KSC) in Florida for inspection and eventual stacking in the Vehicle Assembly Building. The huge first and second stages of their Saturn V rocket came from Louisiana by barge, while the third stage and Apollo spacecraft arrived by air aboard unique cargo aircraft. By February 1969 their launch vehicle was undergoing testing and assembly.

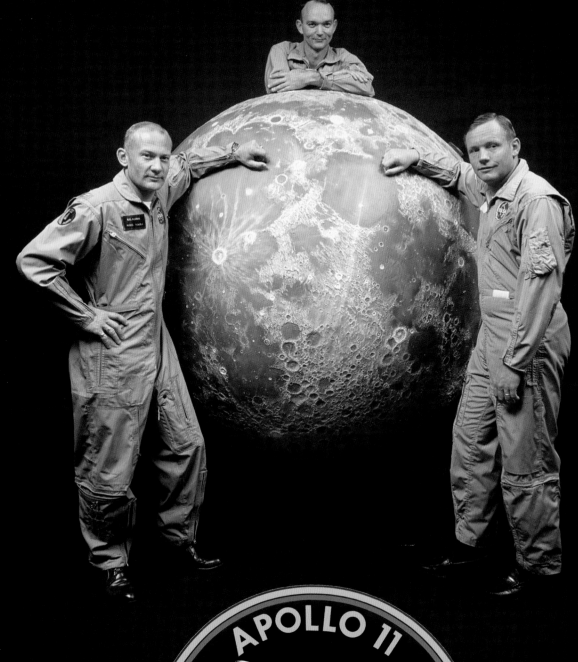
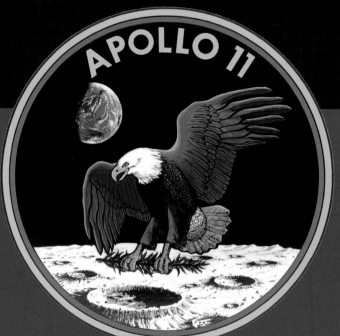

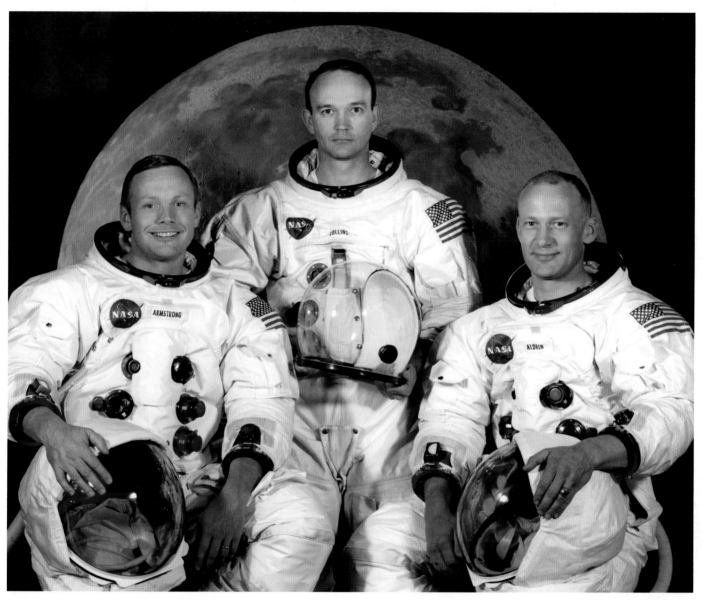

Facing page, top: The Apollo 11 crew poses for *Life* photographer Ralph Morse in April 1969. Their landing site is roughly even with Armstrong's waistband on the left edge of the Sea of Tranquility. Morse had set up the photo session at a Houston area hotel. (Photo by Ralph Morse).

Facing page, bottom: Collins designed the crew's mission emblem; the olive branch was moved from the bald eagle's beak in the original version to its claws to make it appear less menacing.

Above: The Apollo 11 crew sits for a formal portrait during a photo session at Manned Spacecraft Center (MSC) on April 14, 1969. *Left to right*: Commander Neil Armstrong, age 38; Command Module Pilot Mike Collins, age 38; and Lunar Module Pilot Buzz Aldrin, age 39. This is a lesser-known portrait of the crewmen holding their space suit helmets. Cost of each space suit was $100,000 in 1969. (NASA)

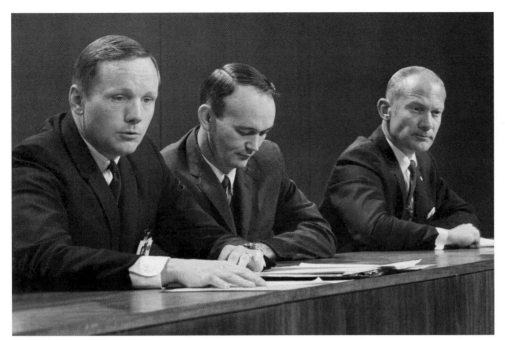

Left: Armstrong, Collins, and Aldrin (*left to right*) were announced as the prime crew for Apollo 11 at a news conference in the MSC Building 2 auditorium on January 10, 1969. Armstrong said, "It was a great honor to be selected," and Aldrin added that "Fate was kind enough to put us in this position." (AP photo)

Below: Following the news conference, Aldrin, Armstrong, and Collins (*left to right*) pose for news photographers in front of a full-scale mockup of the lunar module (LM) just outside Building 1 at MSC. (NASA)

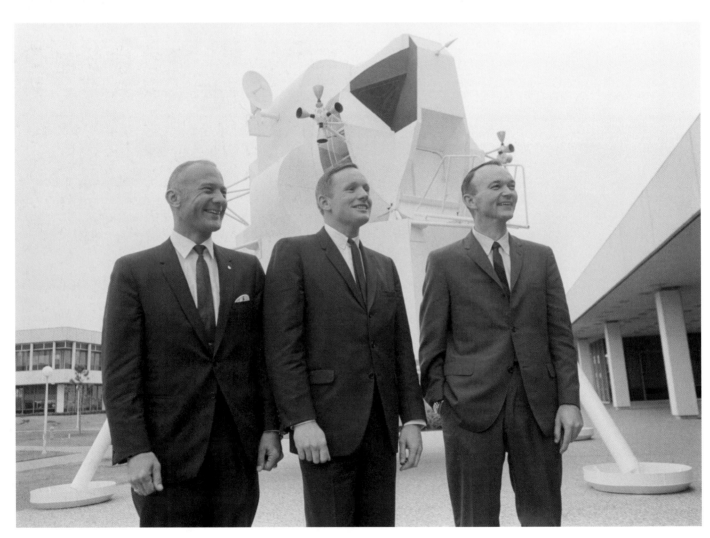

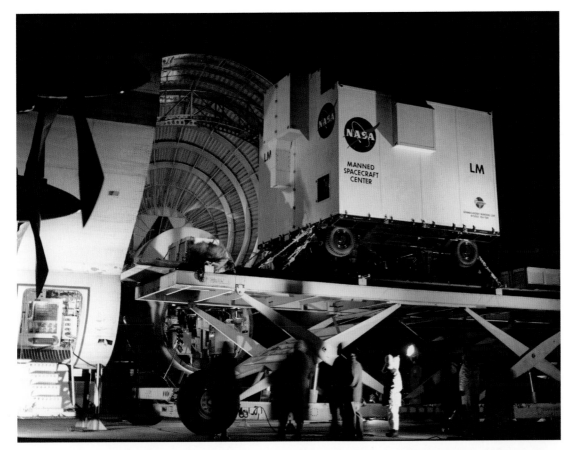

The ascent stage for Apollo 11's LM (LM-5) arrives late in the day on January 8, 1969, at the Cape Kennedy Air Force Station Skid Strip. The ascent stage was the first piece of Apollo 11 flight hardware to arrive at KSC. The stage was shipped from the prime contractor, Grumman Aerospace Corporation, on Long Island, New York. (NASA)

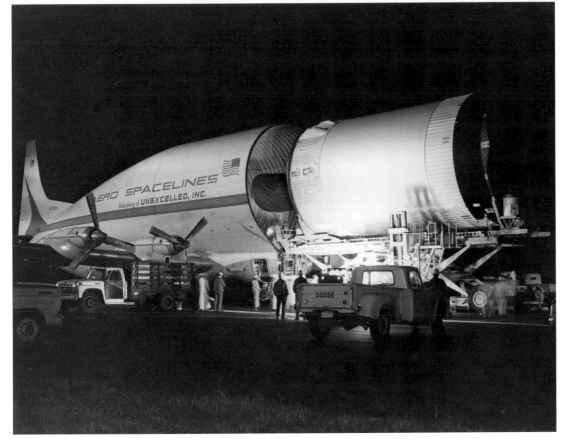

The S-IVB (third stage) of Apollo 11's Saturn V rocket arrives at the Cape Kennedy Skid Strip early in the morning on January 18, 1969. The 23,000-pound stage was the first segment of this Saturn V to arrive in Florida. (NASA)

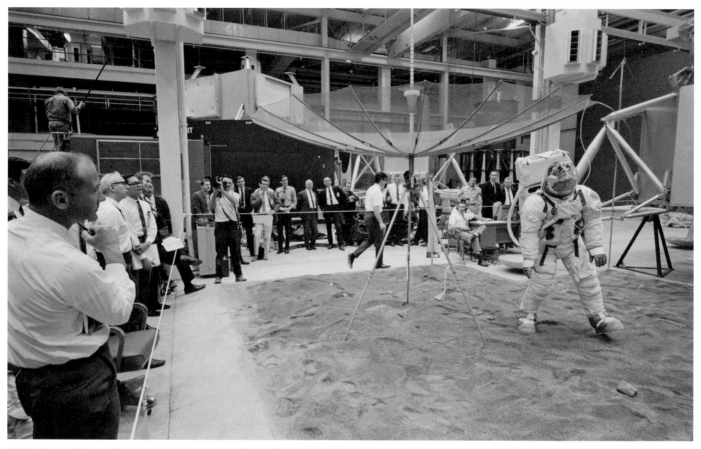

Aldrin intently watches astronaut Don Lind go through a simulation of deploying lunar surface experiments during training in Building 9 at MSC on January 21, 1969. Lind was joined in the simulation by astronaut Schmitt. (NASA)

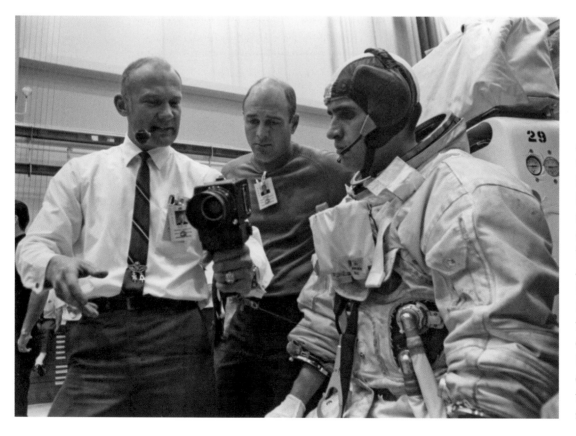

Aldrin *(left)* meets with astronauts Ron Evans *(center)* and Schmitt during a lunar surface experiment deployment simulation on January 21. Aldrin examines a Hasselblad 500 EL Data Camera similar to one he would use on the lunar surface. Evans was a member of the Apollo 11 astronaut "third string" support crew. (NASA)

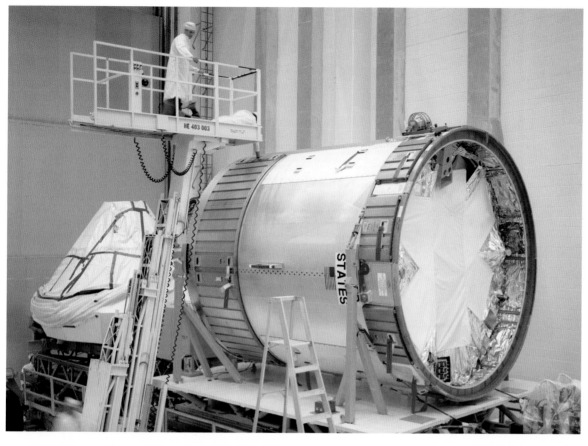

Left: North American Rockwell technicians at the KSC Manned Spacecraft Operations Building (MSOB) begin unpacking and inspecting Apollo 11's command and service modules on January 23, 1969. The spacecraft arrived the previous night from the North American plant in Downey, California, aboard an Aero Spacelines *Super Guppy* cargo plane. The four reaction control system (RCS) quads have not yet been mounted on the SM. The building would be renamed in Armstrong's honor in July 2014. (NASA)

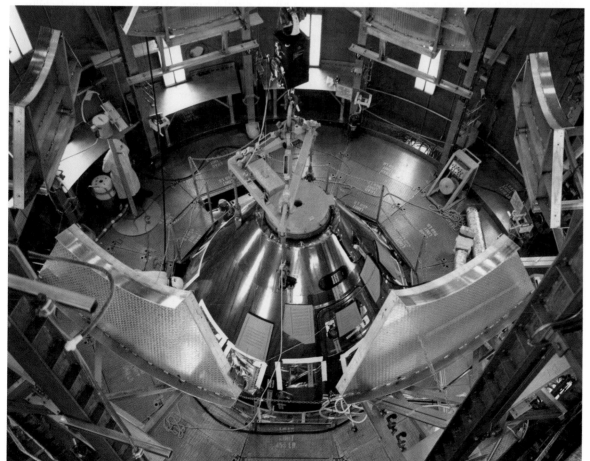

Bottom left: Apollo 11's command module (CM-107) was installed in altitude chamber L in the MSOB on January 29, 1969, where it would remain for the next two months. Platforms would be lowered to allow technicians full access to the CM. (NASA)

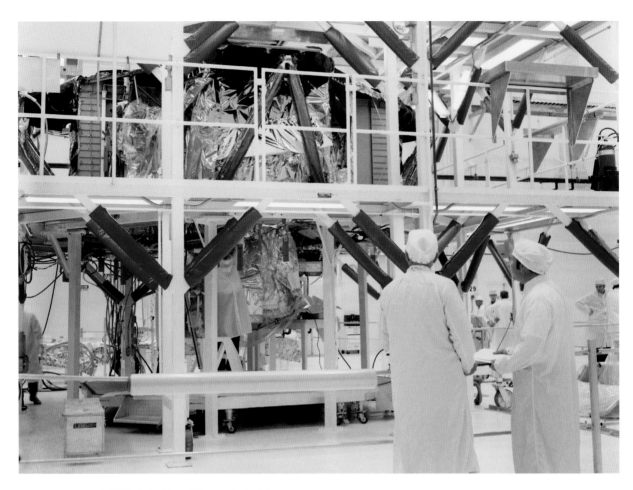

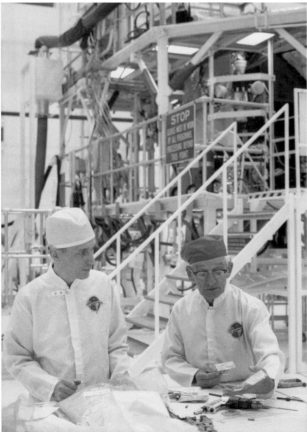

Above: Grumman technicians observe Apollo 11's LM descent stage in a workstand at the MSOB on February 3, 1969. The stage had been delivered to KSC on January 17. (NASA)

Left: Grumman employees work with Mylar insulation for Apollo 11's LM in the MSOB on February 3. The LM ascent stage can be seen within the multi-level workstand behind them. (NASA)

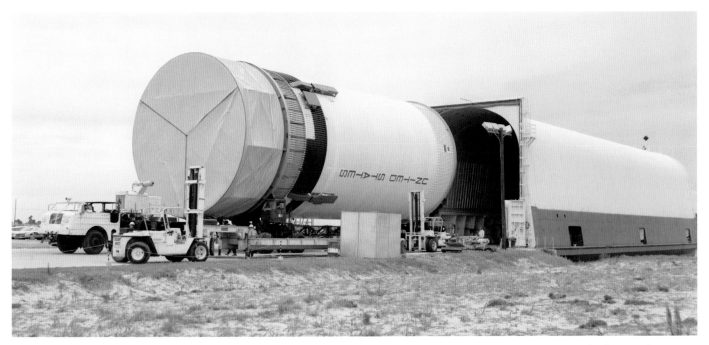

The S-II (second stage) of Apollo 11's Saturn V is offloaded from the barge *Orion* at the Turning Basin dock near the Vehicle Assembly Building (VAB) on February 6, 1969, after being shipped from the NASA Michoud Assembly Facility in Louisiana. (NASA)

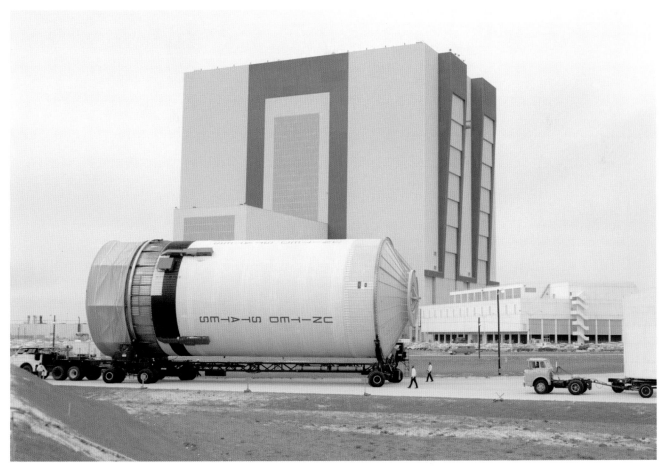

The Apollo 11 S-II is towed to the VAB on February 6. The rocket segment would be checked out inside the VAB in preparation for "stacking." The Launch Control Center is at right. (NASA)

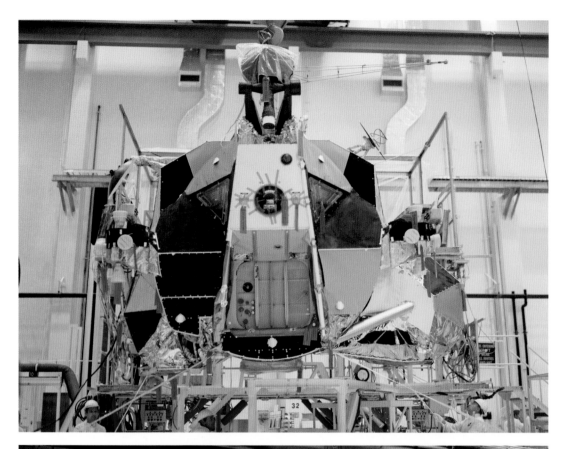

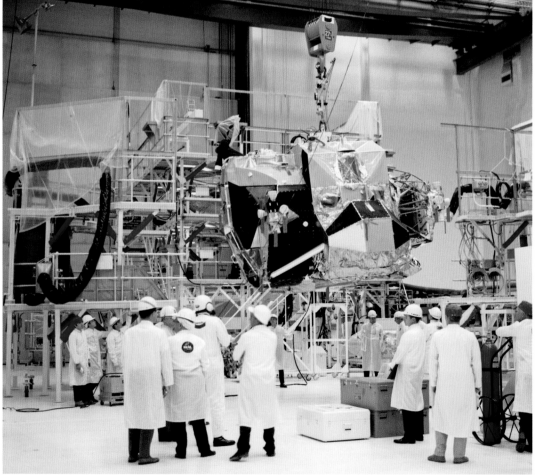

NASA and Grumman technicians use an overhead crane to move the LM's ascent stage from its work stand to a special device to check for foreign objects on February 7. Once secured to the cleaning positioner, the stage would be slowly rotated to turn up any parts, tools or other items inadvertently left behind. (NASA)

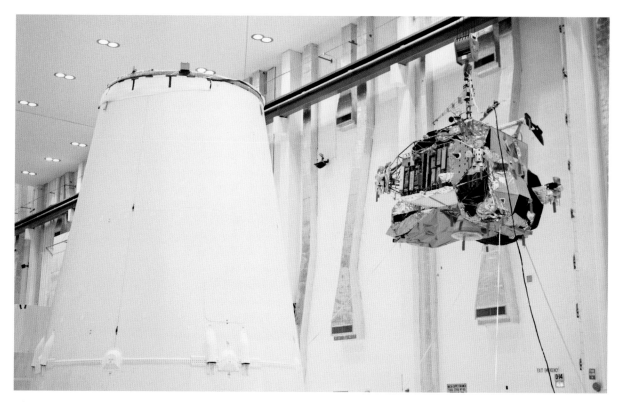

The ascent stage, festooned with red "Remove Before Flight" streamers, passes Apollo 11's Saturn V Spacecraft Lunar Adapter (SLA), its eventual home for launch. Thermal blankets and micrometeoroid shields have have not yet been attached to the aft equipment bay. Following rotation on the cleaning positioner, the stage would next be inverted and lowered into altitude chamber L for docking tests with the Apollo 11 CM on February 11. (NASA)

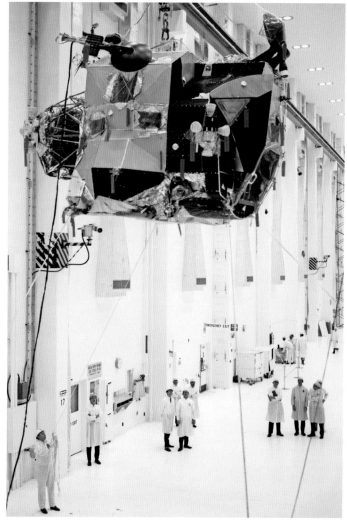

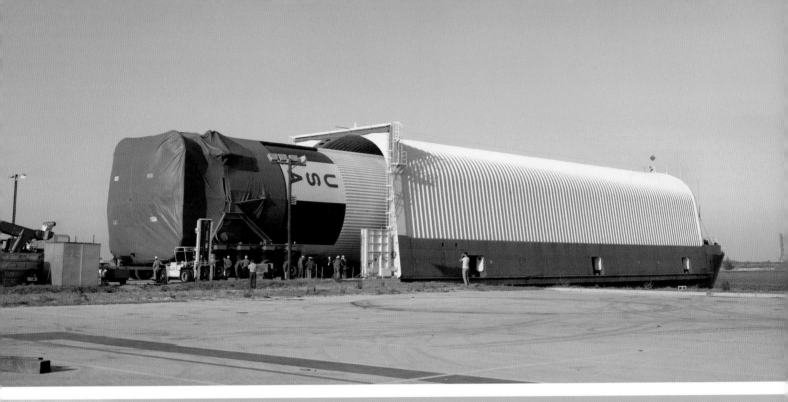

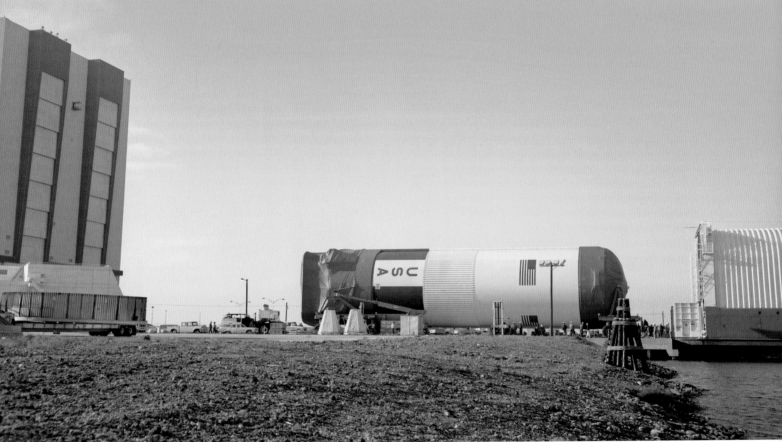

Top: Workers begin offloading the S-IC (first stage) of Apollo 11's Saturn V after arrival at the Turning Basin dock on January 20, 1969. *Poseidon*, shown here, shared with fellow barge *Orion* the duty to transport the large S-IC stages to KSC from Louisiana's Michoud Assembly Facility near New Orleans. The various stages for one Saturn V spent up to seventy days in transit at sea before arriving at KSC. (NASA)

Bottom: The S-IC is towed toward the VAB using special ground support equipment on January 20. The booster was then moved into the transfer aisle, where checkout would begin for stacking and eventual rollout. (NASA)

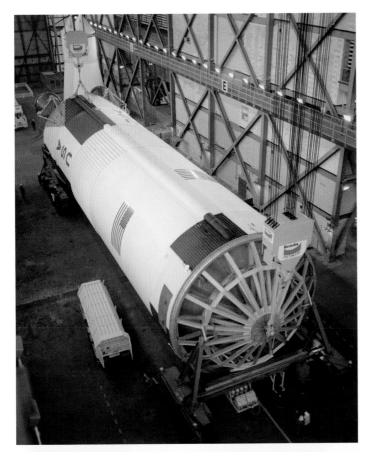

Left: The S-IC is shown on its transport in the horizontal position on February 21, 1969, in the transfer aisle of the VAB. Two cranes have begun the process of lifting the booster into a vertical position. (NASA)

Bottom left: An overhead crane in the VAB places the S-IC in a vertical position on February 21. The booster was built by the Boeing Company of Seattle, Washington. (NASA)

Bottom right: An overhead crane in the VAB raises the S-IC for stacking atop Mobile Launcher (ML) No. 1 on February 21. The stage weighed 289,000 pounds without fuel. (NASA)

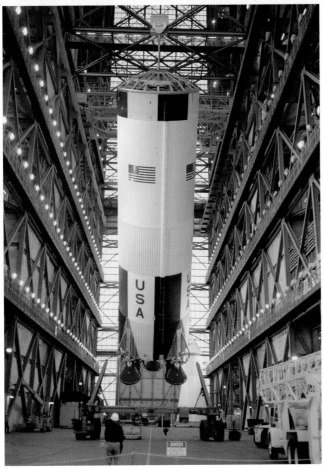

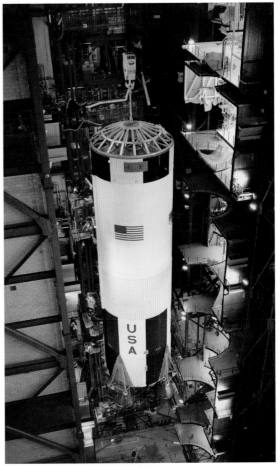

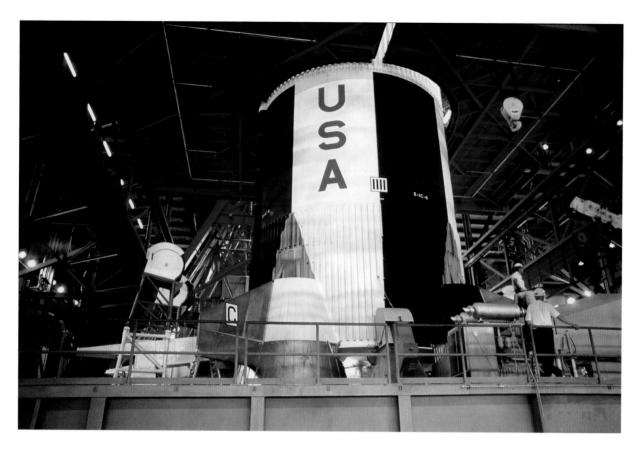

Above: Apollo 11's 138-foot-tall, 33-foot-round S-IC is secured atop ML-1 inside high bay 1 of the VAB in early 1969. The S-IC produced 7,500,000 pounds of thrust powered by five F-1 engines at launch. (Photo by Tiziou News Service)

Left: The Instrument Unit (IU) for Apollo 11's Saturn V arrives at the Cape Kennedy Skid Strip on February 27, 1969, and is unloaded from the *Pregnant Guppy* transport aircraft. The IU was then taken to the VAB for processing and eventual mating with the Saturn V rocket. (NASA)

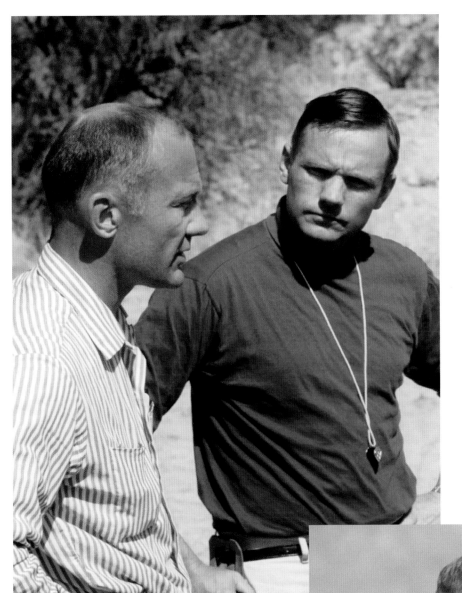

Left: Aldrin (*left*) and Armstrong spend February 25, 1969, in the Chihuahuan Desert near El Paso, Texas, practicing with tools similar to those they will use on the lunar surface. Both also recorded their impressions of various rock types. (NASA)

Below: Armstrong tries out a geology hammer during the training session in the Quitman Mountains, a volcanic area 70 miles southeast of El Paso. The two crewmen were joined by Apollo 11 back-up astronauts Lovell and Haise, as well as astronauts William Pogue, a support crew member, Jack Swigert, and Harrison Schmitt. (NASA)

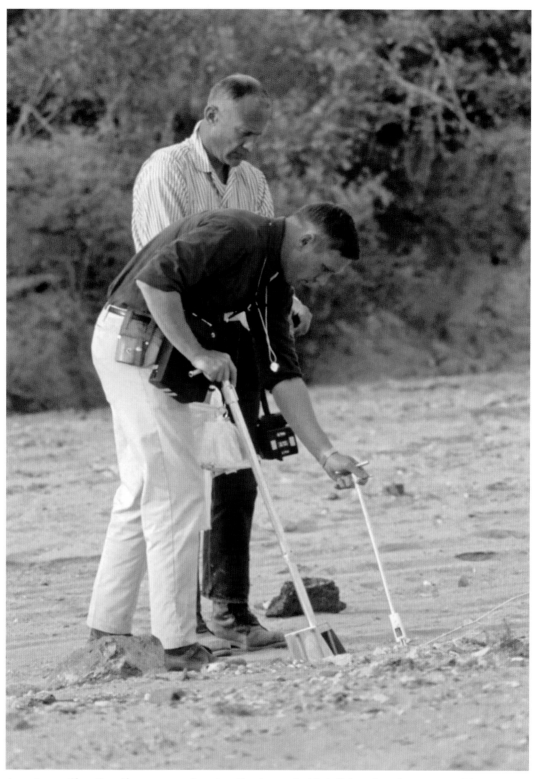

Armstrong (*front*) gathers a sample using the tongs in his left hand and a scoop with an extension handle in his right hand. Two days later, on February 27, 1969, NASA announced that Aldrin would be the first to step on the Moon because of his role as lunar module commander. (NASA)

3

Assembly and Checkout

March 1969 was a busy time at Launch Complex 39 (LC-39, pads A and B). Apollo 9 spent ten days in Earth orbit, honing rendezvous and docking maneuvers required for a Moon landing. The Apollo 10 launch vehicle was rolled out to the pad, and hardware for Apollo 12 began arriving.

At this point, Apollo 11's Saturn V booster was only awaiting its payload: the command and service module (radio call sign *Columbia*), and its two-stage lunar module (*Eagle*). These spacecraft were undergoing testing in KSC's cavernous vacuum chambers and having their electronics, fuel systems, and communications tested. One month later they would be mated with the launch vehicle, a major milestone.

Armstrong, Aldrin, and Collins underwent extensive mission-specific training for their flight from launch through splashdown and spent many hours in special flight simulators.

Public interest in the mission, already high, was growing. Actor Gregory Peck and a Hollywood crew showed up at KSC to film scenes for a drama about a fictional Apollo crew trapped in orbit.

Above: Tourists at MSC in Houston in the spring of 1969 pose for photographs in front of the lunar module mockup. Tourism at the primary NASA centers was on the upswing as a lunar landing approached. (Photo by Tiziou News Service)

Facing page: A crane prepares to lift Apollo 11's S-II booster off a workstand in the transfer aisle of the VAB on February 6, 1969. The 81.5-foot-tall and 33-foot-diameter S-II was built by North American Rockwell in Seal Beach, California, and, powered by five J-2 engines, produced approximately 1,000,000 pounds of thrust. (NASA)

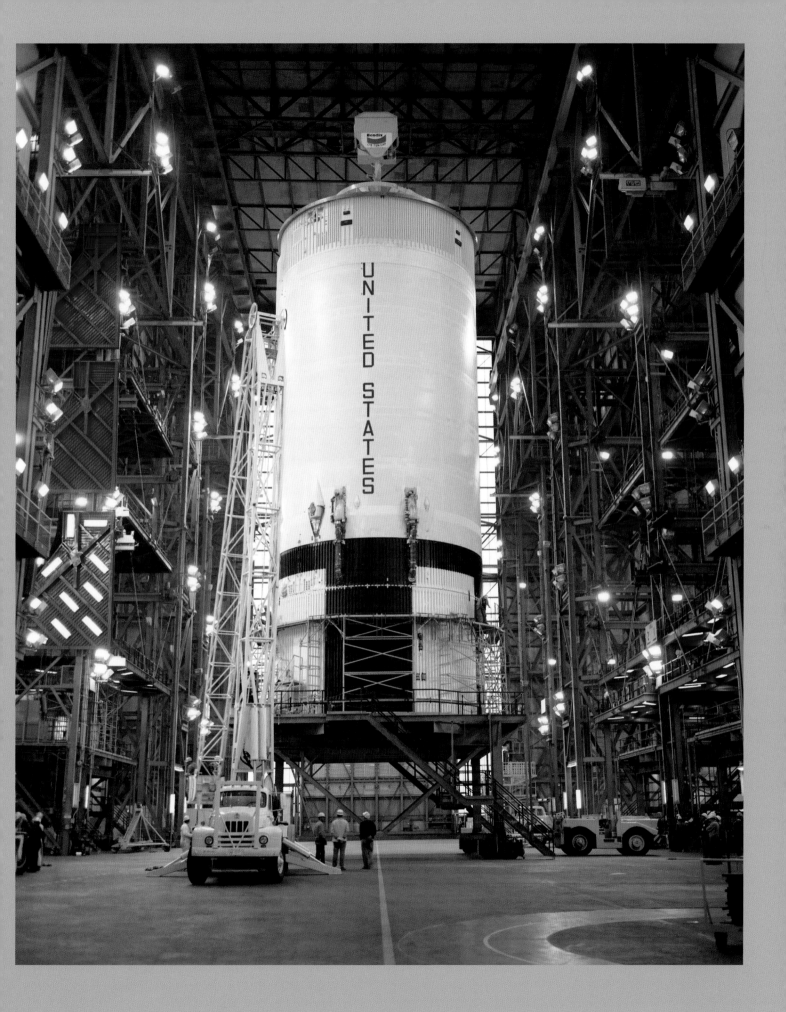

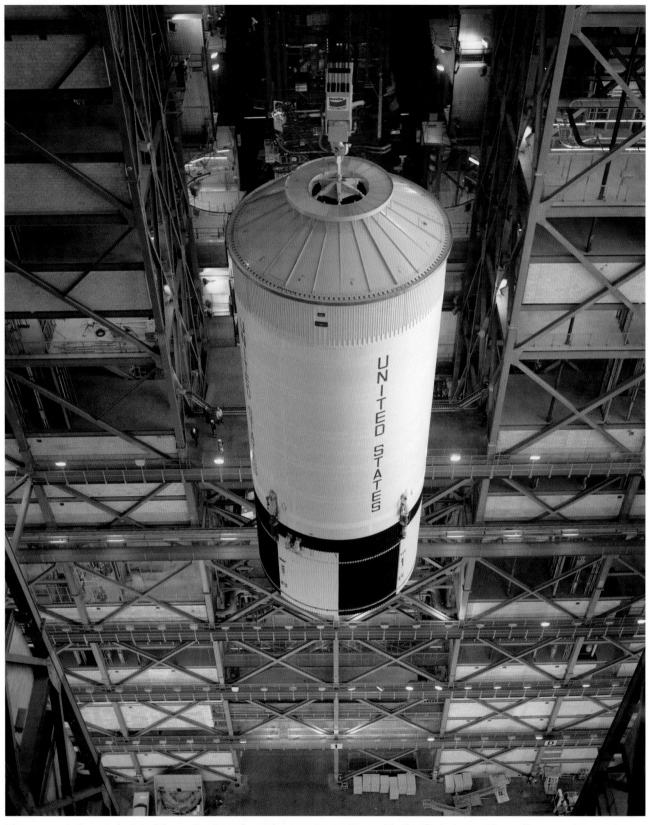

The second stage is hoisted from the transfer aisle prior to mating with the first stage. The yellow cap is a protective handling cover which will be removed before the third stage is stacked. (NASA)

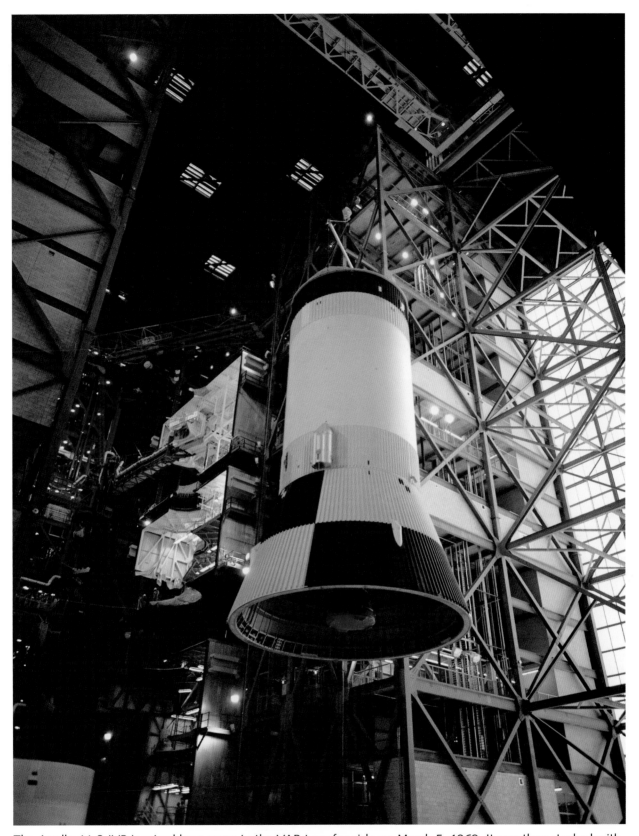

The Apollo 11 S-IVB is raised by a crane in the VAB transfer aisle on March 5, 1969. It was then stacked with the first and second stages of the Saturn V in high bay 1. The S-IVB, built by McDonnell Douglas in Huntington Beach, California, was capable of 225,000 pounds of thrust powered by a single J-2 engine, which was required to fire twice. The engine was needed first to get Apollo 11 into Earth orbit, and second to push the spacecraft out of orbit toward the Moon. (NASA)

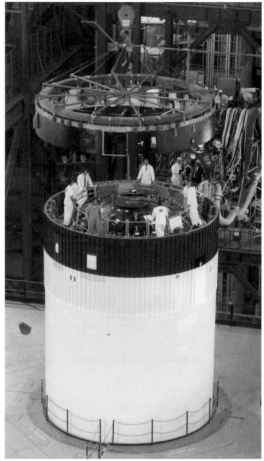

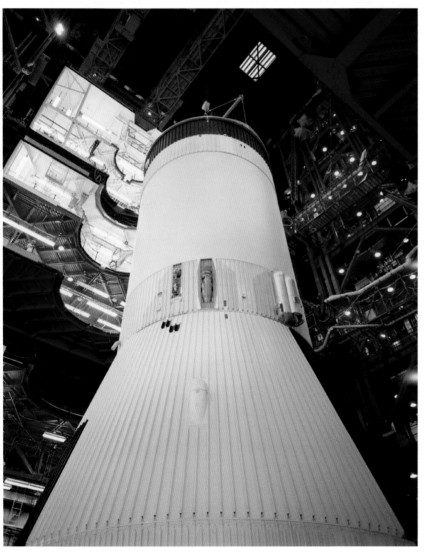

Above: The Instrument Unit for Apollo 11's Saturn V is gently lowered into position atop the S-IVB on March 5. The IU was developed by NASA's Marshall Space Flight Center in Huntsville, Alabama, and the guidance system was manufactured by IBM. The IU was considered the "brains" of the mighty Saturn V. (NASA)

Left: Close-up view of the Apollo 11 S-IVB (third stage) mated to the S-II (second stage). The silver-toned pods at right are one of two auxiliary propulsion system (APS) modules, built by TRW. Each module's three small engines provided roll control for the stage during powered flight, as well as three-axis control in Earth orbit and during LM extraction. (NASA)

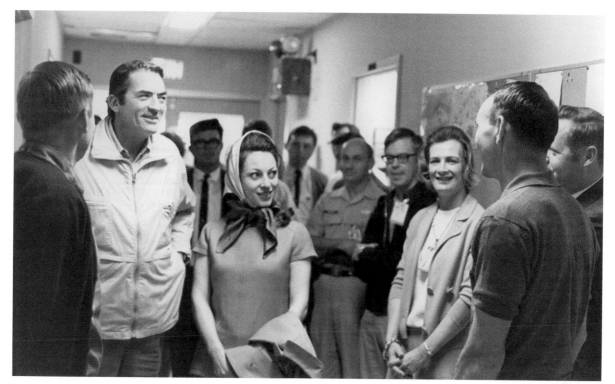

Actor Gregory Peck and his wife Veronique meet with the Apollo 11 astronauts during a tour of KSC on March 7, 1969. Hollywood released a handful of space-themed movies during the buildup to Apollo 11, and Peck starred in one such film titled *Marooned*. Astronaut crew quarters secretary Lola Morrow is left of Collins; NASA Public Affairs Offiver Jack King, who would be the launch commentator, is at far right. (NASA)

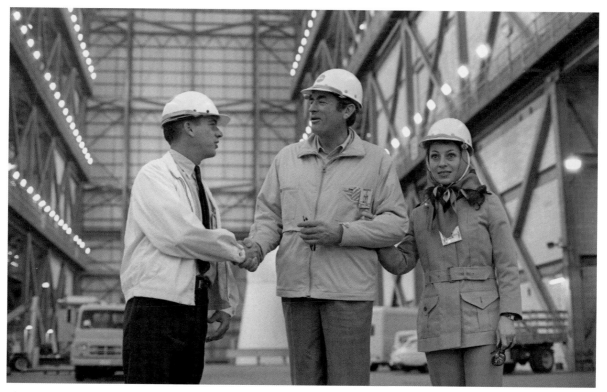

The Pecks get a VIP tour of the cavernous VAB on March 7 by NASA Test Conductor Don Phillips. Peck was filming *Marooned* at the time, based on a 1964 novel by Martin Caiden involving astronauts trapped in space. The movie was released less than four months after the Apollo 11 Moon landing. (NASA)

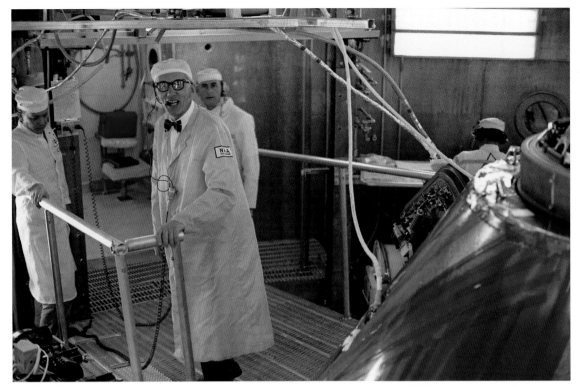

Guenter Wendt in altitude chamber L of KSC's MSOB as he awaits the arrival of the Apollo 11 astronauts prior to a chamber test with the CM on March 18, 1969. Wendt was born in Germany and became a U.S. citizen in 1955. He is best known by the title of pad leader for the Mercury, Gemini, and Apollo programs, working first for McDonnell Aircraft and later for North American Rockwell during Apollo. (NASA)

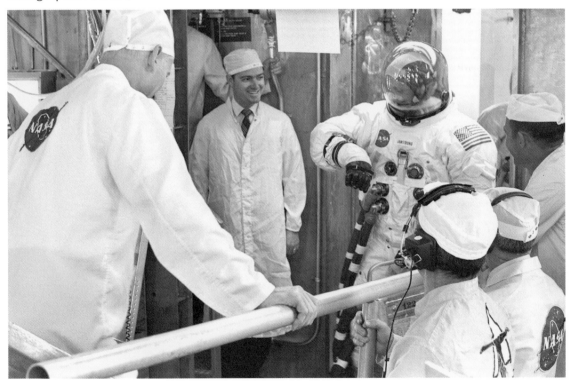

Armstrong checks his watch as he enters the altitude chamber on March 18 prior to the CM test. At left is suit technician Joe Schmitt. Armstrong was soon joined by astronauts Collins and Aldrin. Four tests were performed with the CM during the nine weeks it was in chamber L. (NASA)

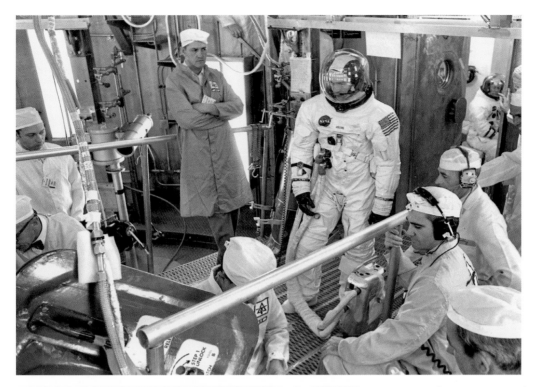

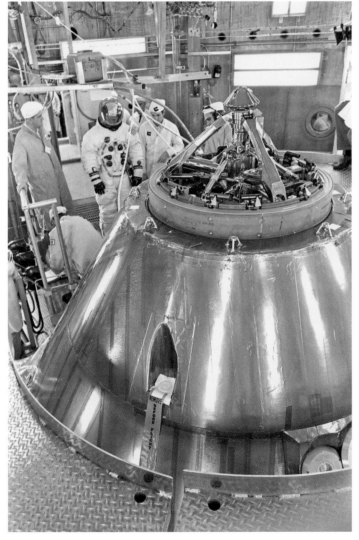

Above: Collins pauses on the grated walkway to the CM. Wendt (*left*) prepares for Collins to ingress. Aldrin is seated at far right at the entrance to the chamber. (NASA)

Left: Aldrin (*upper left*) stands outside the CM as preparations are made for his ingress. Above the CM's docking ring are its docking probe and twelve automatic capture latches, which would help keep the CM and LM "hard docked" during the trans-lunar phase and when the LM returned from the lunar surface. One of four mounts for the Launch Escape System's tower is below with a "Remove Before Flight" streamer. (NASA)

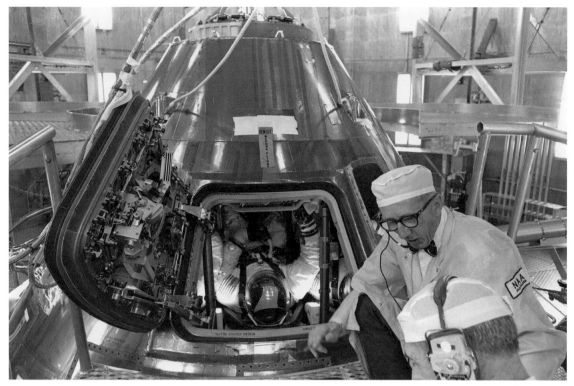

The Apollo 11 astronauts are inside the CM as Wendt monitors preparations for a chamber test on March 18. The crew entered the CM shortly before 10:00 a.m. (ET), and the air was then pumped out of the chamber to simulate an altitude of more than 200,000 feet, or about 38 miles. (NASA)

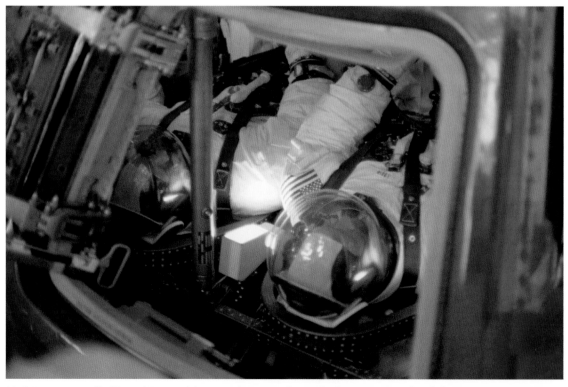

Neil Armstrong (*left*) and Buzz Aldrin can be seen through the open hatch of the CM on March 18 in altitude chamber L prior to the test. The astronauts were busy checking systems and equipment they would rely on during their mission. (NASA)

Left: A space suit Portable Life Support System (PLSS) "backpack" is shown stowed in the floor of Apollo 11's lunar module on March 18 prior to an altitude chamber test in chamber R of the MSOB. (NASA)

Below: Apollo 11's Early Apollo Surface Experiments Package (EASEP) on March 19, 1969, during final preflight closeout checks before being loaded into the scientific equipment bay in the descent stage of the LM. (NASA)

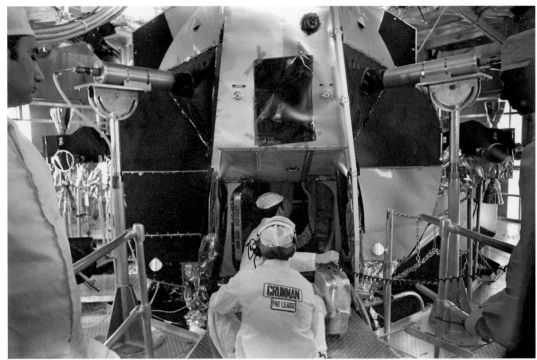

Above: A wide view shows Apollo 11's LM in MSOB's altitude chamber R on March 21. Numerous work platforms allowed engineers to access all areas of the spacecraft while it was in the chamber. Suit technician Ron Woods assists one of the astronauts through the open hatch of the LM. Two television cameras are also visible aimed into the LM windows. (NASA)

Right: Aldrin enters altitude chamber R on March 21 to join Armstrong for the chamber test. Four manned LM tests were conducted during the six weeks the LM was in the chamber, one with the prime crew and one with the back-up crew (Lovell and Haise). (NASA)

Facing page: A technician checks on Armstrong through the window as the astronaut waits in the MSOB's altitude chamber R prior to the test of the LM. The LM had been moved into the chamber on February 13. (NASA)

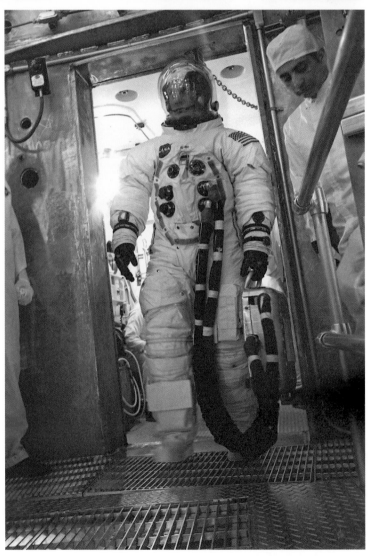

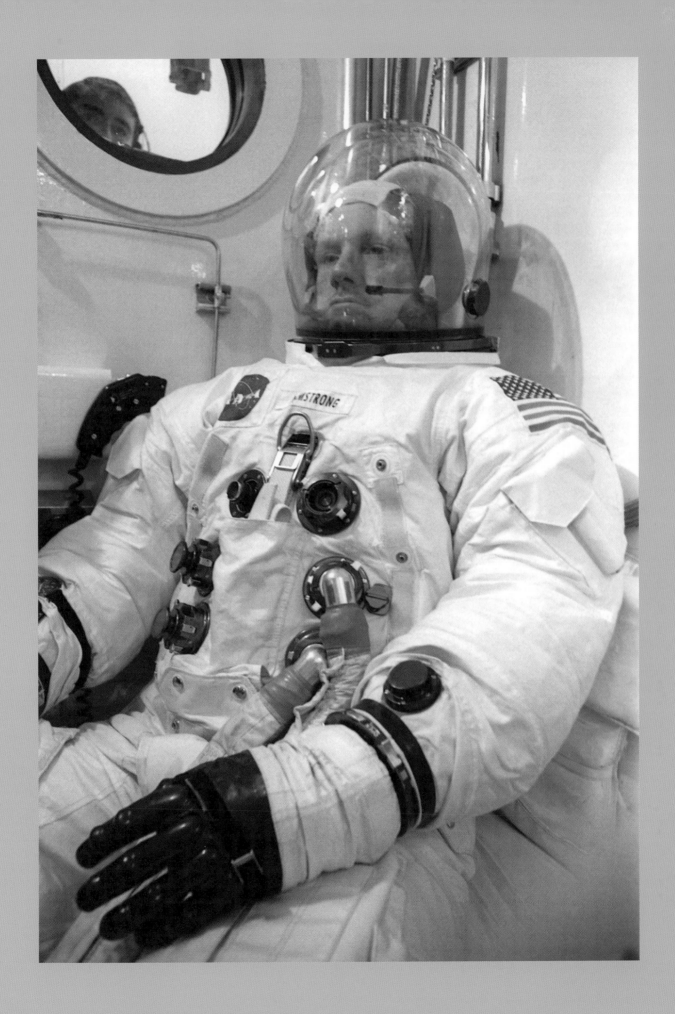

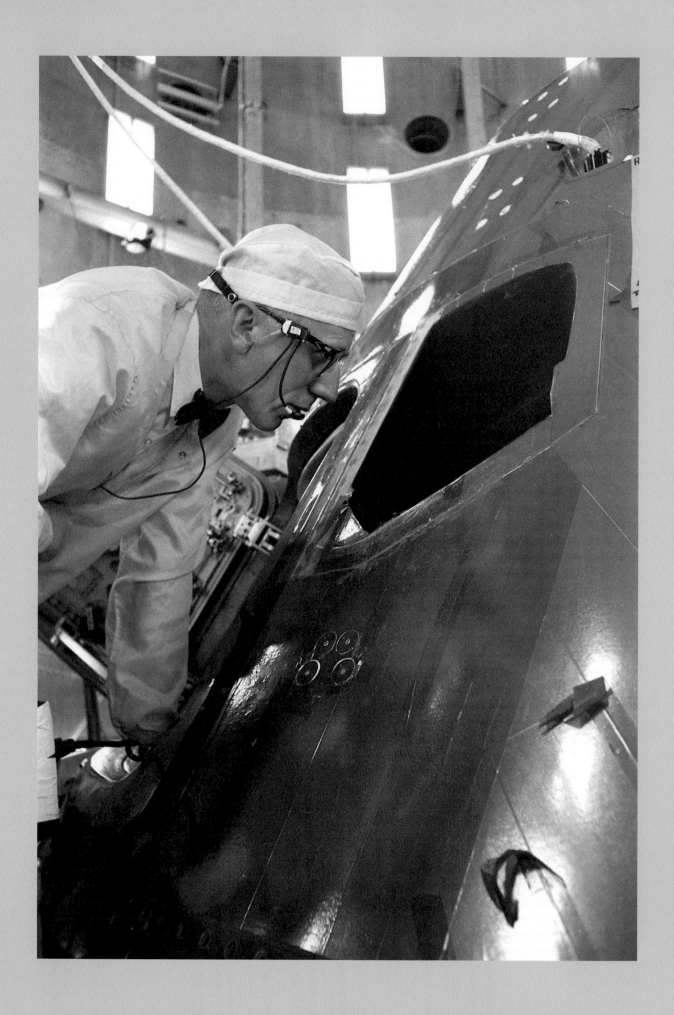

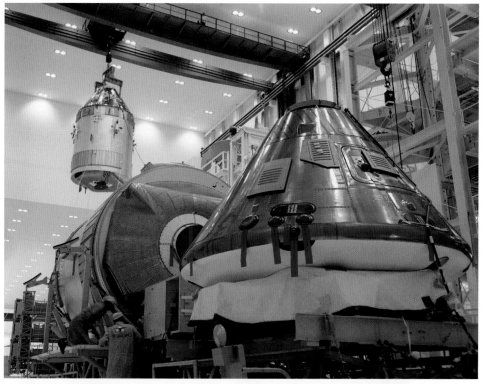

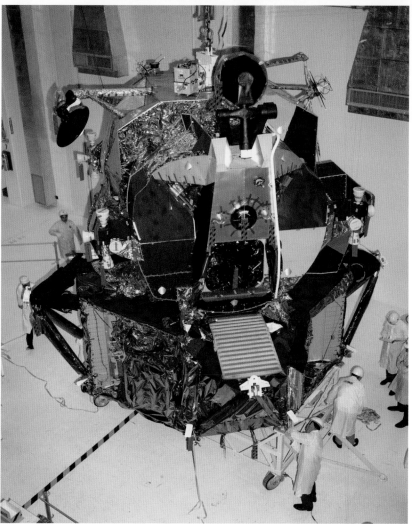

Facing page: Wendt peers into *Columbia*'s right-hand rendezvous window three days later, when the back-up crew of astronauts Lovell, Haise, and William Anders participated in a chamber test. This window was above what would be Collins's couch, as Aldrin had trained to fly the CM from the center couch as back-up Apollo 8 CM pilot. (NASA)

Above: At upper left, the Apollo 11 CSM is moved by handling fixture from the MSOB's altitude chamber L at KSC on April 1, 1969. In the foreground is the Apollo 12 CM and SM, which had just been delivered to KSC for processing. All the Apollo CMs were covered in a transparent blue plastic protective film during processing at KSC, which was removed at the pad before the boost protective cover was installed over the command module a few days before launch. (NASA)

Left: The LM begins the move by handling fixture to the landing gear support stand in the MSOB on April 1, where four landing legs and footpads would be attached. (NASA)

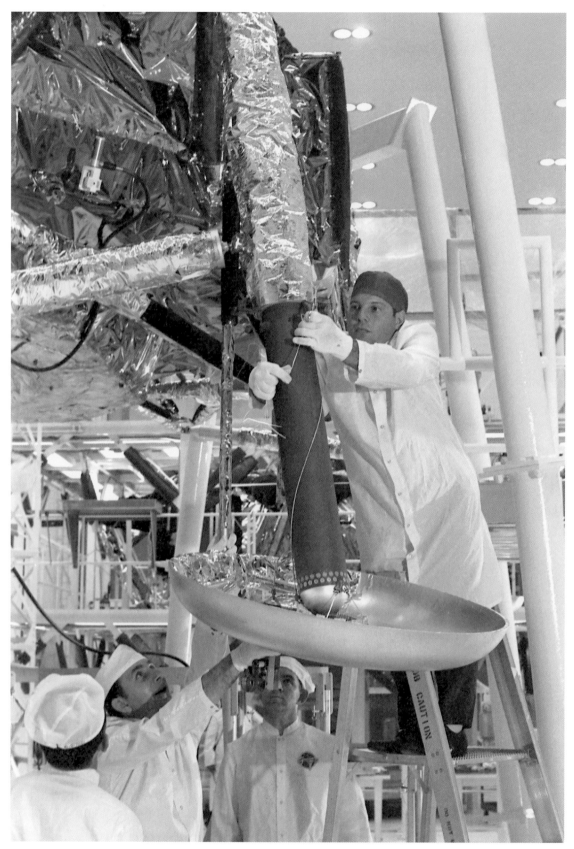

Grumman technicians work to stow a lunar surface sensing probe on April 4, 1969, in the MSOB. The probe, with its tip wrapped in black, here is hinged upward against the leg's primary strut. The technician on the ladder is temporarily securing the probe until it's locked in place. Only the front LM leg did not have a sensing probe. (NASA)

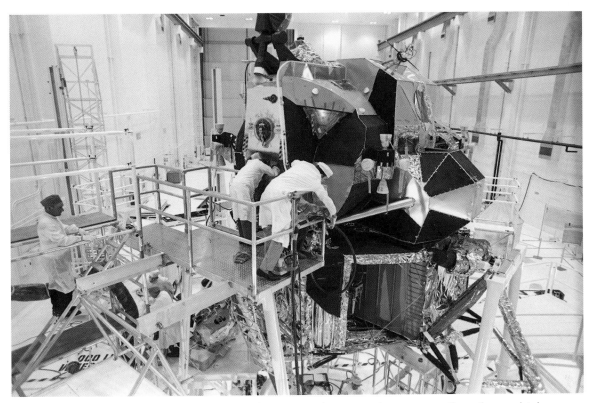

The LM is on the landing gear support stand as two technicians observe operations from a higher vantage point inside the MSOB at KSC on April 4. The process of installing and testing the landing gear took several days. (NASA)

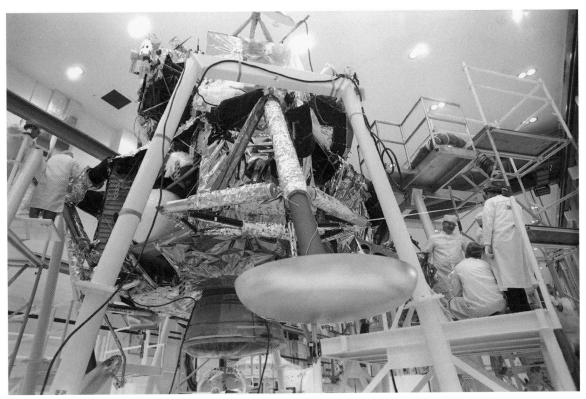

Ground level view of technicians installing landing gear on the lunar module inside the MSOB at KSC. This was the only opportunity for reporters and photographers to see the LM while it was at KSC. (NASA)

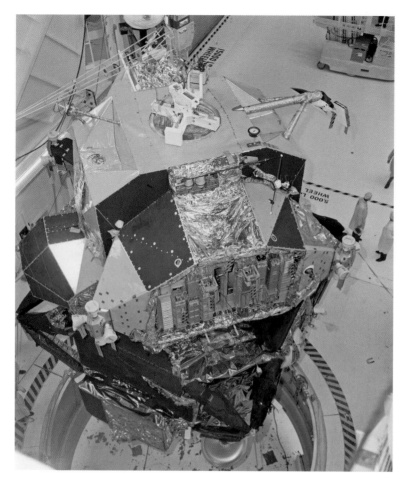

The LM is slowly lowered into the Spacecraft LM Adapter (SLA) below on April 4 in the MSOB. The SLA was a four-paneled conical structure that supported the CSM and protected the LM during the launch phase. (NASA)

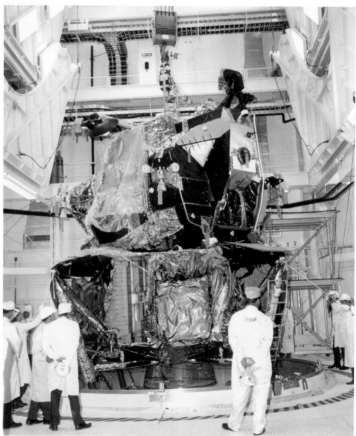

Workers in the MSOB monitor the LM being secured to the SLA's mounting ring on April 4. (NASA)

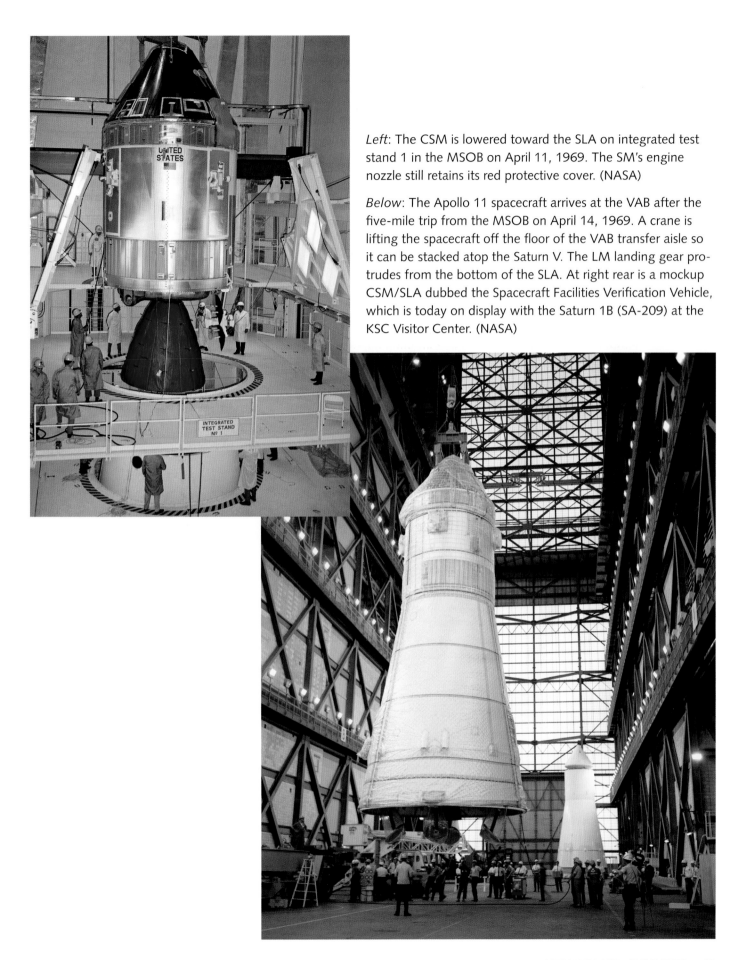

Left: The CSM is lowered toward the SLA on integrated test stand 1 in the MSOB on April 11, 1969. The SM's engine nozzle still retains its red protective cover. (NASA)

Below: The Apollo 11 spacecraft arrives at the VAB after the five-mile trip from the MSOB on April 14, 1969. A crane is lifting the spacecraft off the floor of the VAB transfer aisle so it can be stacked atop the Saturn V. The LM landing gear protrudes from the bottom of the SLA. At right rear is a mockup CSM/SLA dubbed the Spacecraft Facilities Verification Vehicle, which is today on display with the Saturn 1B (SA-209) at the KSC Visitor Center. (NASA)

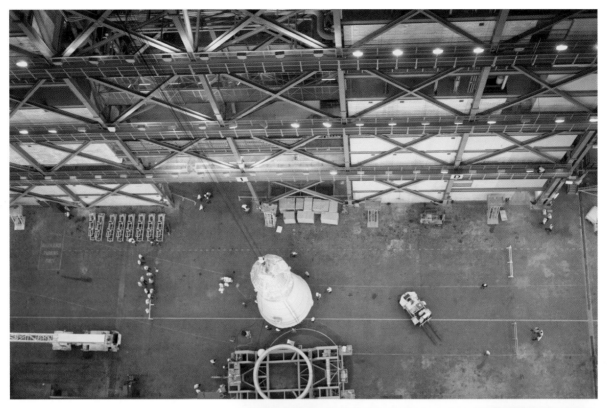

Above: A photographer in the upper level of the VAB records the Apollo 11 spacecraft on April 14 as it is hoisted from the transfer aisle hundreds of feet below. The spacecraft was moved to the VAB on the transport seen at the bottom of the image. (NASA)

Left: Workers in the VAB follow the progress of the spacecraft as it makes its way to the top of the Saturn V for stacking on April 14. The S-II stage is visible in a bay behind it. (NASA)

Facing page: The spacecraft is gently lowered for mating with the IU. The 380-foot Launch Umbilical Tower (LUT) can be seen in the background. The LUT was equipped with nine arms that permitted the Saturn V to be fueled and serviced at the launch pad. The top swing arm can be seen at upper right. (NASA)

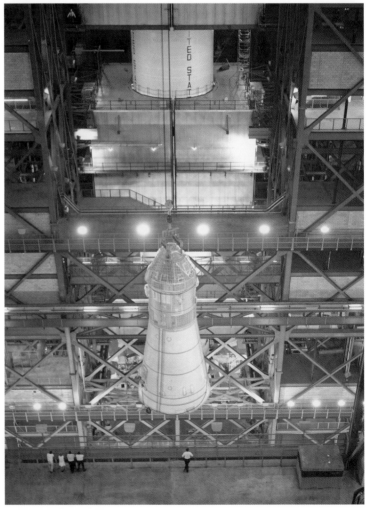

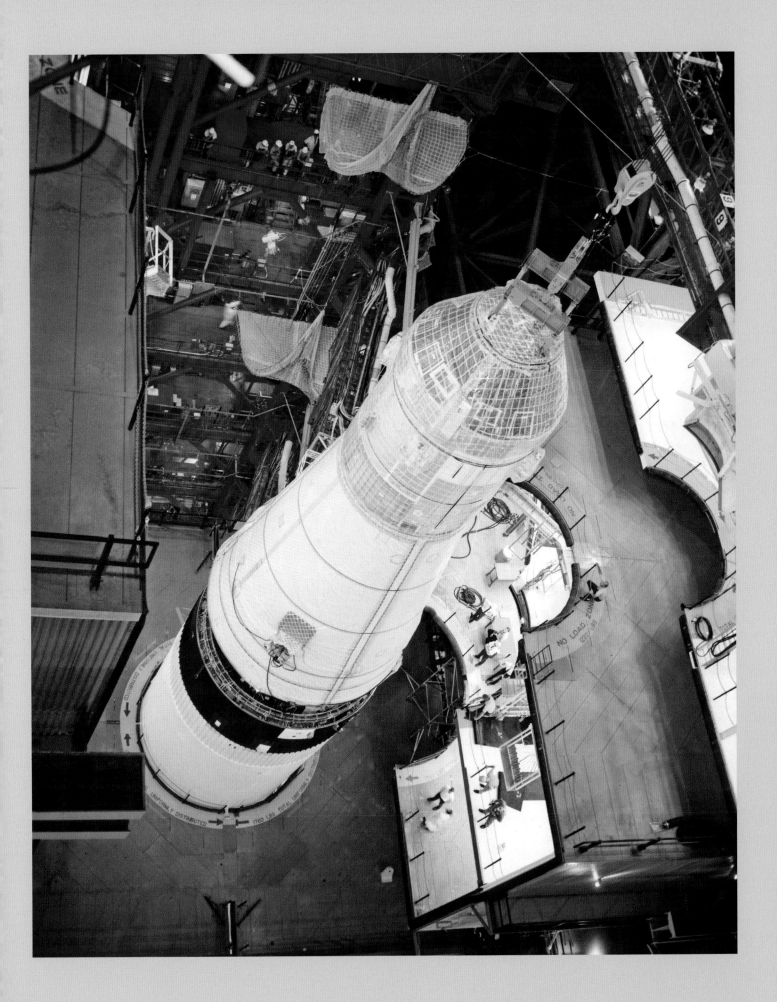

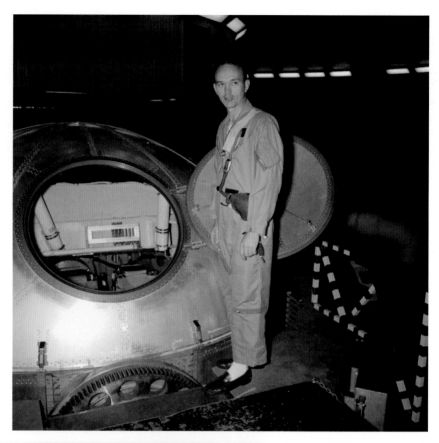

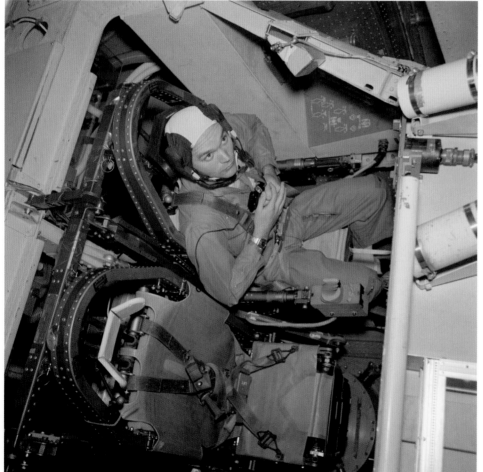

Above: Collins poses next to the gondola connected by a 50-foot arm to the MSC centrifuge on April 14, 1969. The centrifuge was in the Flight Acceleration Facility at MSC in Houston. (NASA)

Left: Collins sits in the three-seat gondola on the centrifuge at MSC on April 14. The centrifuge would swing the occupants at high speed, simulating the additional G-forces astronauts would experience during launch and re-entry. (NASA)

Facing page bottom: Armstrong and Aldrin participate in a simulation at MSC on April 18 of their planned lunar surface activities. The astronauts practiced deploying experiments and using tools they would use during their actual EVA. A full-scale LM mockup is behind them. (NASA)

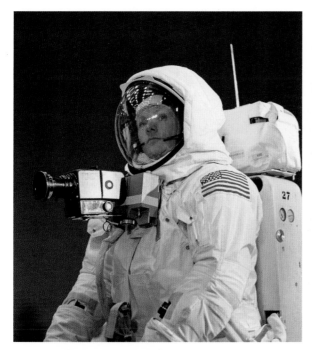

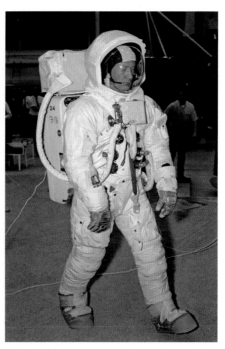

Above left: Armstrong in full lunar gear during an EVA training exercise in Building 9 at MSC on April 18, 1969. For lunar surface EVAs, the combined space suit, PLSS, and associated systems were called the Extravehicular Mobility Unit (EMU). A Hasselblad 500 EL camera is mounted on Armstrong's chest. (NASA)

Above right: Aldrin participates in lunar surface training at MSC on April 18. His EMU includes a PLSS manufactured by Hamilton Standard of Windsor Locks, Connecticut—a division of United Aircraft. Aldrin had officially learned four days earlier that he would not leave the LM first as had been planned. Apollo Program Manager George Low instead confirmed that Armstrong would be first on the surface as mission commander. (NASA)

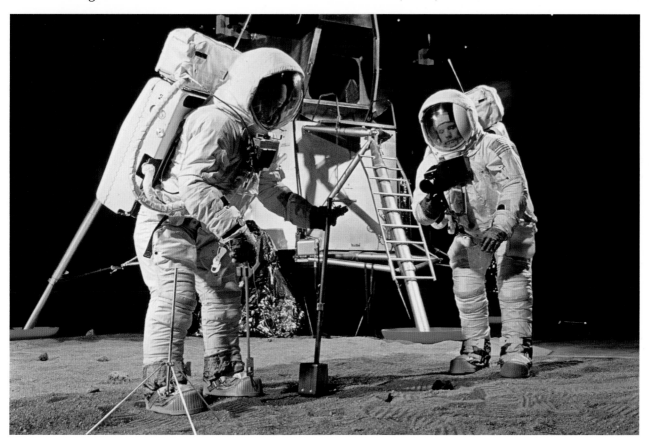

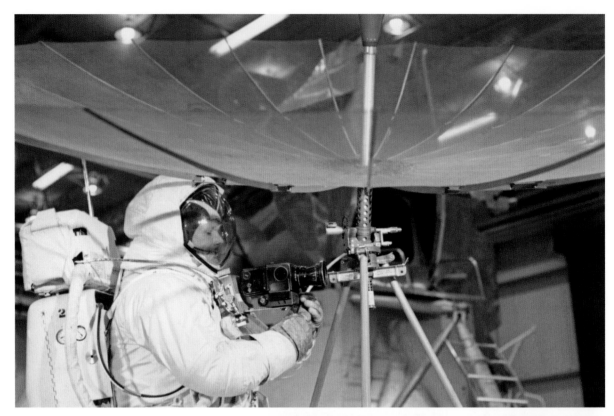

Above: Armstrong adjusts an Erectable S-band Antenna he has just deployed during the April 18 training session. Potential problems receiving downlinks from the lunar surface were enough of a concern that engineers created the antenna for Apollo 11, but since deploying it would have consumed nineteen precious minutes of the EVA, it was not used after a quick assessment determined the black-and-white TV signal through *Eagle*'s antenna was adequate. It was, however, deployed on both Apollo 12 and 14. (NASA)

Right: Armstrong (*foreground*) practices deploying an S-band communications antenna as Aldrin collects lunar material in a scoop during the 2½-hour April 18 EVA training exercise. (NASA)

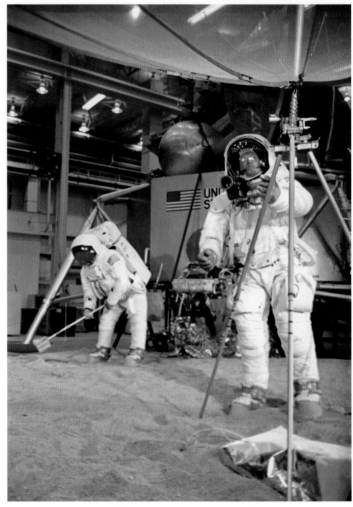

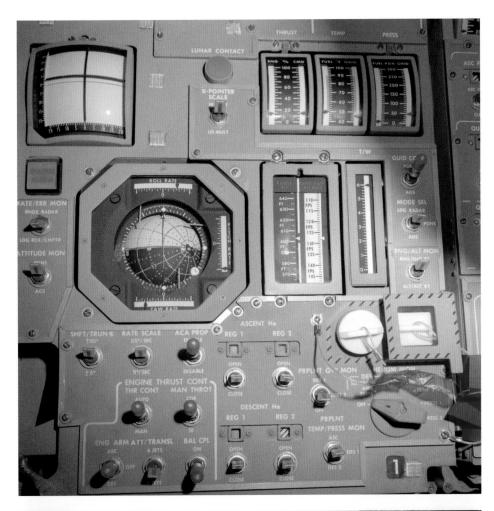

Top: This is LM panel No. 1 on Armstrong's side of the cockpit with gauges and indicators critical for the landing. Note the blue "lunar contact" indicator at top center, which would light up when the probes on *Eagle*'s footpads contacted the surface. This was Armstrong's cue to shut down the descent engine. (NASA)

Left: Part of the LM's Environmental Control Unit was the oxygen control module, shown here. It controlled the supply of cabin oxygen and provided refills for the PLSS tank. Before staging, oxygen was supplied from a tank in the descent stage. After staging, or if the descent stage tank were depleted, a tank in the ascent stage would supply oxygen to this module. (NASA)

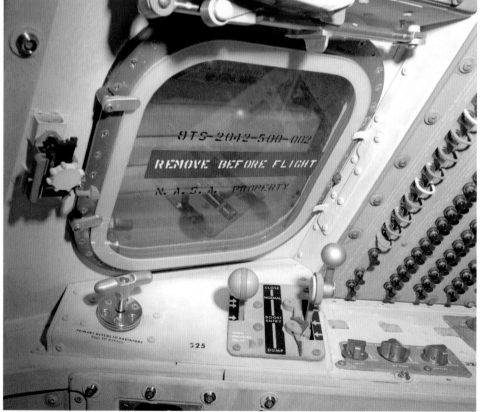

Top: The center console of the Apollo 11 CM is shown in this closeout photo from April 1969 at KSC. The caution and warning panel is at upper center, reaction system controls are at lower center, and some of the CSM propulsion system controls are in the upper right corner. Part of the main CM hatch is at the top of image, and the tunnel leading to the LM is below the panel in the center. (NASA)

Left: The CM has five windows; this is window no. 1 on the left-hand (Armstrong's) side of the cockpit. As the "Remove Before Flight" label indicates, it is protected by a cover to prevent damage. Below the window is panel 325. The T-handle is related to the use of a water/glycol solution to dissipate the spacecraft's excess heat through radiators on the exterior of the SM. The handles just right of center are for cabin pressure relief. (NASA)

4

Rolling toward Launch

It was May 1969: Apollo 10 was on its way to the Moon, and Apollo 11 would be up next. On May 20 another major milestone was achieved: moving the massive Saturn V and its Apollo 11 spacecraft to LC-39A. Among KSC officials in attendance was Don "Buck" Buchanan, KSC director of design engineering, who developed the mobile launcher concept. The flight crew arrived as well, taking reporters' questions shortly before sunset.

During the month, the astronauts took part in training for ocean splashdown and recovery operations. On May 26 Apollo 10 returned safely from testing the LM in lunar orbit, a dress rehearsal mission for its successor.

The Kennedy Space Center had come into its own as a "moonport" during this time. Apollo 10, launched from LC-39B, was a success, Apollo 11 stood ready at LC-39A, and Apollo 12 had been stacked in the VAB. This scenario was what early design engineers of KSC had predicted would one day be a familiar sight.

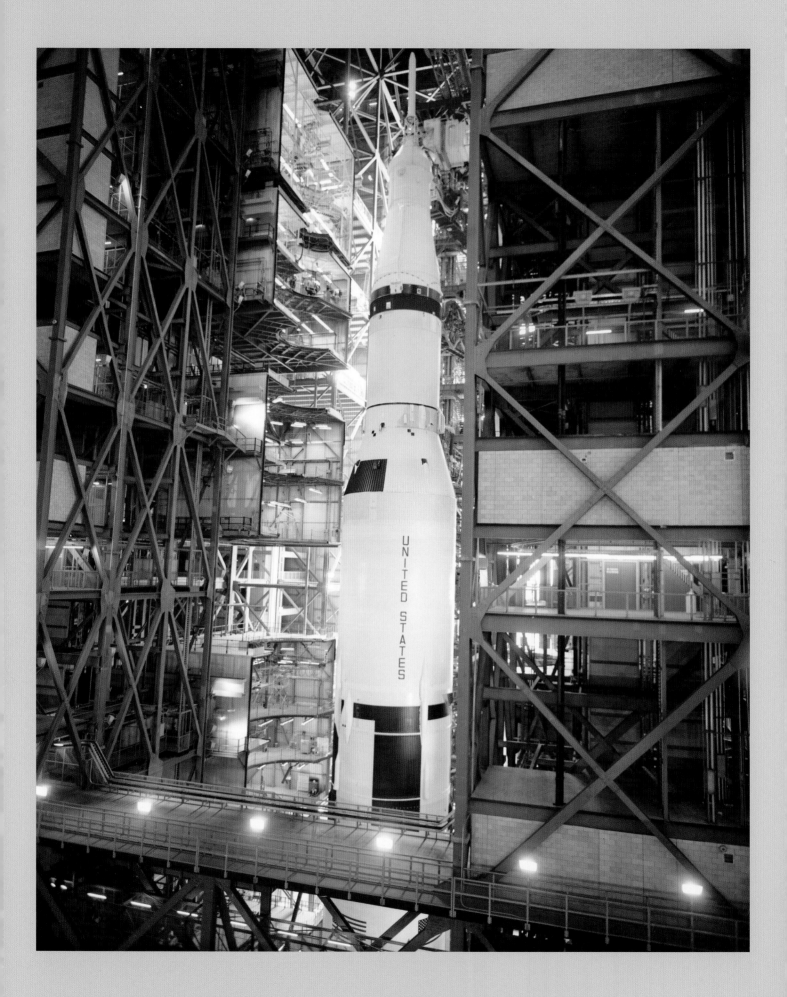

Facing page: The fully stacked Saturn V spends a final morning in the VAB prior to rolling out to LC-39A that afternoon. The CSM and SLA were protected by a weatherproof covering during the trip to the pad. (NASA)

Above: The Apollo 11 Saturn V is reflected in a pool of water shortly after departing high bay 1 of the VAB on May 20, 1969. (Photo by Tiziou News Service)

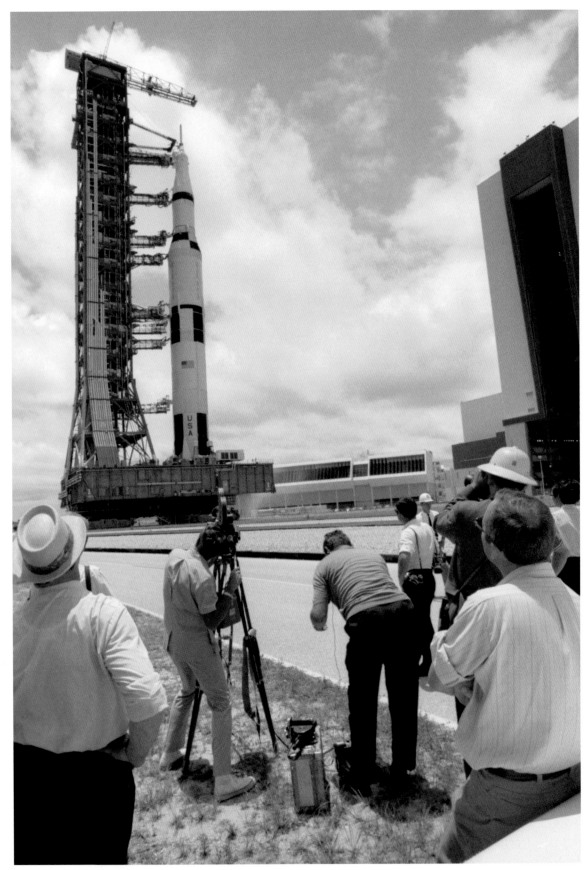

News reporters and photographers observe the Saturn V from near the crawlerway as the rocket begins the 3.5-mile trip to LC-39A. The rollout officially got under way at 12:30 p.m. (ET). (NASA)

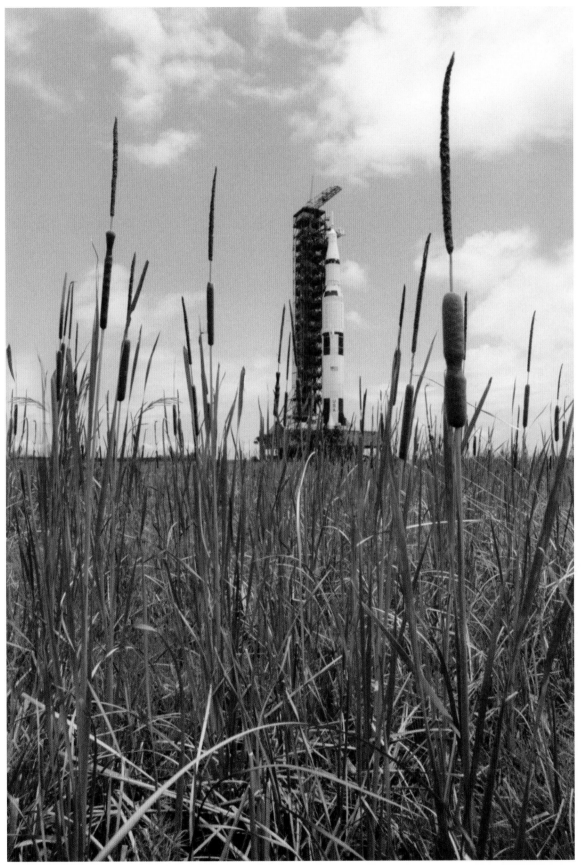

Nature meets machine as the Saturn V moves past a group of cattails near the crawlerway. The roll-out took more than seven hours, with the diesel-powered crawler transporter averaging a speed of less than one mile an hour. (NASA)

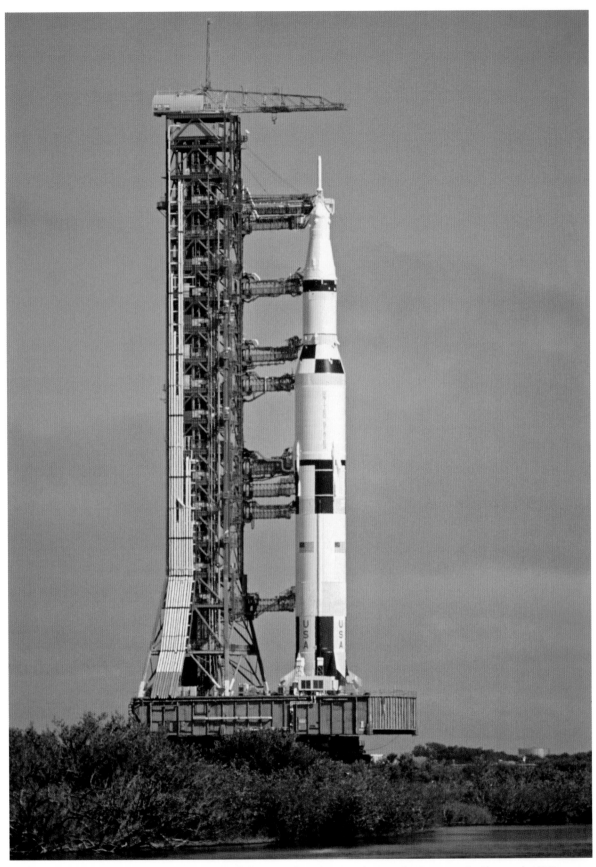

The 363-foot-tall Saturn V rides atop Mobile Launcher (ML) 1 during the journey to the pad. KSC operated three MLs, and ML-1 had previously been used for the Apollo 8 launch on December 21, 1968. (Photo by Tiziou News Service)

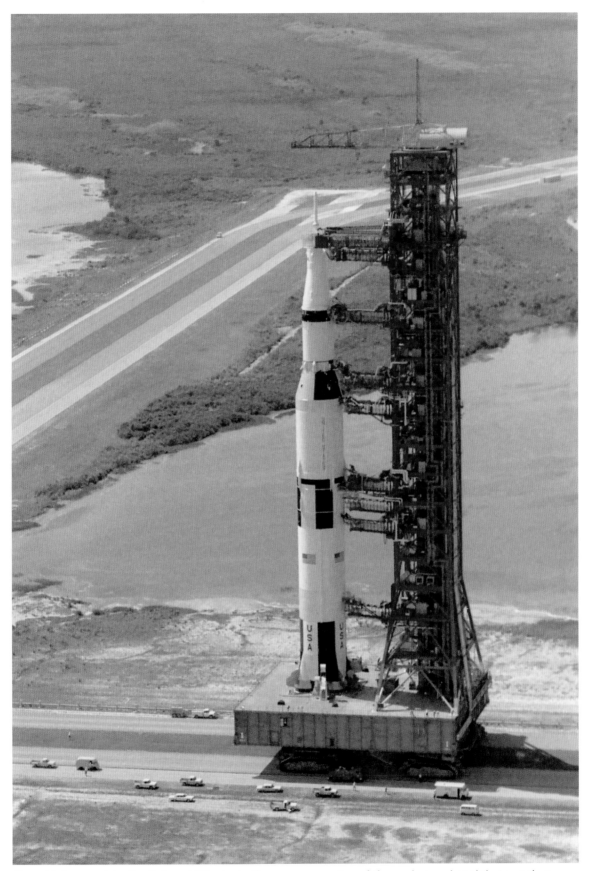

Cars driving next to the Saturn V illustrate the enormous size of the rocket and Mobile Launcher. The red Launch Umbilical Tower (LUT) weighed 12 million pounds, and the unfueled Saturn V rocket weighed in at half a million pounds. Broadaxe Creek is in the background. (NASA)

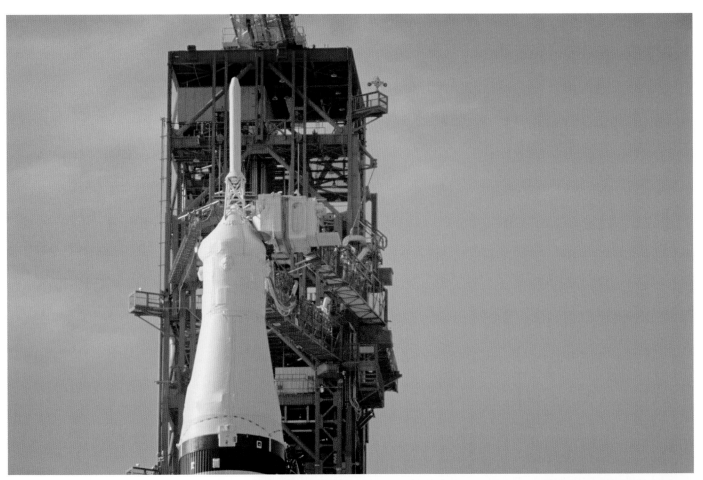

Above: The Launch Escape System (LES) sits atop the CSM as the Saturn V moves to LC-39A. The LES consisted of three solid-fueled rocket motors that would pull the spacecraft away from the launch vehicle in case of an emergency. (Photo by Tiziou News Service)

Right: The Apollo 11 Saturn V moves past the Mobile Service Structure (MSS) at its parked site, signaling 1.5 miles remaining to reach the pad. The 410-foot-tall MSS, originally intended primarily for ordinance installation, had five work platforms (the lower two were vertically adjustable) that provided access to the Saturn and a base that contained several service compartments. (NASA)

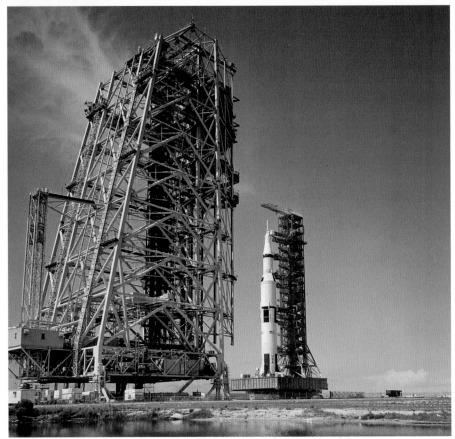

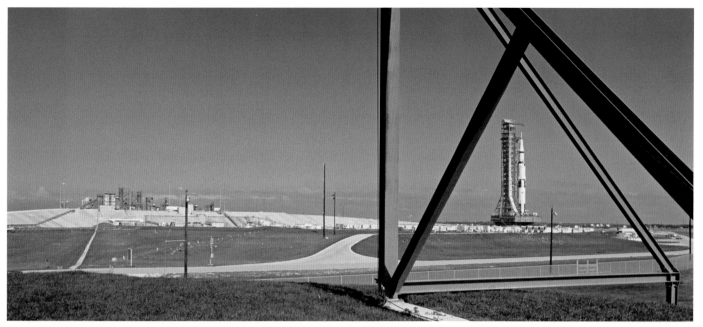

Distant view of the crawler transporter moving the combined 12.5-million-pound weight of the Saturn V and LUT up the LC-39A incline. Its leveling system keeps the Mobile Launcher level to within .16 degrees, or about one foot of vertical, at the top of the Saturn V while moving up the 5 percent grade to the launch site. (Photo by Tiziou News Service)

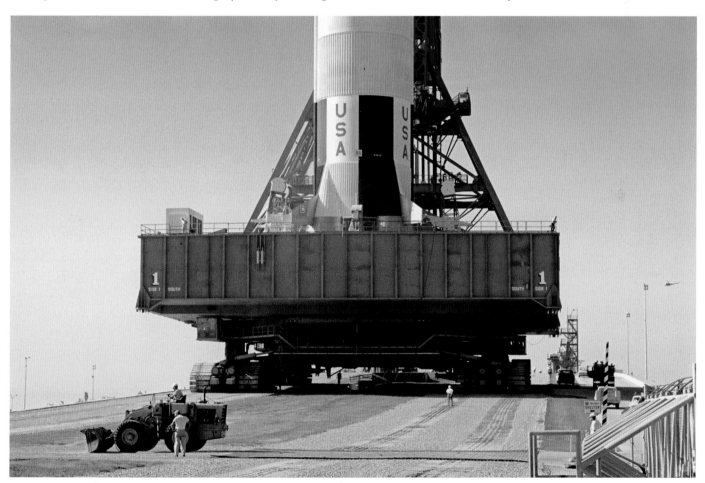

The crawler transporter inches its way to the hardstand as the rollout is nearly complete. The crawler transporters were equipped with four pairs of tracks beneath them, and each tread shoe weighed one ton. The crawlers were built by the Marion Power Shovel Company of Marion, Ohio. (Photo by Tiziou News Service)

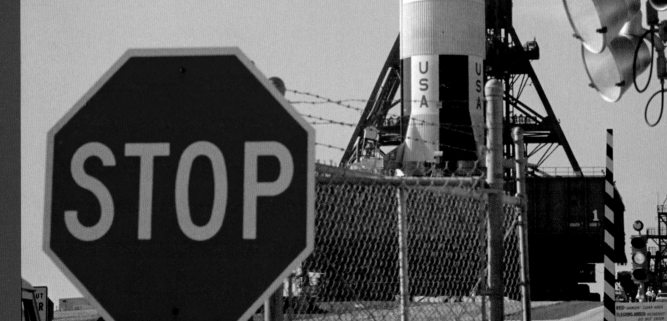

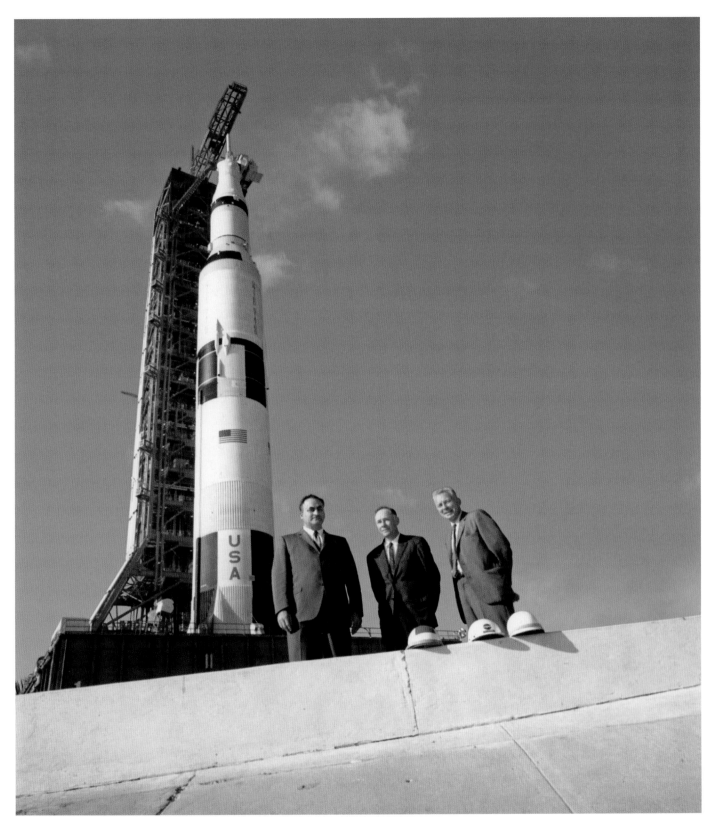

Facing page: A stop sign greets incoming vehicles at the guard gate shortly after the Saturn V arrived at LC-39A. The launch vehicle was finally in place at 7:46 p.m. (ET). (Photo by Tiziou News Service)

Above: The "big three" who kept Apollo launches running smoothly: Launch Operations Director Rocco Petrone, Launch Operations Manager Paul Donnelly, and Director of Design Engineering Donald "Buck" Buchanan (*left to right*) at LC-39A following rollout on May 20. (NASA)

Left: Armstrong answers questions from reporters after pausing from a busy training schedule to observe the Saturn V rollout. (Photo by Tiziou News Service)

Below: Armstrong, Collins, and Aldrin (*left to right*) pose for news photographers as the Saturn V towers behind them following rollout on May 20. This was only the second time NASA had chosen an all veteran crew for a flight; Apollo 10 was the first. (Photo by Tiziou News Service)

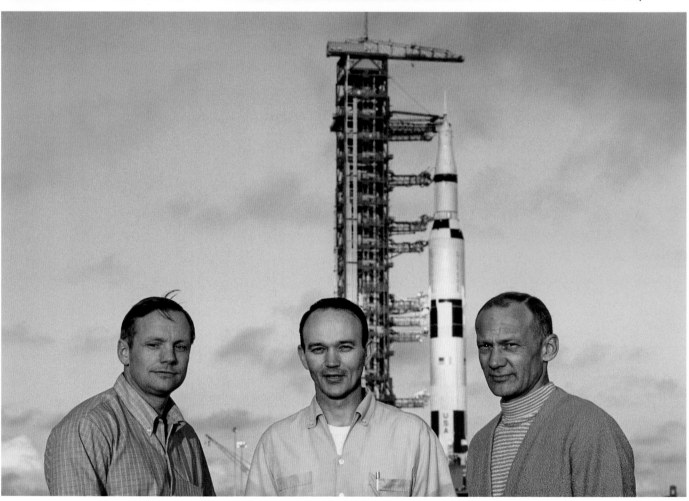

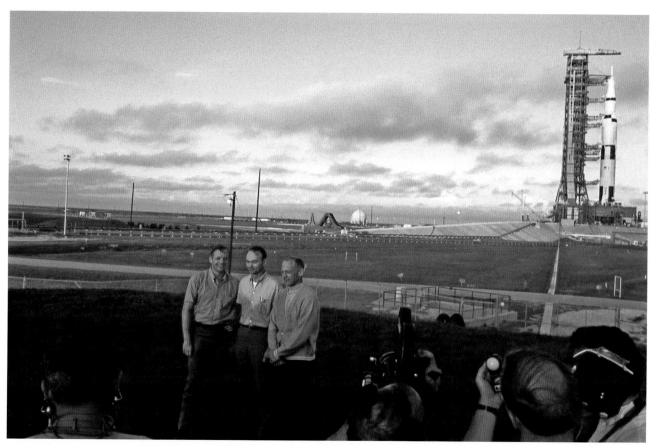

The sun sets on Armstrong, Collins, and Aldrin as they speak with reporters. LC-39A and the Atlantic Ocean are in the background. (Photo by Tiziou News Service)

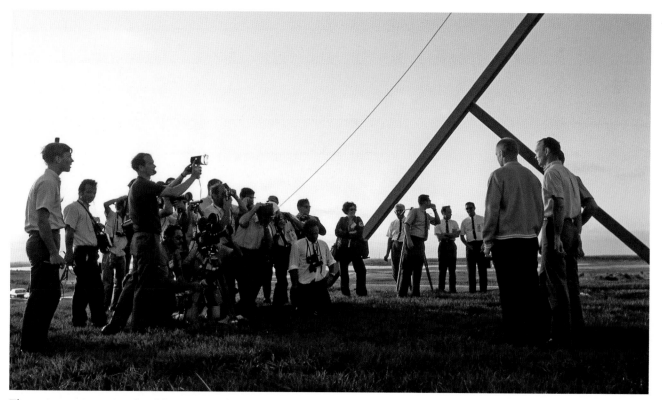

The astronauts patiently oblige news photographers clamoring for the best angle. The Saturn V is out of view to the right. (Photo by Tiziou News Service)

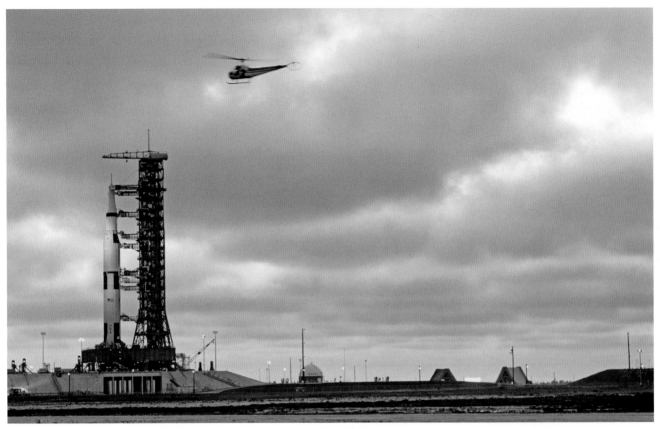

A NASA helicopter provides aerial photography as floodlights begin to illuminate the launch vehicle on May 20, 1969, and the sun sets between two flame deflectors parked away from the flame trench. (Photo by Tiziou News Service)

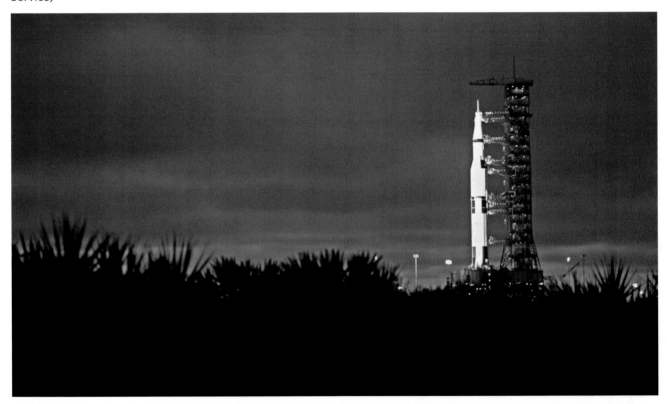

The sun sets on the Apollo 11 Saturn V shortly after the rocket's arrival at the launch pad. Launch is still nearly two months away. (Photo by Tiziou News Service)

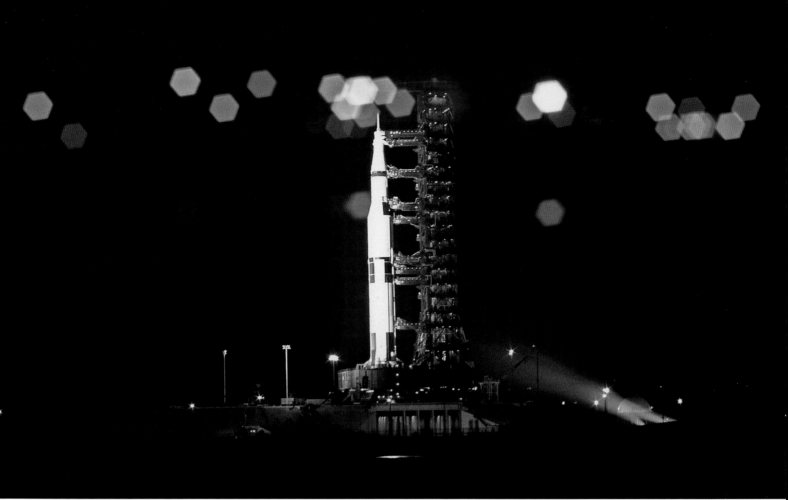

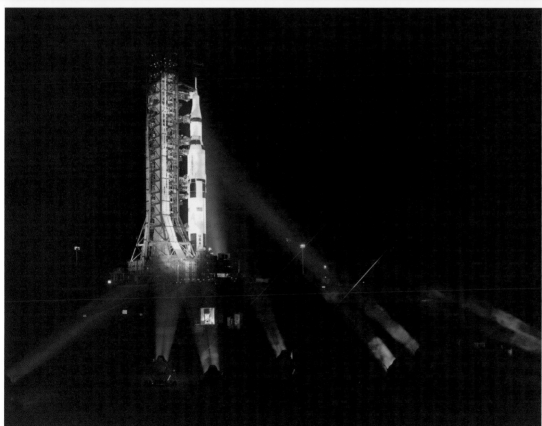

Above: Artistic lighting creates a striking picture of the Apollo 11 Saturn V on the evening of May 20. (Photo by Tiziou News Service)

Left: Xenon floodlights illuminate the launch vehicle and spacecraft on the night of May 20. Apollo 10, meanwhile, was only hours away from entering lunar orbit. (NASA)

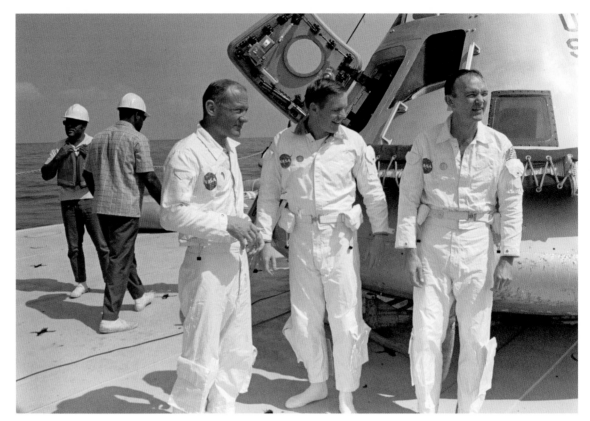

Aldrin, Armstrong, and Collins (*left to right*) during recovery training on the deck of MV *Retriever* in the Gulf of Mexico (off the coast of Galveston, Texas) on May 24, 1969. (NASA)

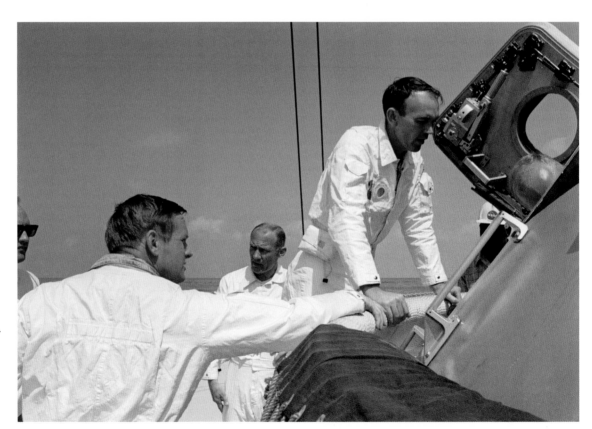

Collins prepares to enter Apollo command module training vehicle Boilerplate 1102A on May 24 as Armstrong and Aldrin wait their turn. The astronauts wear inflight coveralls made from flame-resistant Beta cloth. (NASA)

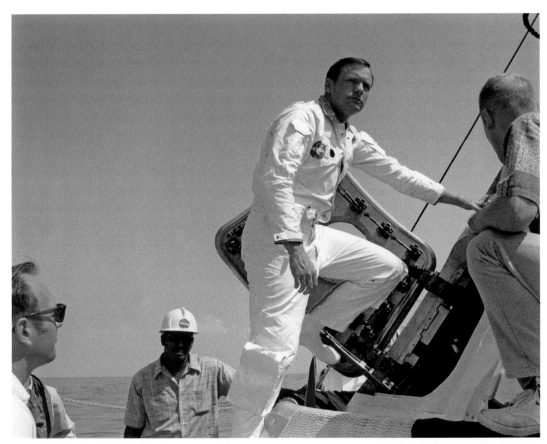

Left: Armstrong prepares to enter Apollo CM Boilerplate 1102A prior to recovery training. (NASA)

Below: The astronauts are in a raft after egressing CM Boilerplate 1102A. They practiced donning biological isolation garments as part of the exercise. A swimmer from MSC stands at the hatch. The CM's three Dacron fabric flotation bags have been inflated with nitrogen to insure the module is upright. (NASA)

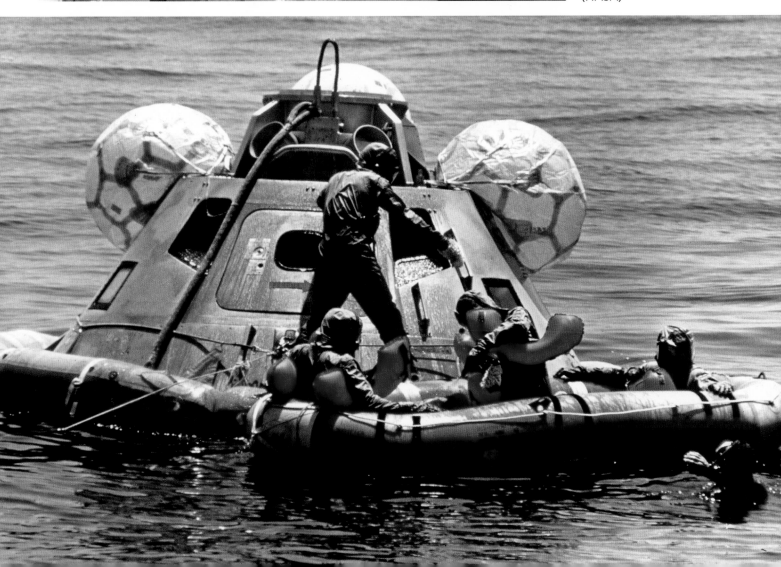

Armstrong aboard MV *Retriever* takes a break from recovery training on May 24. Apollo 10 would splash down two days later on May 26, as NASA Administrator Thomas Paine announced, "There are no obstacles on the path to the Moon." (NASA)

Training Makes Perfect

June 1969 brought a surge in mission preparation activity. The Apollo 11 astronauts found themselves traveling more frequently between their home base in Houston and the Cape in Florida. The Saturn V and Apollo 11 spacecraft were in place at LC-39A and were undergoing a thorough checkout.

Crew training was now in full gear. Armstrong spent time at Ellington Air Force Base with the Lunar Landing Training Vehicle, and the entire crew spent more hours in the command module and lunar module simulators. Armstrong and Aldrin also rehearsed their planned activities on the lunar surface for a final time.

Moon fever was spreading across the country. The public became more and more interested in these three brave astronauts who were going to attempt a lunar landing, and the media were more than happy to cover their history-making story.

Right: Apollo 11 prime and back-up crews arrive at LC-39A on June 10, 1969, for a walkthrough of emergency escape routes and an inspection of the Apollo 11 CM. Shown are (*left to right*) Jim Ragusa of Bendix, back-up commander James Lovell, Armstrong, and Aldrin. (NASA)

Below: The astronauts walk across the "zero" level of the Launch Umbilical Tower (LUT)with Lead Launch Vehicle Test Conductor Bill Schick of KSC on June 10. Two of the three tail service masts, at center, provide support for electrical cable, propellant loading lines, and pneumatic lines for the first stage. At far right is one of four hold-down arms which released the Saturn at launch. (NASA)

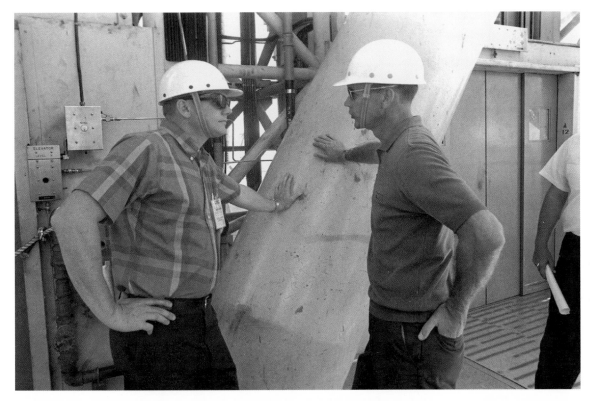

Armstrong (*left*) and Collins talk on June 10 while waiting to take one of the MSS elevators (*at right*) to the 320-foot (crew access) level. (NASA)

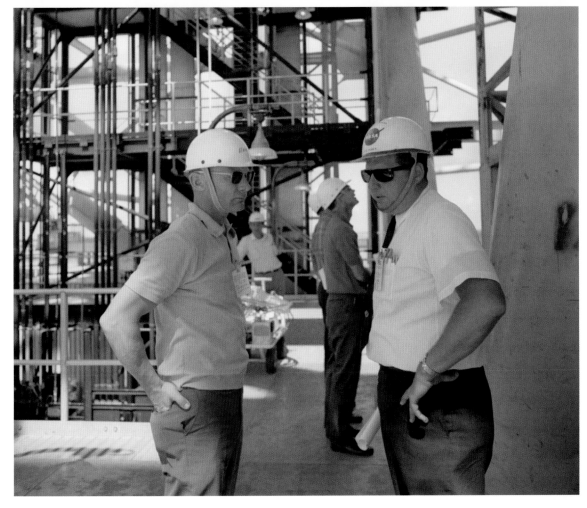

Aldrin (*left*) chats with Bill Schick prior to boarding the elevator. Armstrong and Aldrin, behind them, look up at the Saturn V. (NASA)

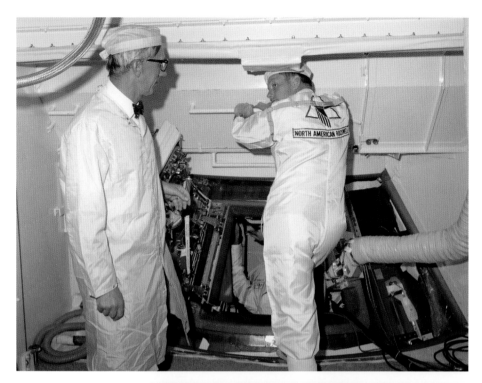

Left: Pad Leader Guenter Wendt (*left*) talks with Armstrong outside the CM hatch in the white room at LC-39A on June 10. The astronauts wear North American Rockwell coveralls. (NASA)

Below: The crewmen conduct a crew compartment "fit and function" check in the CM. This is a check of the stowage locations in the crew compartment. Armstrong and Aldrin later conduct a similar check aboard the LM. (NASA)

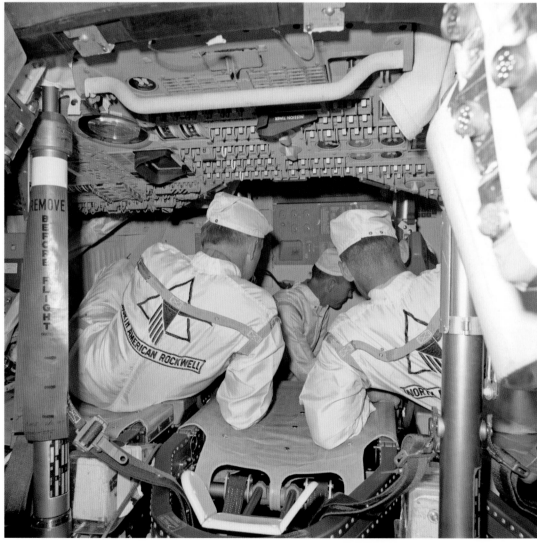

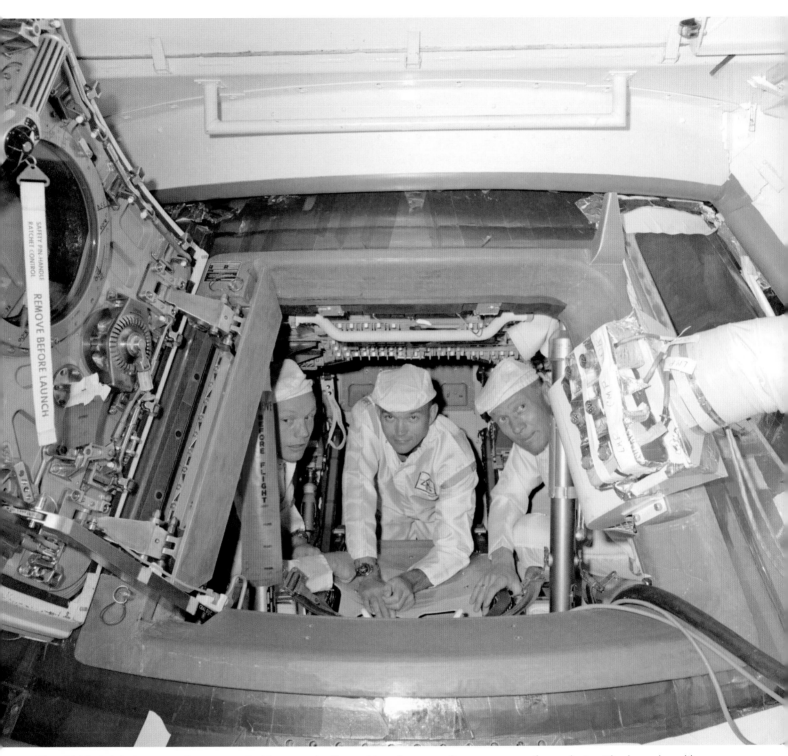

The CM hatch is temporarily surrounded by a protective rubber frame as the crew poses for a photo. The large box-like structure at right sends fresh air to the cabin and has communication hookups for technicians working inside. A grab bar above facilitated entry and exit. (NASA)

Armstrong, followed by Collins and Aldrin, departs after completing the CM inspection. (NASA)

The astronauts pause on the LUT with swing arm number 9 behind them. Each wears a flight-specific badge known as a "temporary mission decal"; like all pad visitors, they had temporarily exchanged their permanent ID badges at the guard gate for the pad permits. (NASA)

Aldrin, Collins, and Armstrong examine the emergency slide wire "cab" at the 320-foot level of the LUT during the June 10 visit. The crew also had the option of using a high-speed elevator in the event of an emergency at the pad. (NASA)

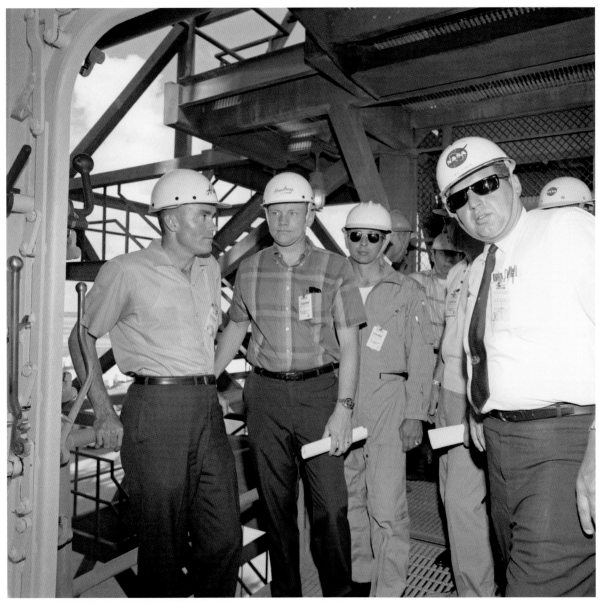

Schick (*right*) leads astronauts (*left to right*) Haise, Armstrong, and Anders to an elevator in the LUT prior to inspecting the emergency bunker ("rubber room") below the pad on June 10. (NASA)

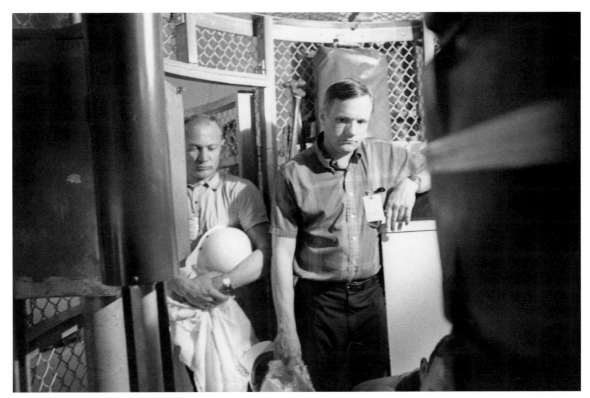

Aldrin (*left*) and Armstrong enter the bunker, intended to provide a safe refuge for personnel on the launch pad in the event of an imminent explosion of the Saturn V. It was accessed via a 200-foot slide chute. (NASA)

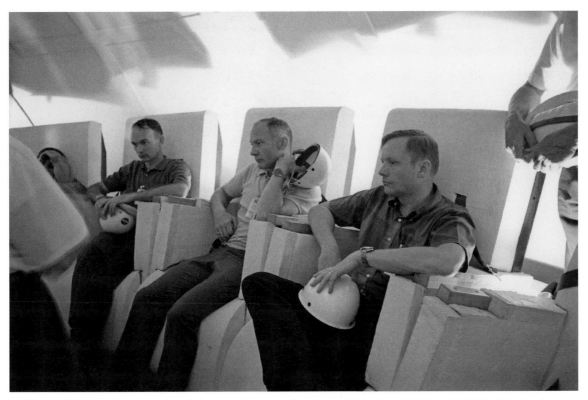

Collins, Aldrin, and Armstrong (*left to right*) seated in the rubber room on June 10. The bunker is circular in shape with a domed ceiling. Contoured seats ring the perimeter of the room. The concrete floor is floating, supported by springs and shock absorbers to cushion any blast. (NASA)

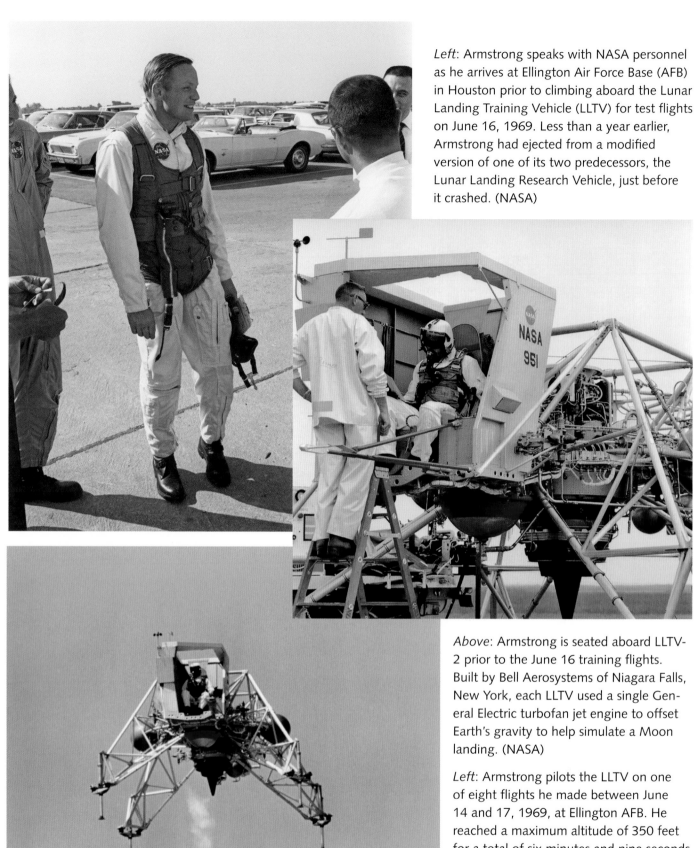

Left: Armstrong speaks with NASA personnel as he arrives at Ellington Air Force Base (AFB) in Houston prior to climbing aboard the Lunar Landing Training Vehicle (LLTV) for test flights on June 16, 1969. Less than a year earlier, Armstrong had ejected from a modified version of one of its two predecessors, the Lunar Landing Research Vehicle, just before it crashed. (NASA)

Above: Armstrong is seated aboard LLTV-2 prior to the June 16 training flights. Built by Bell Aerosystems of Niagara Falls, New York, each LLTV used a single General Electric turbofan jet engine to offset Earth's gravity to help simulate a Moon landing. (NASA)

Left: Armstrong pilots the LLTV on one of eight flights he made between June 14 and 17, 1969, at Ellington AFB. He reached a maximum altitude of 350 feet for a total of six minutes and nine seconds of flight time. This vehicle is today on display at California's Neil A. Armstrong (formerly Dryden) Flight Research Center. (NASA)

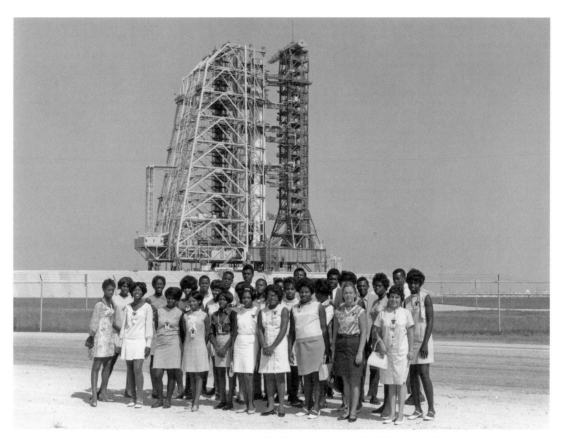

A group of summer interns at KSC tours the facility and visits Apollo 11 at the pad on June 17, 1969. The interns, sponsored by the Federal Summer Employment Program for Youth, attended KSC area high schools as well as Brevard Junior College and other colleges across the country. (NASA)

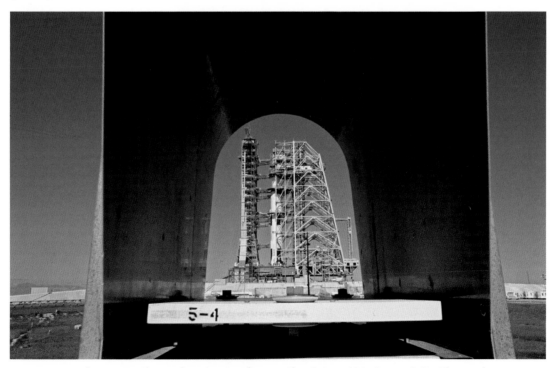

A camera enclosure on the pad perimeter frames the Saturn V in June 1969. The enclosures protected the equipment from sun, weather, and debris strewn by the rocket at launch. (Photo by Tiziou News Service)

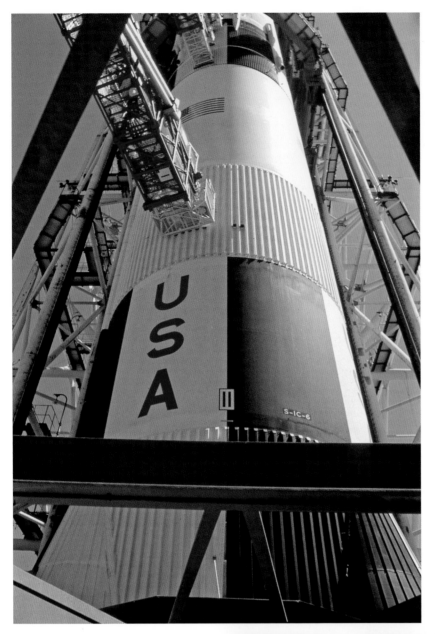

Left: The lower half of the Saturn V at LC-39A in June 1969 as seen from the LUT. Swing arm number 1 is visible at the 60-foot level. The Mobile Service Structure can be seen in the background. (Photo by Tiziou News Service)

Below: One of the four stabilization fins at the base of the S-IC stage on the Saturn V at the pad in June 1969. The fins provided stability during the first minutes of flight. (Photo by Tiziou News Service)

Facing page: Circular work platforms extend from the MSS at right next to the Saturn V at LC-39A in this June 1969 photo. The nine swing arms extend from the LUT. (Photo by Tiziou News Service)

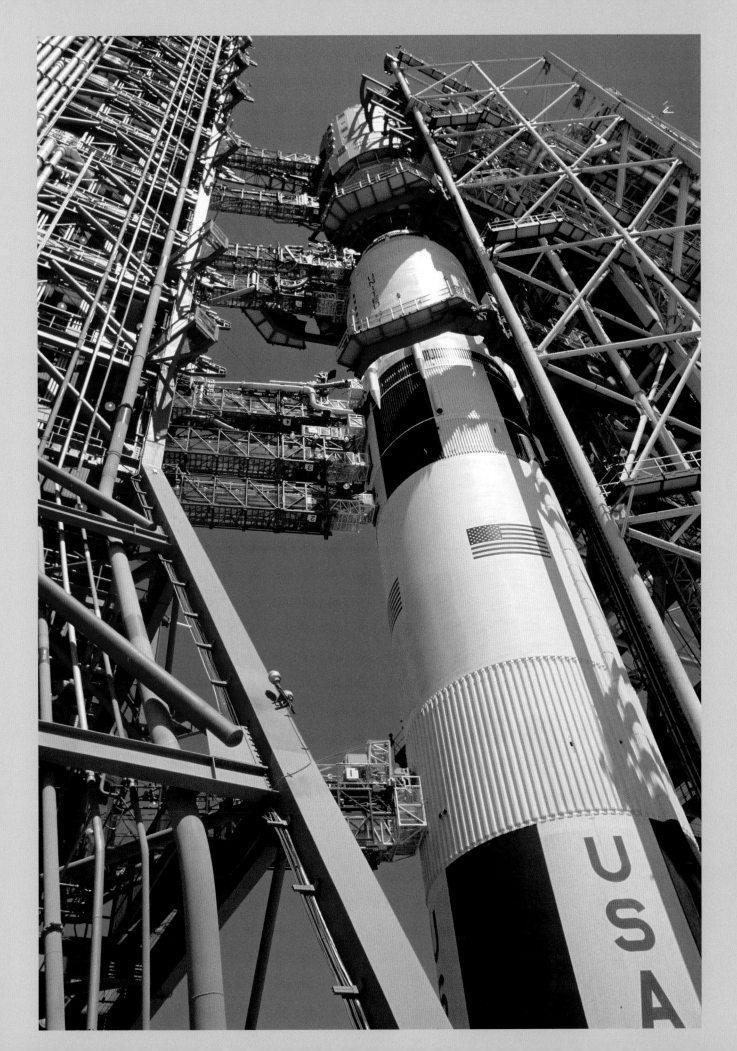

Armstrong shortly after arriving at Patrick AFB from Ellington AFB on June 17, 1969, to resume training at KSC. (NASA)

Armstrong on the tarmac at Patrick AFB after climbing from his T-38 on June 17. The Northrop-built T-38 *Talon* is a two-seat, twinjet supersonic jet trainer that is still in use today by NASA and the military. (NASA)

Left: Armstrong (*left*) and Flight Crew Operations Director Deke Slayton walk from the ramp at Patrick AFB after arriving on June 17. Armstrong had flown the Lunar Landing Training Vehicle twice the day before at Ellington AFB near Houston. (NASA)

Below: Armstrong signs car rental agreement papers after arriving at Patrick AFB on June 17. The astronauts were afforded their own transportation when visiting the Space Coast. (NASA)

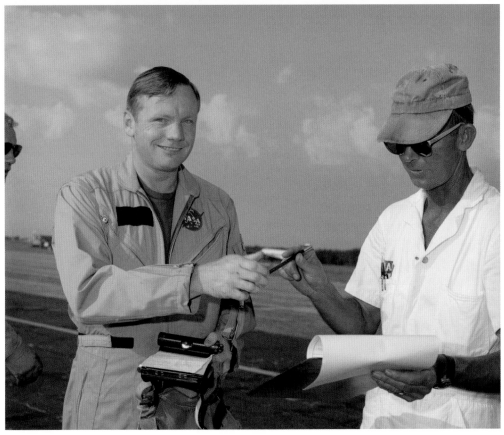

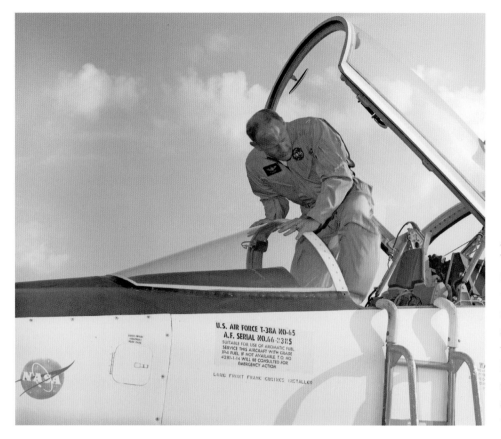

Aldrin climbs from a T-38 after arriving at Patrick AFB on June 17. All NASA astronauts had to qualify as military jet pilots, though the requirement had been waived for six scientists chosen as astronaut candidates in 1965. (NASA)

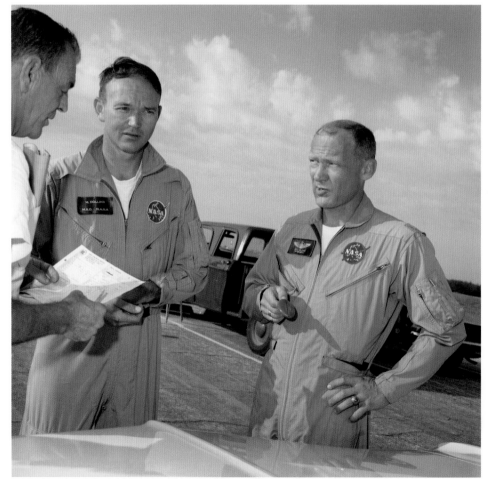

Collins (*left*) and Aldrin receive their rental car agreements after arriving at Patrick. All three crewmen drove straight to KSC, where they resumed training in simulators. (NASA)

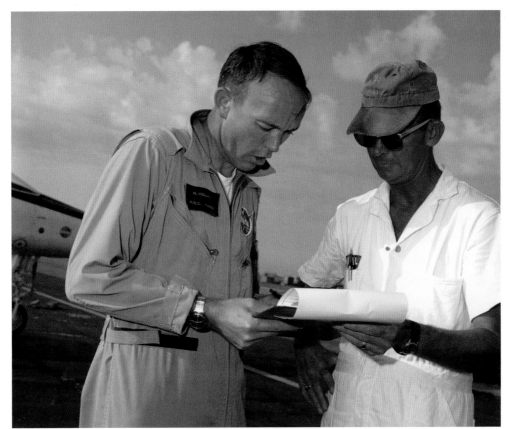

Collins signs rental car paperwork. It was approximately a 30-mile drive from Patrick AFB to the astronaut quarters at KSC. (NASA)

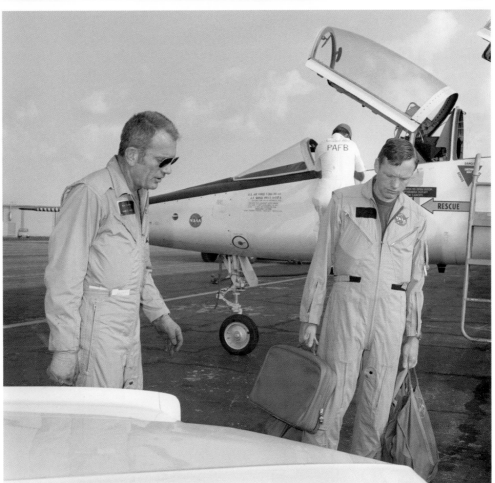

Slayton (*left*) helps Armstrong load his personal effects into his rental car prior to departing for KSC. (NASA)

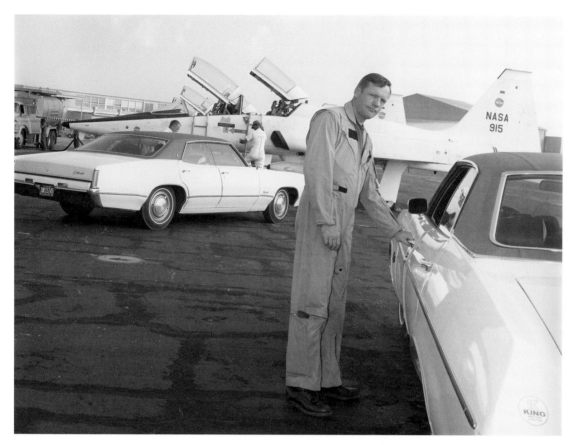

Above: Astronaut Armstrong prepares to climb into his rental Chevrolet on June 17. That evening, after the day's flight readiness review, Apollo Program Director Lt. Gen. Samuel C. Phillips announced that the launch was "go" for July 16. (NASA)

Right: Collins sorts through his luggage and camera equipment on the tarmac at Patrick AFB. (NASA)

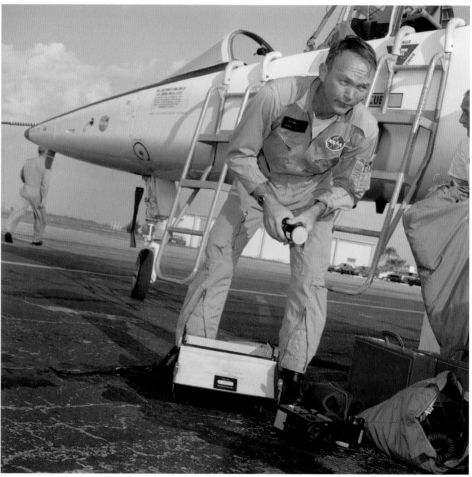

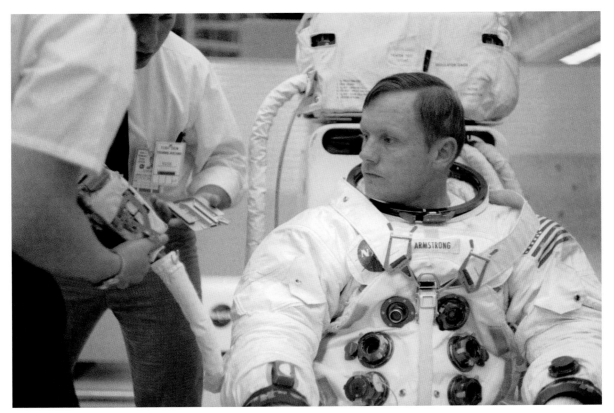

Armstrong in the KSC Flight Crew Training Building as suit technicians prepare him for EVA training on June 18, 1969. (NASA)

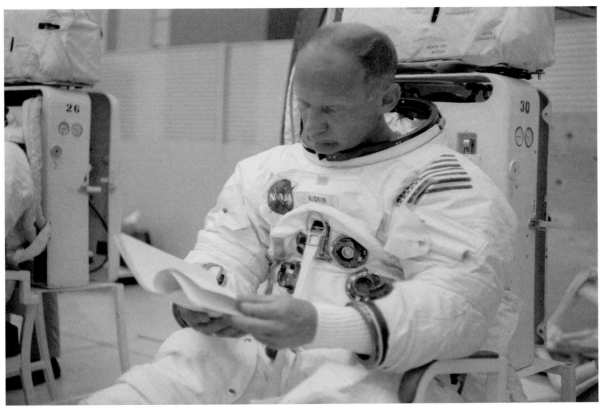

Aldrin looks over notes while getting suited for the EVA training exercise at KSC on June 18. Earth weight of the full EVA EMU "wardrobe" is 120 pounds. (NASA)

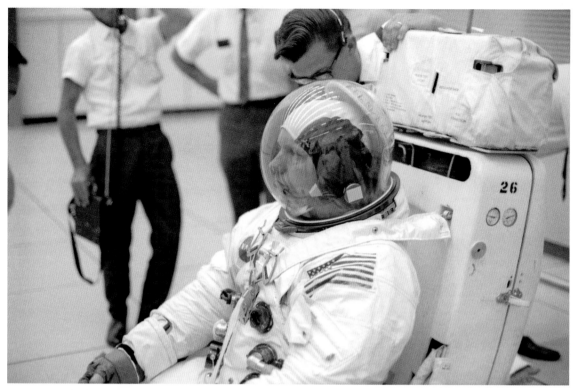

Armstrong before the EVA suit visor assembly has been placed over his helmet on June 18. The assembly consisted of a polycarbonate shell onto which the cover, visors, hinges, eyeshades, and latch are attached. (NASA)

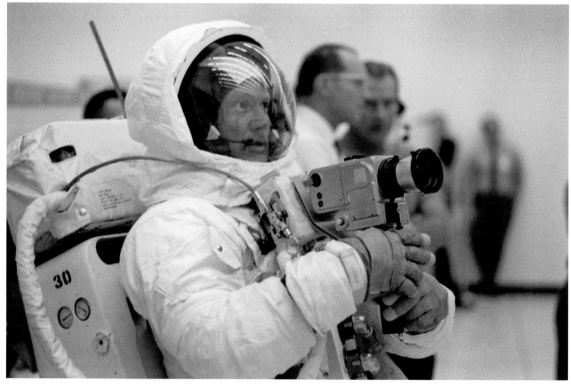

Aldrin trains with Hasselblad 500 EL Data Camera on June 18. He wears the A7L torso-limb suit used on Apollo 7 through 14, and his gloves are covered in the same Chromel-R steel cloth that had been used for Gene Cernan's pants during his Gemini 9A EVA in June 1966. Lt. Gen. Phillips and Slayton are in the background. (NASA)

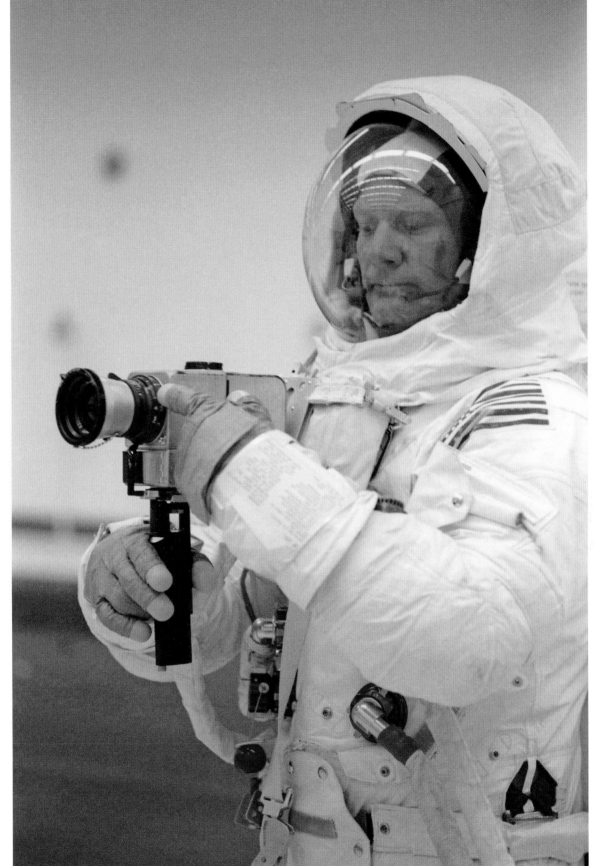

Aldrin practices using the Hasselblad during EVA training at KSC on June 18. The camera featured semiautomatic operation and was equipped with a 60mm Zeiss Biogon lens. The camera was bracket-mounted on the front of the astronaut's suit but had no viewfinder. Aldrin's EVA checklist, printed on Beta cloth, is sewn to his left cuff. (NASA)

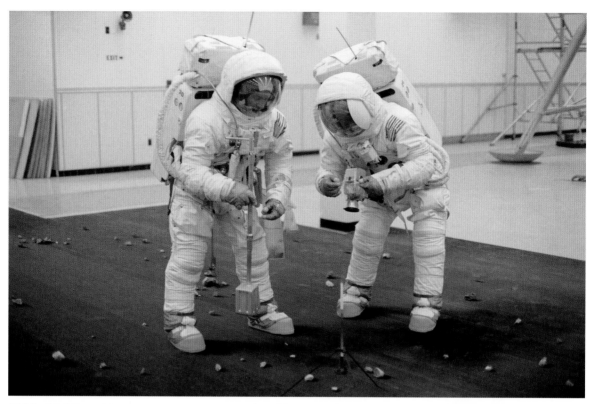

Aldrin (*right*) and Armstrong train on a simulated lunar surface in the Crew Training Building on June 18. The astronauts practiced gathering, categorizing, and photographing rocks. (NASA)

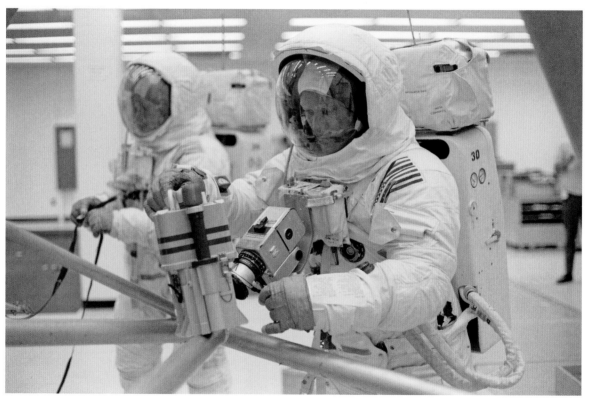

Armstrong and Aldrin during the EVA simulation. Aldrin deploys a mockup of the lunar surface stereo camera. During the actual mission, the base of the camera was placed on the Moon's surface and a trigger under the handle was pulled. The camera had twin lenses underneath to photograph the surface. (NASA)

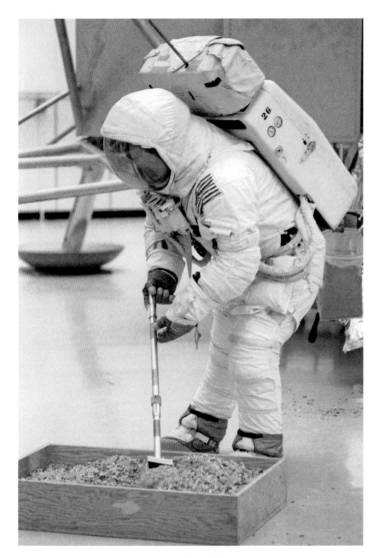

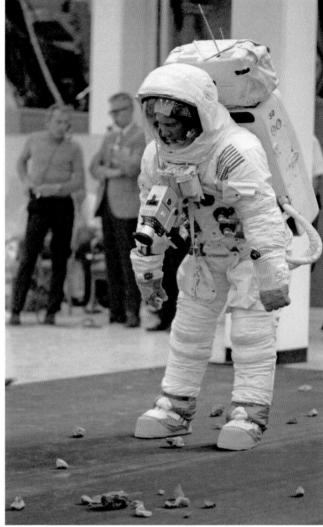

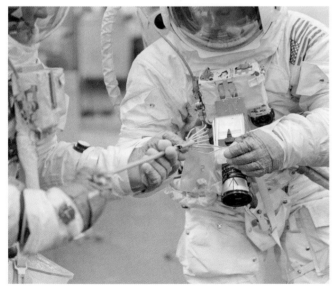

Above left: Armstrong uses a large aluminum alloy box-shaped scoop with an extension handle in a box of simulated lunar soil. The astronauts' glove fingers and ankles are covered with Chromel-R, while the fingertips consist of a rubber/neoprene compound to provide sensitivity; the cuffs are Beta cloth. (NASA)

Above right: Aldrin surveys strewn rocks as Deke Slayton listens in on a headset (*at left*). As the two astronauts' EMUs were visually identical except for their name tags, differentiating them later in photos proved difficult; commanders of succeeding missions wore red bands. This crew would bring 50 pounds of tools, bags, and containers to collect 58 lunar samples weighing 47.5 pounds. (NASA)

Left: Aldrin uses a set of 26" aluminum tongs to drop a simulated lunar rock sample into a collection bag held by Armstrong. (NASA)

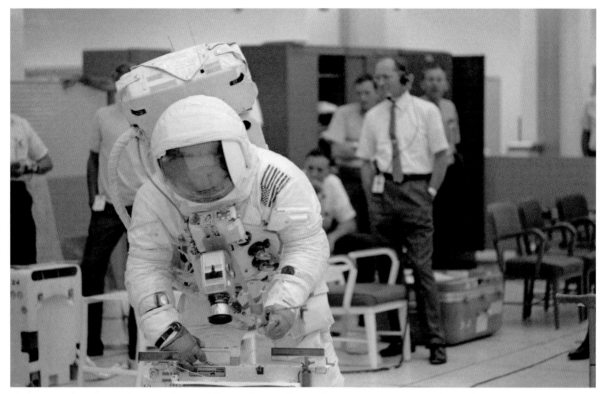

Armstrong works with a mockup of the Early Apollo Surface Experiments Package during training on June 18. Apollo Program Director Lt. Gen. Sam Phillips observes in the background. He had been brought to NASA on detachment from the U.S. Air Force in 1963 to run the Apollo program, based on his reputation managing the Minuteman missile program and other USAF projects. (NASA)

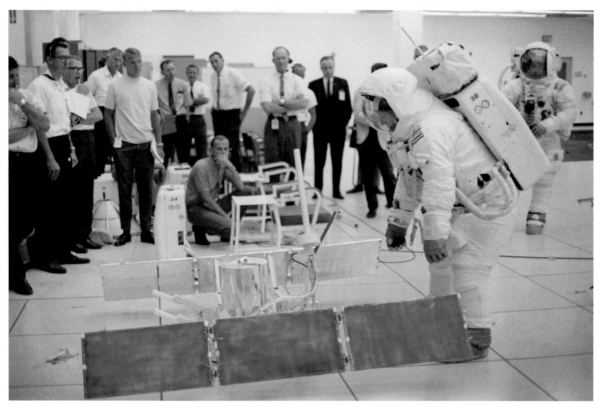

Aldrin rehearses deploying the Passive Seismic Experiment Package. Subsequent Apollo crews would rehearse EVA procedures outdoors as well. (NASA)

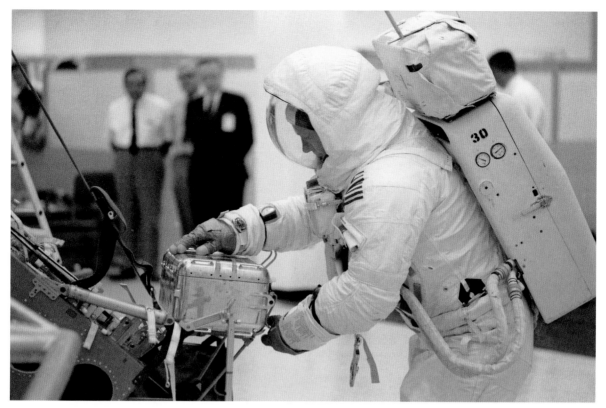

Aldrin works with the Sample Return Container at the base of the LM mockup during the EVA simulation on June 18. (NASA)

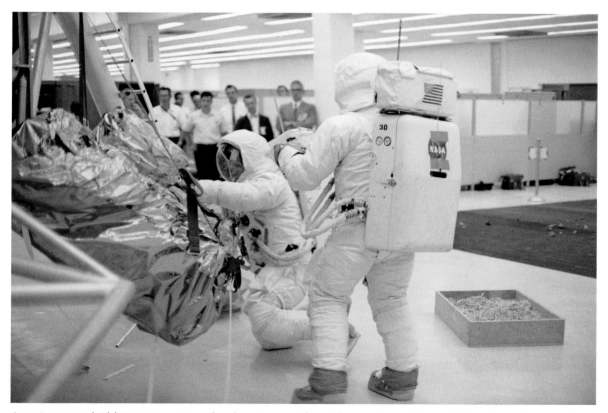

Armstrong and Aldrin prepare to unload equipment from the equipment bay of the LM mockup on June 18. (NASA)

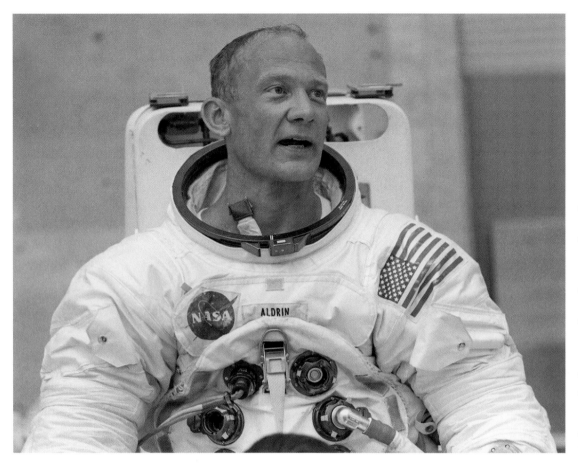

Left: Aldrin, wearing his PLSS, comments to suit techs after the EVA training. (NASA)

Below: Armstrong is contemplative following the June 18 session. He had recently received thousands of suggestions regarding what his first words on the Moon should be. (NASA)

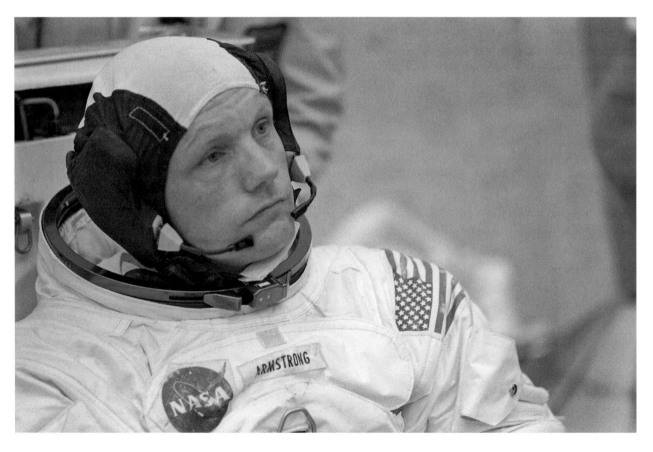

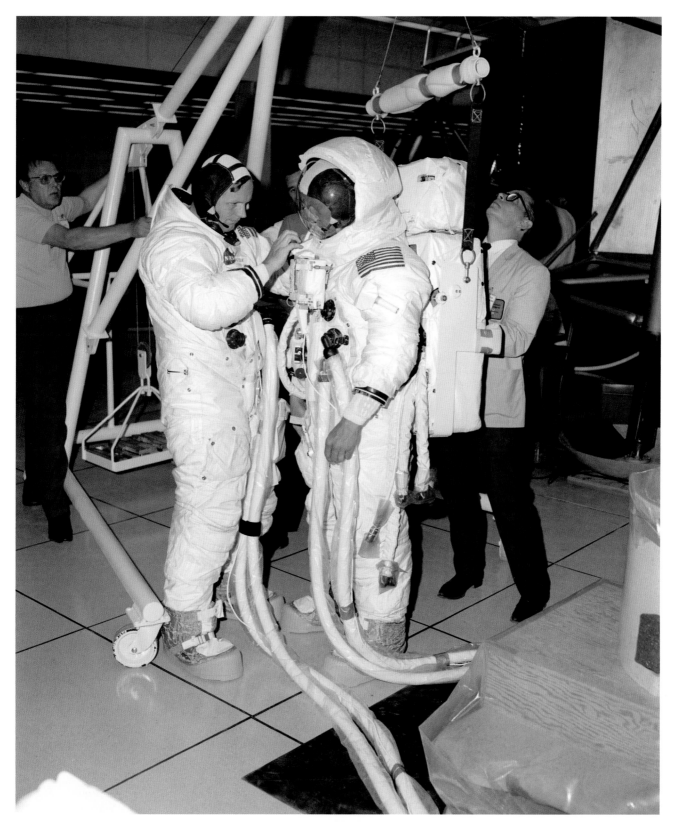

Armstrong and Aldrin participate in an Extravehicular Mobility Unit donning procedure verification exercise in the Manned Spacecraft Operations Building at KSC on June 25. The procedure allowed the crewmen to have a final look at the flight hardware and gave them an opportunity to resolve any issues. Armstrong is connecting the Oxygen Purge System on/off actuator to the Remote Control Unit (RCU). On the left is Joe Johnson with the GE Support Group, with Jim Howe of Hamilton Standard at right. (NASA)

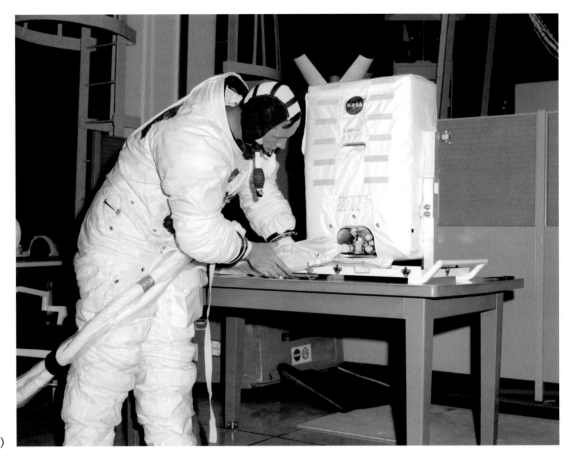

Armstrong performs the "feedwater collection procedure" at KSC on June 21. After his EVA training, the remaining water from the feedwater loop of the Portable Life Support System was collected and then weighed to determine how much water was used during the EVA. The resulting weight was used to calculate the crewman's total EVA metabolic heat load expended. (NASA)

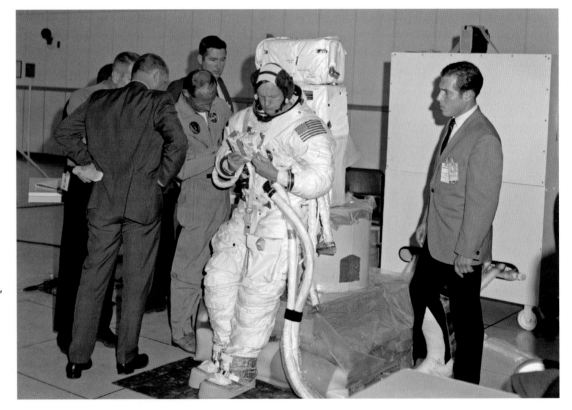

Armstrong at KSC on June 25 connects his RCU to the PLSS left and right upper straps that are in turn connected to the suit upper D ring. Assisting are (left to right) Slayton; Robert Smylie, Crew Systems Division acting chief; Aldrin; MSC's Harley Stutesman; and suit technician Dan Schaiewitz. (NASA)

Left: Collins pauses on ladder that leads to the CM simulator in the Crew Training Building at KSC on June 19, 1969. The LM and CM simulators were often used in conjunction with each other. (NASA)

Below: Collins practices rendezvous and docking maneuvers during a session in the CM simulator on June 19. Although movement was not simulated, technicians could mimic any number of problems the crewmen might encounter. (NASA)

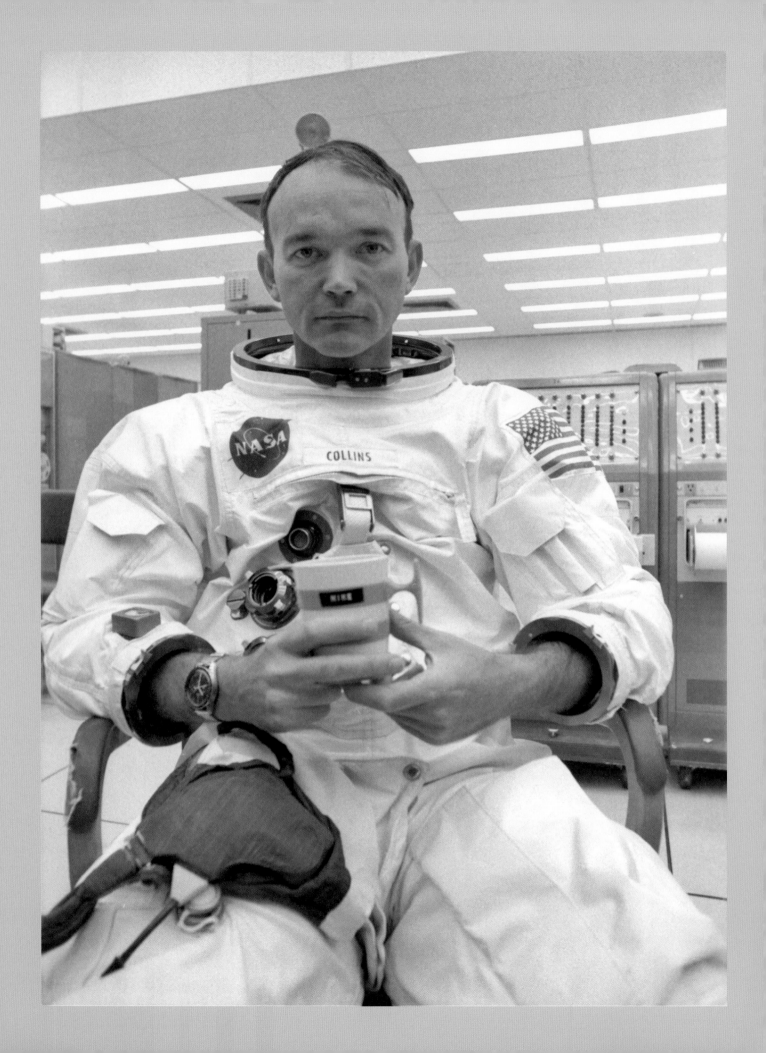

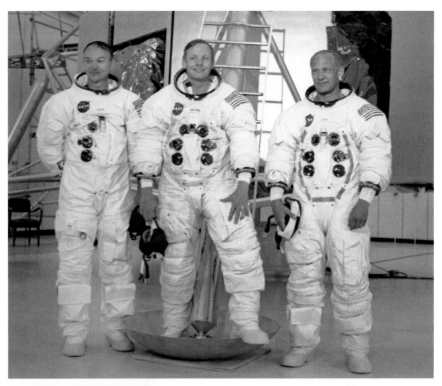

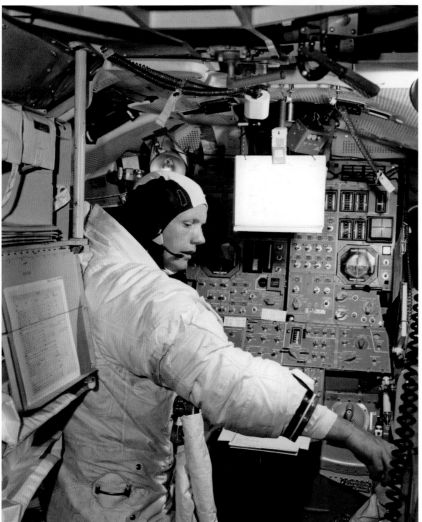

Facing page: Collins relaxes with a cup of coffee after a session in the CM simulator at KSC on June 19. (NASA)

Above: Astronauts Collins, Armstrong, and Aldrin (*left to right*) take a break from their training schedule in front of the LM mockup on June 19 at KSC. (NASA)

Left: Armstrong in the LM simulator at KSC on June 19. All aspects of lunar module flight that the crew would encounter were simulated, including lunar descent, landing, ascent, rendezvous, and docking. Three simulation engineers conducted the training missions. (NASA)

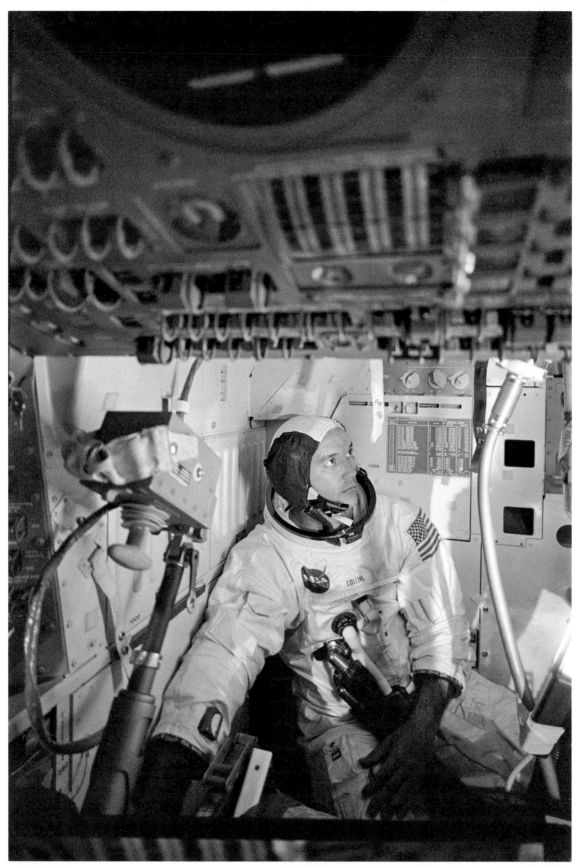

Collins inside the docking tunnel of the CM mockup in Building 5 at the Manned Spacecraft Center in Houston on June 28, 1969, while practicing procedures with the Apollo docking mechanism. The same day, Aldrin was at NASA's Langley Research Center in Virginia making twelve successful landings in a lunar landing trainer. (NASA)

6

Final Preparations

The first half of July 1969 signaled the relative calm before the storm for Apollo 11. It was a very busy period but nothing like what was to come.

Armstrong, Aldrin, and Collins began the month by going through a final launch dress rehearsal at KSC, ensuring that all was in place for their planned launch in mid-month. The reality of the mission began to set in as the month progressed.

The final ten days leading up to launch were a busy period for the astronauts. They answered reporters' question from behind a transparent plastic screen during a Houston "germ free" final news conference. Contact with family members and other personnel was also limited to minimize the astronauts' potential exposure to contagious illnesses. Equipment and spacecraft were checked, and then checked again. The astronauts continued to go over their flight plan and lunar charts.

People from all over the world began descending on the east coast of Florida to witness the launch of the first manned lunar landing attempt. Local officials and authorities had experience with crowds for previous Apollo launches, but Apollo 11 was not only "the big one", it was also in the summer vacation period. As launch day approached, the crowds grew larger. Extensive planning was undertaken to handle the traffic and respond to any emergencies that might arise.

At night the Saturn V stood like a shining tower at LC-39A. The giant machine was both a thing of beauty and a symbol of potential achievement. Other Saturn Vs had taken their place on the seaside launch pad, but this one was different. The Moon was close at hand.

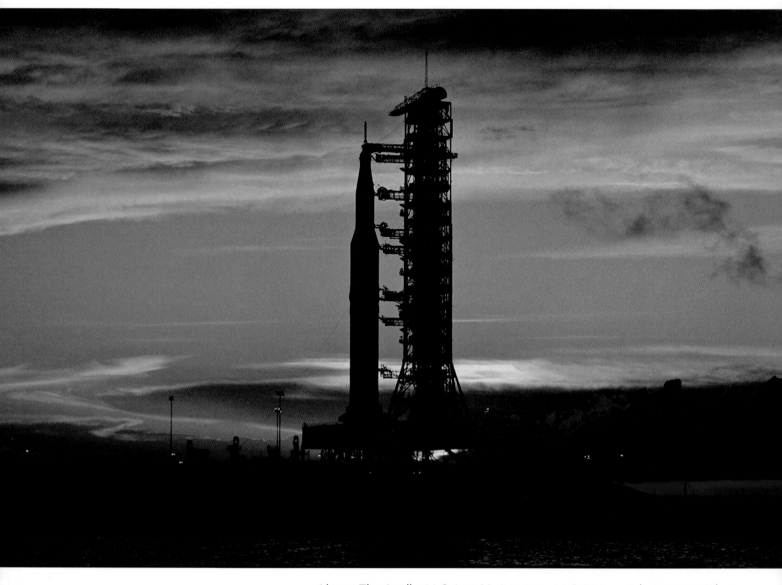

Above: The Apollo 11 Saturn V at sunset at LC-39A on July 2, 1969. (Photo by Tiziou News Service)

Facing page: The Apollo 11 spacecraft seen from the Mobile Service Structure, as the MSS moves away for the start of the two-day Countdown Demonstration Test (CDDT). The CDDT allowed personnel to resolve technical problems, should they arise, prior to the actual countdown, while the crewmen rehearsed everything they would do on launch day. The Atlantic Ocean is in the background. The clamshell sections enclosed the Launch Escape System when a much sturdier three-level compartment (attached below to the MSS) surrounded the command and service modules and the Spacecraft LM Adapter. A beige protective cover secured with a rubber band surrounds the Q-ball at the tip of the LES. First used on Armstrong's initial X-15 flight, Q-balls provide aerodynamic readings during flight. (NASA)

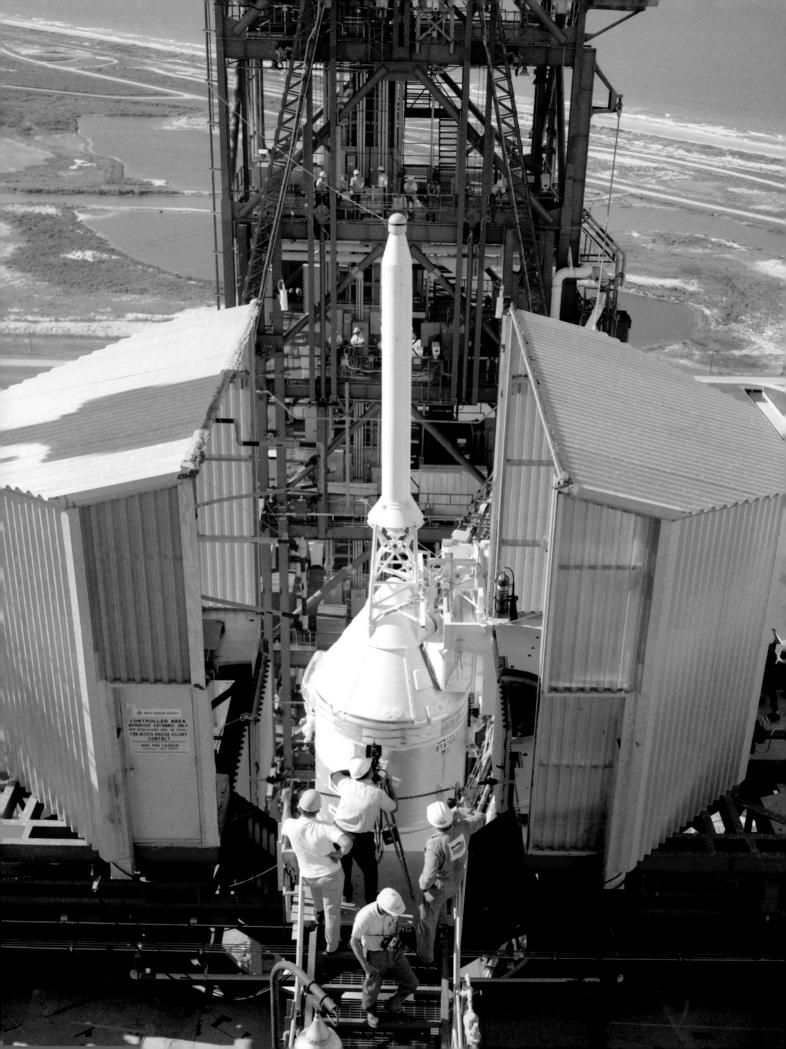

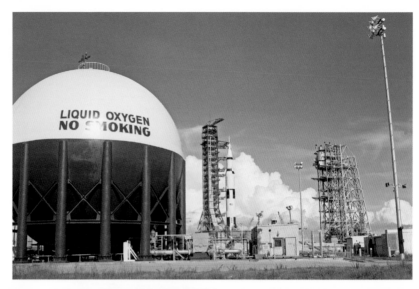

The liquid oxygen (LOX) tank at the northwest corner of the pad dominates the frame as the MSS moves away at right on July 1 to prepare for the CDDT. The 69-inch-diameter tank provided the oxidizer for all three Saturn stages. It stored 900,000 gallons of LOX at a temperature of minus 298 F. Like the liquid hydrogen tank at the northeast corner, it is a vacuum-jacketed dewar bottle with an outer shell of carbon steel and an inner stainless steel shell. (NASA)

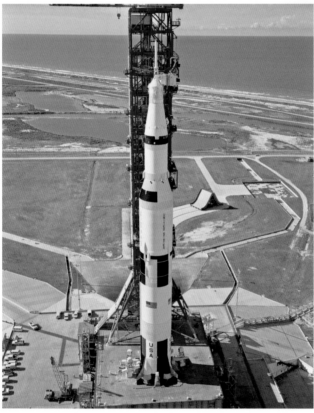

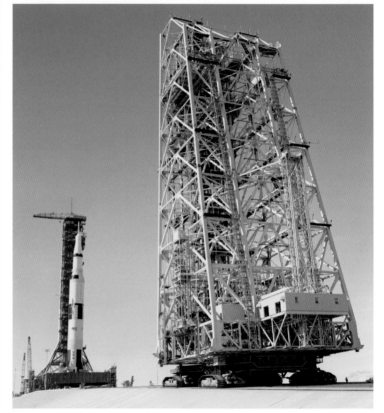

The Atlantic beach is only 500 feet beyond the perimeter of Pad A in this view from the MSS as it pulls away. The pad's reserve flame deflector is parked to the right of center (each pad had two). Each 650-ton deflector is covered with a steel skin coated with at least four inches of ceramic material embedded with temperature sensors. The deflectors are 77 feet long, 48 feet wide and 41 feet high. A pad drainage pond is right of the deflector. (NASA)"

The crawler transporter eases the MSS down the five-degree inclined pad ramp, heading for its parked site to the south. Automatic and manual leveling devices insured its loads never varied by more than two inches from vertical. The 402-foot tall derrick type steel-trussed tower weighed 4,900 tons, and was lowered and secured to four mount mechanisms at the pad. The structure's five work platforms provided access for final connection of certain ordnance items, checkout functions, and equipment for servicing systems components of the CSM. The work platforms also provided access for hypergolic fueling of the CSM and LM. The MSS was scrapped after the final Saturn launch in 1975. (NASA)

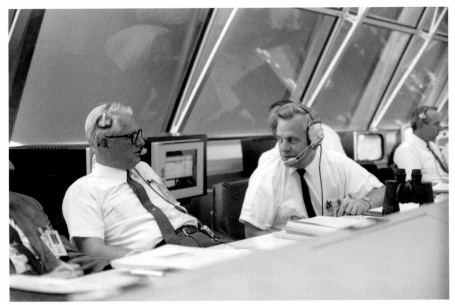

John Williams (*left*), director of KSC Spacecraft Operations, and Walt Kapryan, deputy director of KSC Launch Operations, in the Launch Control Center (LCC) on July 2 during the CDDT. (NASA)

In the LCC during the CDDT are (*left to right*) Andrew Pickett, test operations manager at KSC; Dr. Hans Gruene, director of Launch Vehicle Operations at KSC; and Lee B. James, Saturn V program manager at the Marshall Space Flight Center in Alabama. The Saturn V was fueled during the first part of the CDDT, referred to as the "wet" portion. (NASA)

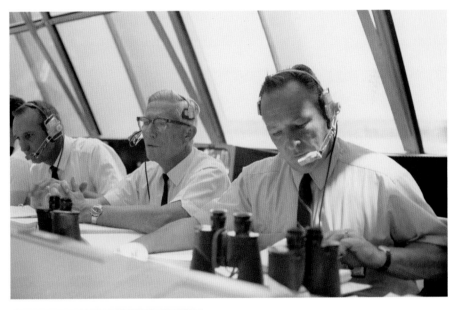

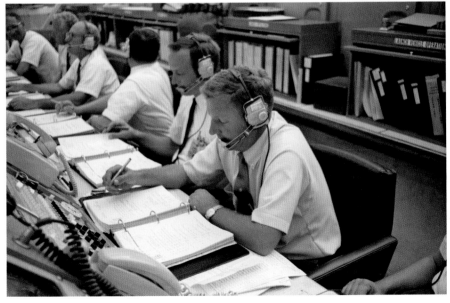

NASA Test Conductors E. Ron Bentti and Norm Carlson monitor CDDT activities from the LCC. The only issue of significance found during the CDDT was concerns about the inertial measurement unit aboard the LM, which was subsequently changed out. (NASA)

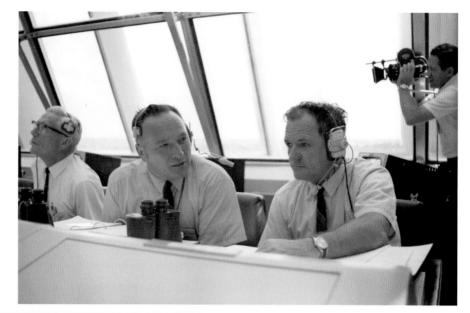

Dr. Hans Gruene, director of Launch Vehicle Operations; Lee James, Saturn V program manager; and Isom "Ike" Rigell, chief engineer under Gruene, monitor the CDDT activities from the LCC on July 2. NASA contract photographer Larry Summers is behind them. (NASA)

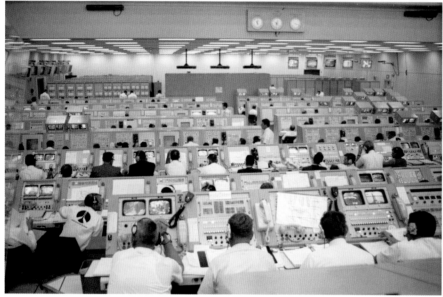

Government and industry engineers monitor the Apollo 11 CDDT in firing room 1 on July 2, 1969. Approximately 450 persons were present during the test. (NASA)

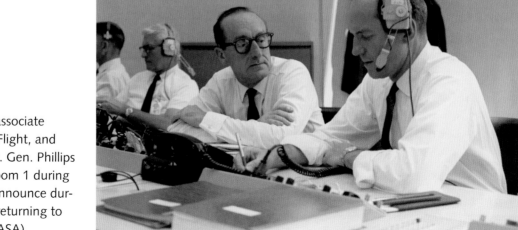

Dr. George Mueller (*left*), associate administrator for Manned Flight, and Apollo Program Director Lt. Gen. Phillips at their consoles in firing room 1 during the CDDT. Phillips would announce during the flight that he'd be returning to the USAF in September (NASA)

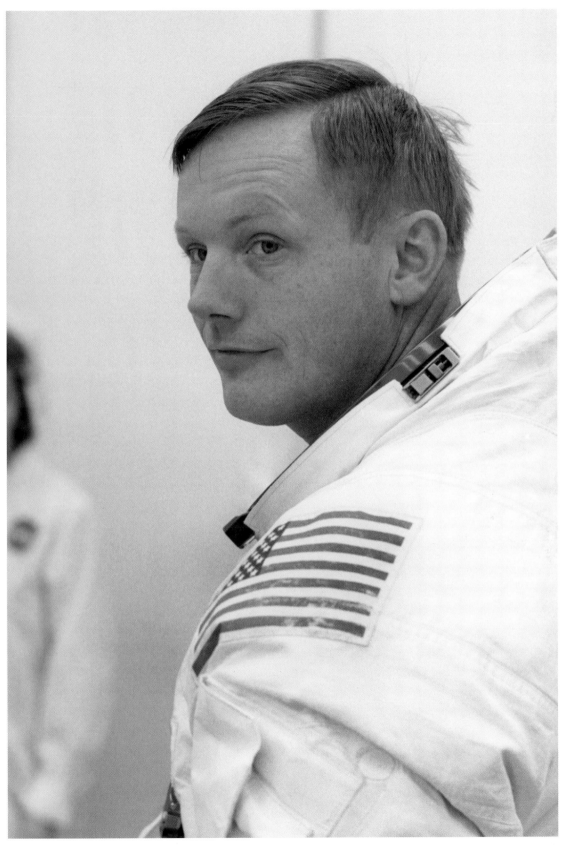

Armstrong in the suit room at the KSC Manned Spacecraft Operations Building on the morning of July 3 during the CDDT. (NASA)

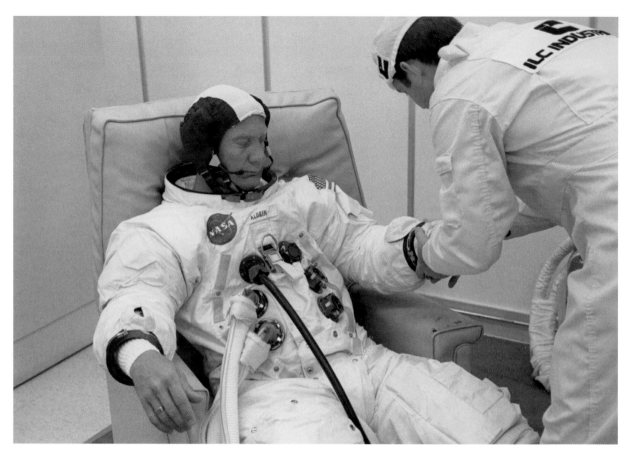

Above: International Latex Corporation suit technician Ron Woods assists Aldrin with donning his gloves in the suit room on July 3 during the CDDT. (NASA)

Right: Collins wears a communications carrier visible through the clear helmet during the CDDT. The carrier was affectionately called a "Snoopy Cap" after the famed comic strip dog and Apollo mascot. The astronauts wore communications carriers throughout the mission. (NASA)

Facing page: Suit tech Ron Woods assists Aldrin in donning the polycarbonate-constructed bubble helmet. The neck ring at the bottom was designed to attach to the neck of the space suit. (NASA)

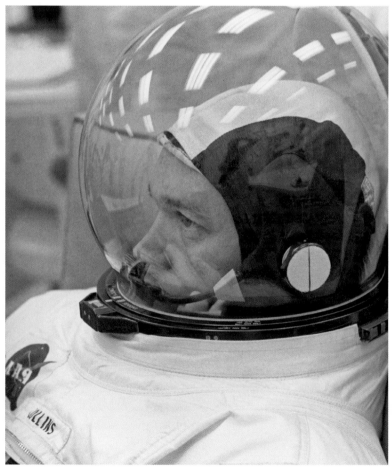

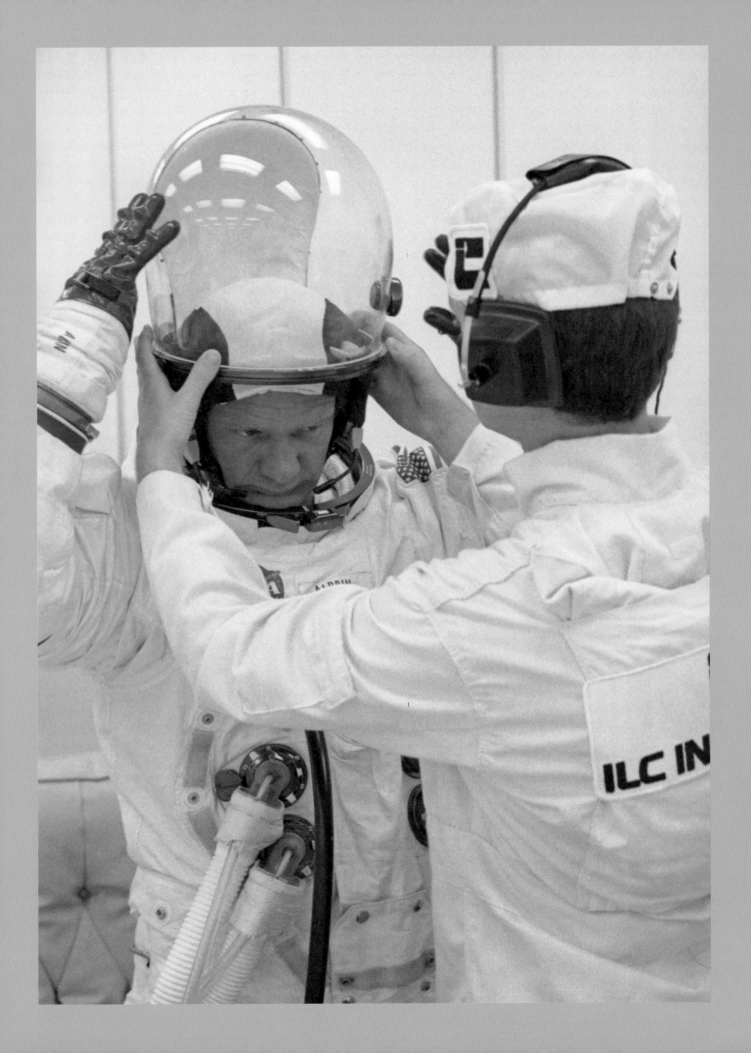

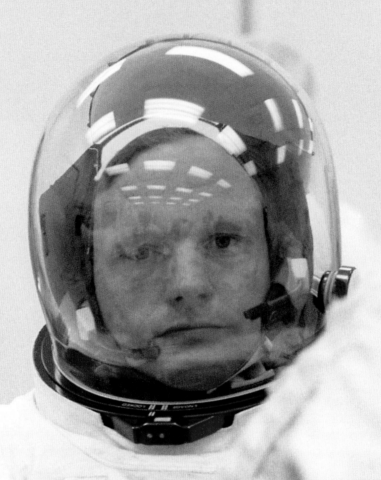

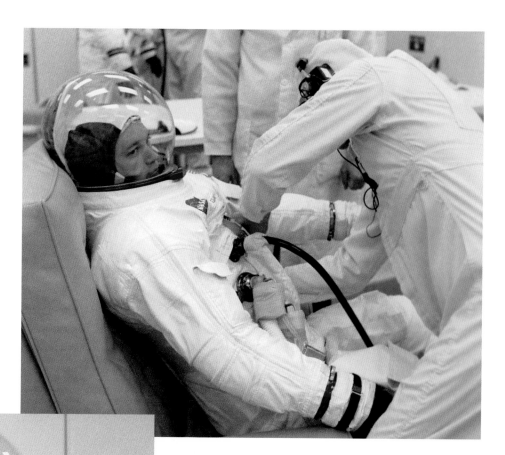

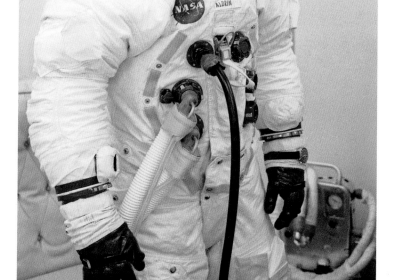

Facing page: NASA suit technician Troy Stewart adjusts Armstrong's pressure suit on the morning of July 3 during the CDDT. (NASA)

Above: Collins has his space suit adjusted by NASA technician Joe Schmitt during the CDDT. (NASA)

Left: Aldrin is fully suited during the CDDT. The Apollo 11 Beta cloth mission emblem had not yet been sewn onto the suits. (NASA)

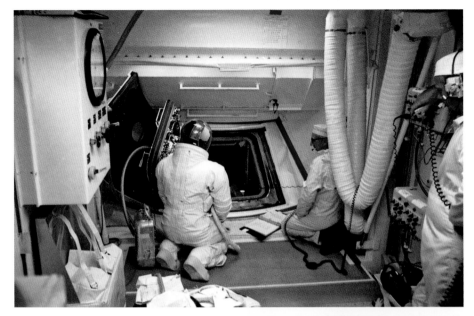

Aldrin in the white room waiting to enter the command module during the CDDT on July 3. With the astronaut crew aboard the CM, the Saturn V was not fueled during this "dry" portion of the test. (NASA)

The CM hatch is closed and sealed before the module is pressurized with a mixture of 60 percent oxygen and 40 percent nitrogen on July 3. All activities in the white room on launch day were rehearsed during the CDDT. (NASA)

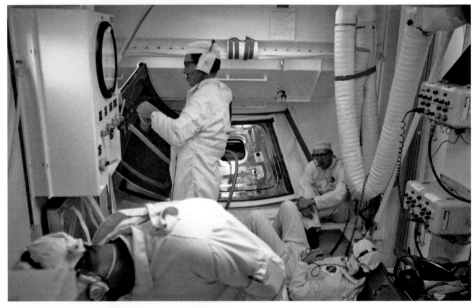

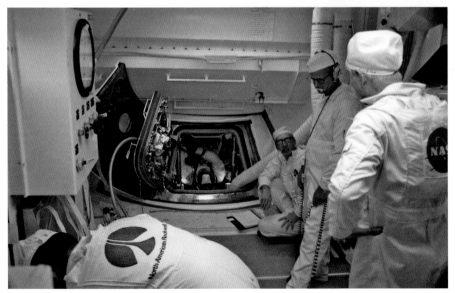

Pad Leader Wendt (*kneeling*) supervises preparations to remove the astronauts from the CM following their participation in the CDDT on July 3. Aldrin is in the middle seat. Apollo 11 was the only mission where the lunar module pilot was assigned that seat. (NASA)

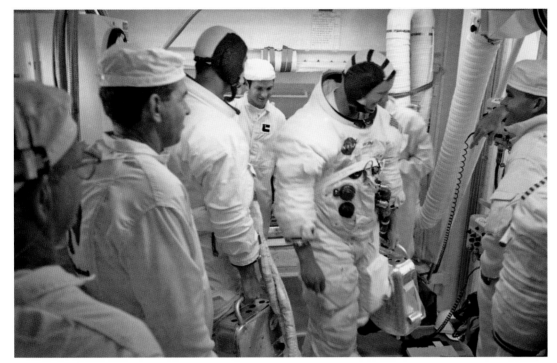

Armstrong is greeted by back-up LM pilot Haise in the white room after departing the CM on July 3. The actual countdown would begin on July 10. (NASA)

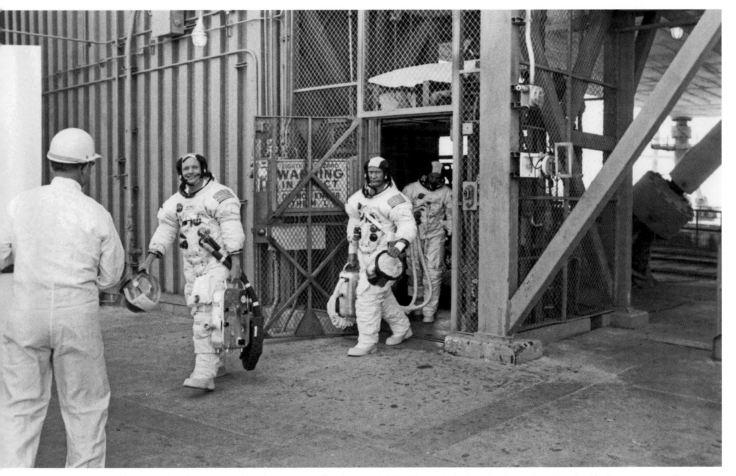

Armstrong, Aldrin, and Collins exit the elevator at the base of LC-39 on July 3 prior to returning to their crew quarters. The astronauts would climb back into simulators at KSC before returning to Houston that evening to enjoy July 4th festivities with their families. They would be back at KSC on July 7. (NASA)

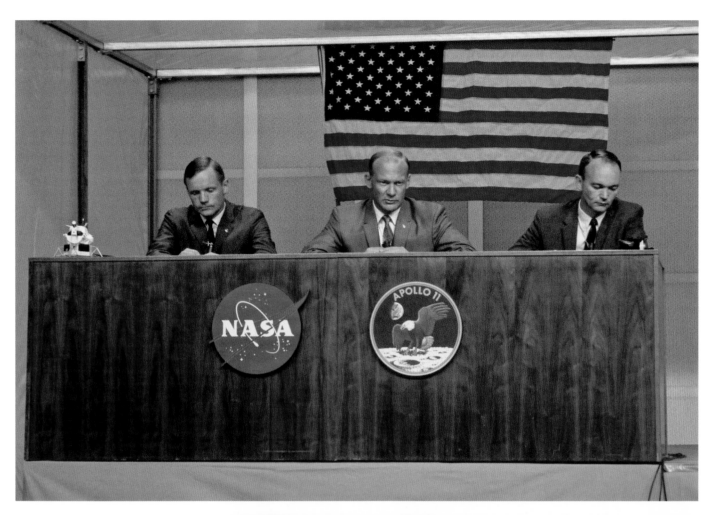

Above: Armstrong, Aldrin, and Collins (*left to right*) participate in a pre-flight news conference in Building 2 at MSC on July 5. The astronauts wore gas masks as they entered a three-sided plastic enclosure to help prevent them from catching any pathogens from reporters in the room. (NASA)

Right: Armstrong tells reporters that the spacecraft radio call signs would be "Eagle" for the LM and "Columbia" for the CM, and that he had no involvement in the decision to have him be the first to step onto the Moon. A Grumman LM model is on the desk. (Photo by Tiziou News Service)

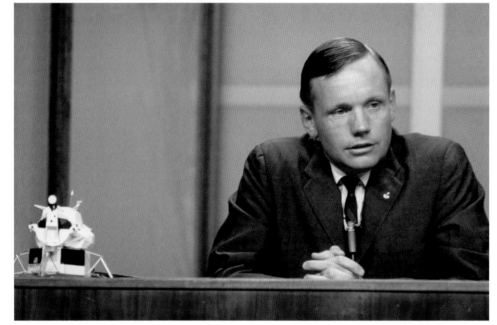

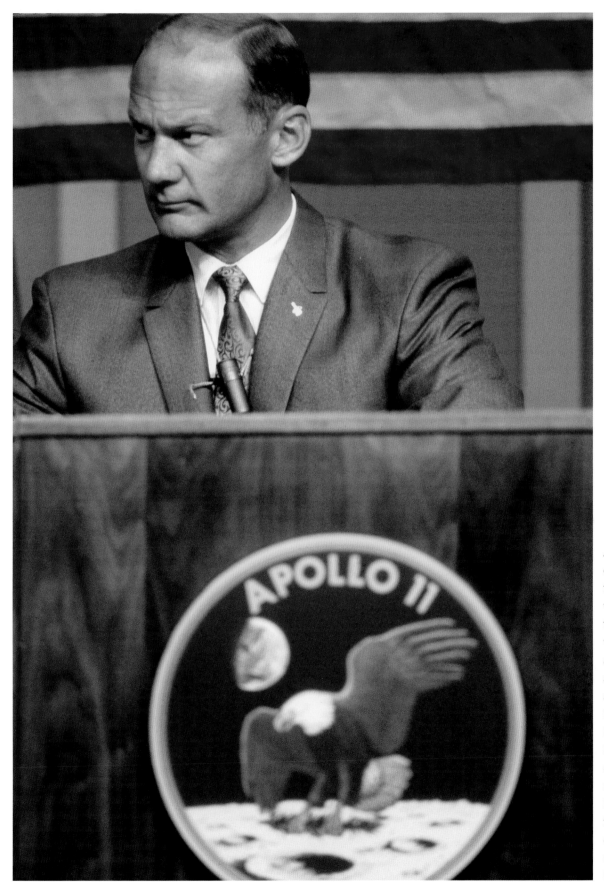

Aldrin answers questions from the media, who were kept fifty feet away while fans blew air toward the audience. Word also came from Flight Surgeon Dr. Charles Berry that he did not recommend President Nixon dine with the astronauts on launch eve. (Photo by Tiziou News Service)

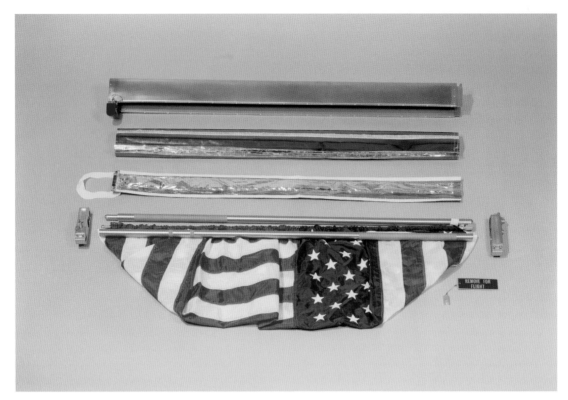

The U.S. flag and gold-anodized pole assembly during pre-flight preparation. The flag, made by Annin Flag Company of Roseland, New Jersey, is believed to have been one of three purchased for use on the mission. MSC secretaries purchased them at three separate Sears department stores in the Houston area. (NASA)

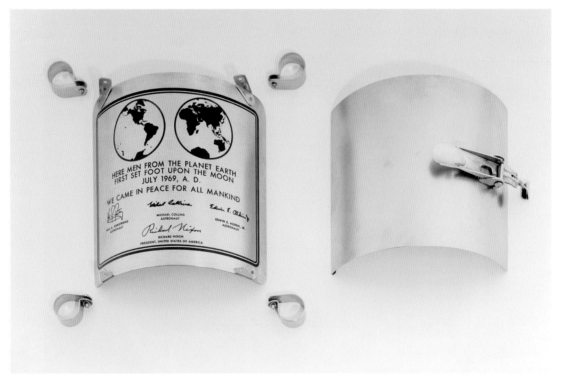

The commemorative plaque to be attached to lunar module landing gear assembly and left on the Moon and its stainless-steel cover. The plaque measures 9 inches by 7 inches and has a brushed chrome finish. (NASA)

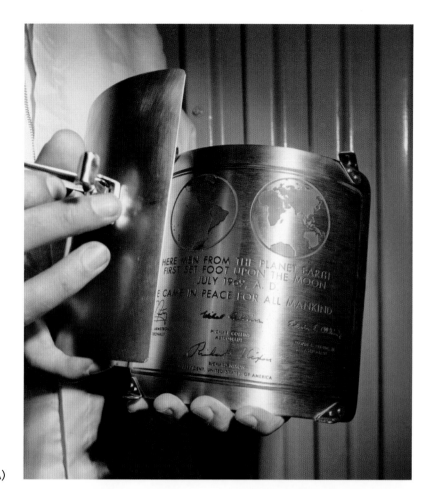

Right: A technician holds the commemorative plaque and its cover on July 11, two days before they were installed on the LM landing gear. (NASA)

Below: The plaque is shown after being installed on the LM on July 13. Technicians crawled into the SLA at the pad and installed the plaque on the LM ladder between the third and fourth rungs from the bottom. (NASA)

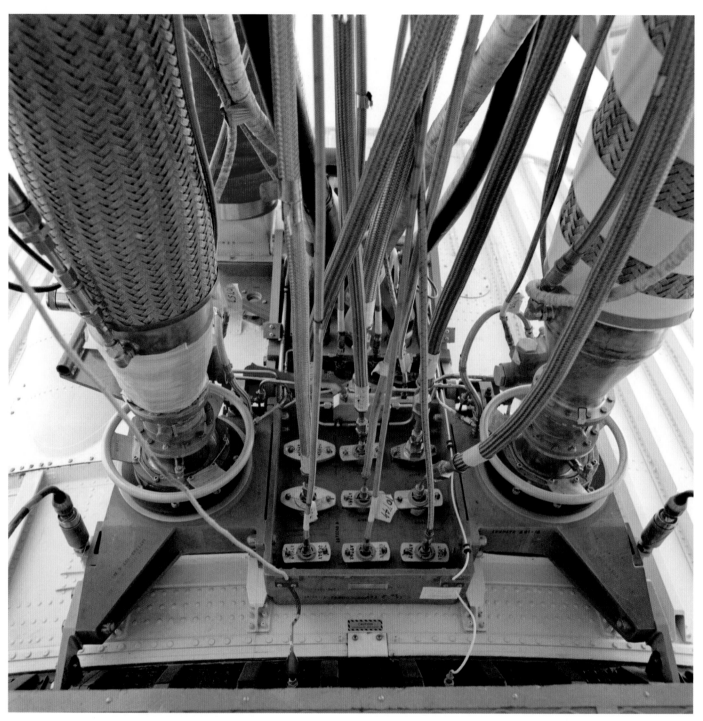

A close-up view of the S-IVB umbilical plate on July 8. Taken from the Launch Umbilical Tower, the photo shows the two large propellant lines (*bottom left and right*) and the electrical connections (*center*). These would all disengage when the swing arm pulled back moments before launch. (NASA)

Apollo 8 Commander Frank Borman held a news conference at the LC-39 Press Site on July 12. The Apollo 11 Saturn V can be seen in distance with the MSS in place. Borman provided a status update on the mission and answered reporters' questions regarding his recent trip to Russia. (Photo by Tiziou News Service)

Borman told reporters that the Soviet Union was working toward a "large manned space station in orbit around the Moon and around the Earth." He also relayed his thoughts on the decision not to allow President Nixon to dine with the astronauts on launch eve, saying he was "dismayed with the decision" and that "it was totally ridiculous." (Photo by Tiziou News Service)

A journalist poses with the sign for news media facilities at LC-39. (Photo by Tiziou News Service)

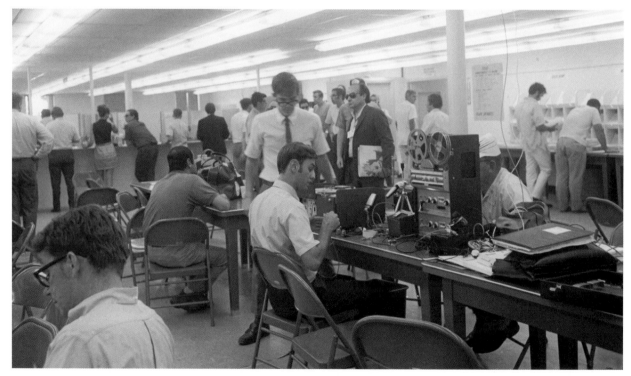

The official off-site Apollo News Center was in a two-story building on Florida State Road A1A in the city of Cape Canaveral near the Cape Kennedy Hilton. This larger facility was necessary to handle the crush of journalists from around the world. On launch day it opened at 2:30 a.m. (ET) and did not close until 5:00 p.m. (NASA)

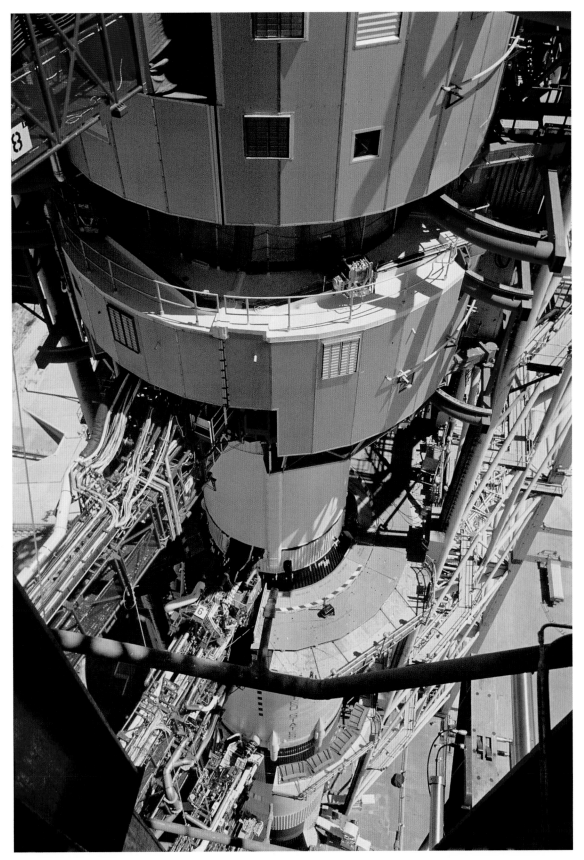

With the LUT and swing arms visible to the left, Apollo 11 is enclosed in the three-level service compartment near the top of the MSS at LC-39A. On July 10, batteries were installed in the LM as well as the ordnances for explosive bolts in the Saturn's stages. (Photo by Tiziou News Service)

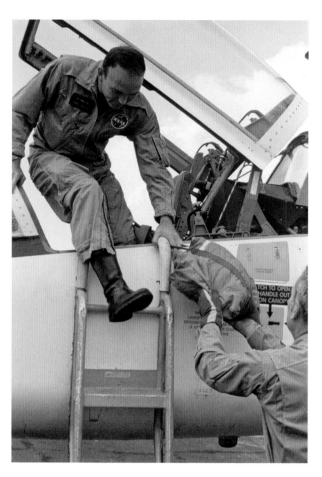

Above: Armstrong looks at the helicopter in which he performed aerobatics on July 12 over Patrick AFB to sharpen his flying skills. The helicopter maneuvers simulated some of the techniques he and Aldrin would execute aboard the LM. (NASA)

Right: Collins is assisted from a T-38 jet by Slayton at Patrick AFB on July 12 after they performed aerobatics south of Sebring, Florida, to hone Collins's flying abilities. (NASA)

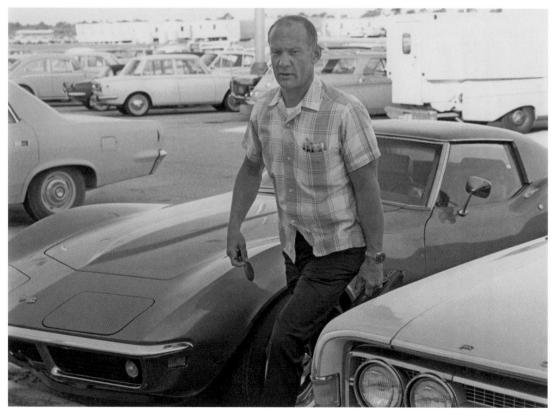

Aldrin exits his 1969 Corvette after arriving at the KSC Crew Training Building on July 12 to resume simulator training. He spent the following day at the crew quarters and received a visit from his father, retired Air Force Col. Edwin Aldrin Sr. (NASA)

Above: Close-up view on July 12 of the CM enclosed in the protective cocoon provided by the MSS. The white room and CM entryway are on the right. (NASA)

Right: The boost protective cover (BPC) has been installed over the CM in this July 12 photo. The cover for the scanning telescope (*left*) and sextant (*right*) would be installed before launch. (NASA)

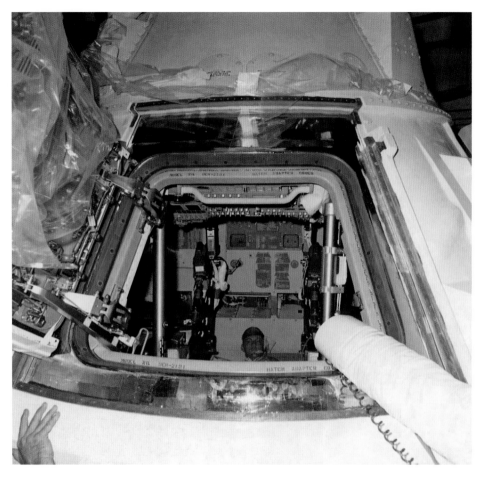

Left: A technician can be seen inside the CM through the hatchway on July 12. The couches were routinely removed to allow access to equipment and to load food and supplies prior to launch. The center couch has not been re-installed, and protective plastic covers the hatch on the left. (NASA)

Below: The center couch of the CM is installed on July 14. This view of the right-hand couch, with the hatch opening at right, shows a lower attenuator strut and an armrest at left. (NASA)

Facing page: Famed *Life* magazine photographer Ralph Morse sets up remote camera equipment under the watchful eye of Ed Harrison of KSC Public Affairs a few days before launch. Morse spent thirty years with *Life* and photographed the space program from the start. (NASA)

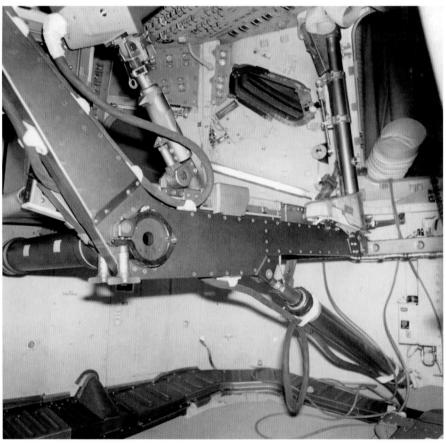

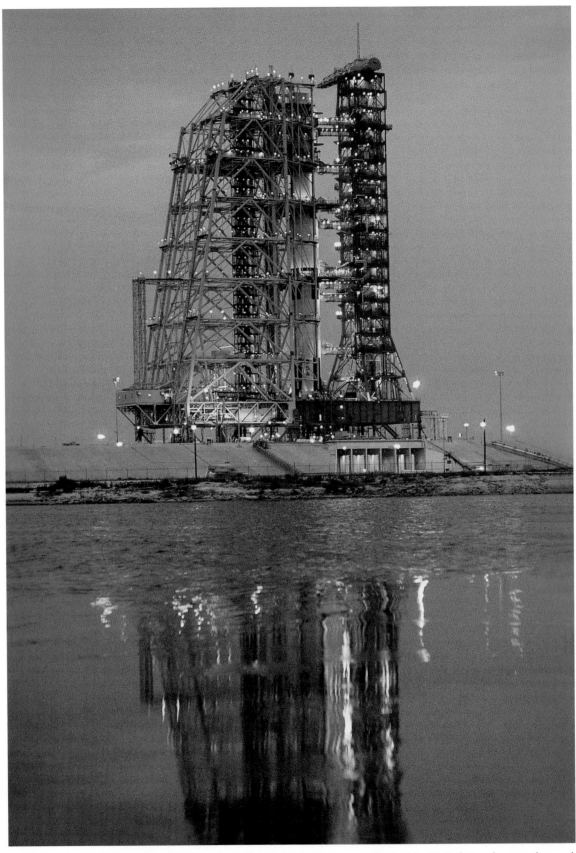

The Saturn V and MSS shine like jewels in the night as they are reflected in Pintail Creek near the pad at dusk on July 14, 1969. (Photo by Tiziou News Service)

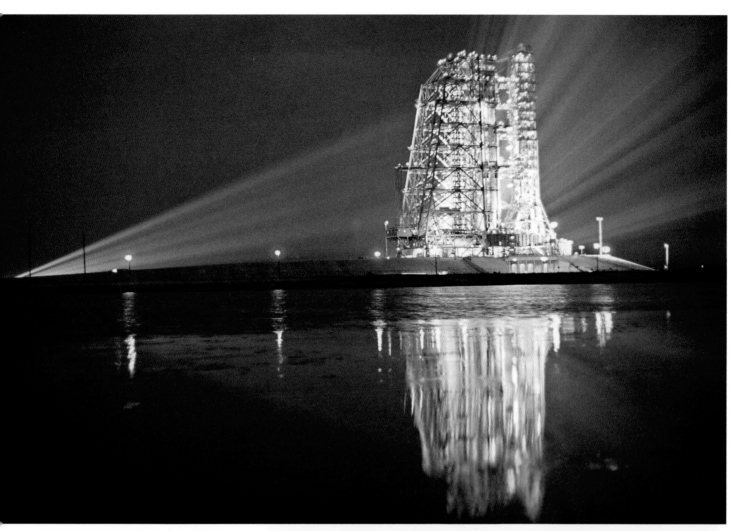

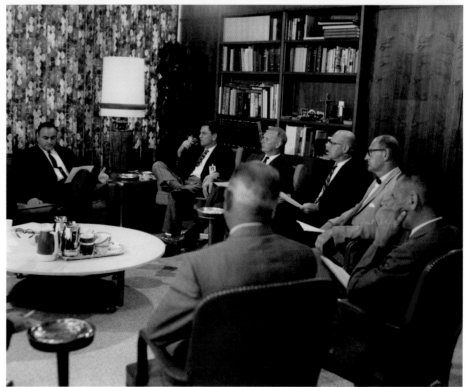

Above: Banks of Xenon floodlights illuminate the Saturn V and MSS as night falls on July 14. The NASA KSC photo team was responsible for moving and aligning the portable Xenon lighting apparatus. (Photo by Tiziou News Service)

Right: Senior members of the Apollo launch team meet at KSC Headquarters on July 14 to discuss readiness to support the Apollo 11 launch. Launch Director Rocco Petrone (*left*) led the discussion. Clockwise, to his left, are G. Merritt Preston, KSC Design Engineering director; Rear Adm. Roderick Middleton, KSC Apollo Program Office manager; Al Siepert, KSC deputy director; George van Staden, KSC director of administration; Gordon Harris, KSC public affairs director; and Fred Miller, director of installation support. (NASA)

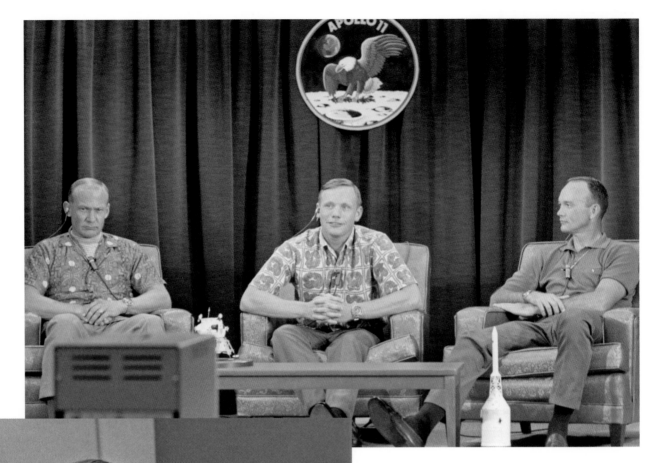

Above: On the evening of July 14, the astronauts held a final pre-flight news conference from the KSC News Center, a converted Gemini parachute facility. Four pool reporters quizzed them for half an hour over a closed-circuit television hookup from the Apollo News Center in the city of Cape Canaveral. Aldrin said, "We are ready to say *when* we land on the Moon—not *if*." (NASA)

Left: Armstrong reviewing flight plans in the MSOB crew quarters at KSC on July 14. (NASA)

Facing page: Tourists at the KSC Visitor Center line up for a chance to view this LM mockup, with Jupiter-C and Gemini/Titan booster displays at right. Over one million tourists visited KSC in 1969. (Photo by Tiziou News Service)

Above: Tourists take in the rocket and spacecraft display at KSC Visitor Center. "Apollo fever" was gripping the country as KSC became the focal point for the upcoming Moon launch. More than 8,000 people were touring the Moonport daily in the week leading up to the launch. (Photo by Tiziou News Service)

Left: Tourists at the KSC Visitor Center in July 1969 view a one-sixth-size model of the Apollo lunar module and listen to an audio presentation on its operations. The Cape area was a beehive of activity. The 5,000 motel rooms on the Space Coast had been filling up months before the scheduled launch. (Photo by Tiziou News Service)

Above: A billboard on the Florida Space Coast in July 1969 advertises TRW's participation in the Apollo Program. TRW was prime contractor for the LM descent engine. In June 1969 Brevard County officials were pushing for a "Beautify Brevard" campaign proposed to make the area look its best for Apollo 11. (Photo by Tiziou News Service)

Right: A fisheye lens view of the LM mockup at the KSC Visitor Center. TWA Services operated NASA Tours at KSC. By 1969 the Visitor Center was the second most heavily visited Florida attraction after Busch Gardens (Disney World was still under construction). (Photo by Tiziou News Service)

Facing page: The Moon Hut restaurant in 1969 in Cape Canaveral. The restaurant opened in 1958 and was famous for its "moonburger." It was a regular stop for many years for locals, tourists, and space workers until business slowed as interest in the space program waned in the 1990s. The Moon Hut went Mexican in 2005. (Photo by Tiziou News Service)

Above: Entrance to the Moon Hut in July 1969 at 7802 Astronaut Boulevard in Cape Canaveral. The restaurant was popular for the many astronaut- and space-related artifacts that covered the walls inside the dining room. (Photo by Tiziou News Service)

Right: A neon rocket adorns a business on the Space Coast in July 1969. This was a common sight in the Cape area after the boom period associated with the rise of activity at the space center. (Photo by Tiziou News Service)

Left: The Satellite Motel in Cocoa Beach in July 1969. The motel was once known for its neon sign, topped by a globe 10 feet in diameter with two orbiting satellites. But lightning struck the globe in the 1970s, and wind toppled it for good in 1984. (Photo by Tiziou News Service)

Facing page: The MSS moves away from the Apollo Saturn V under cloudy skies on the afternoon of July 15. A crawler transporter delivered the giant structure to its parked site 7,000 feet away. (Photo by Tiziou News Service)

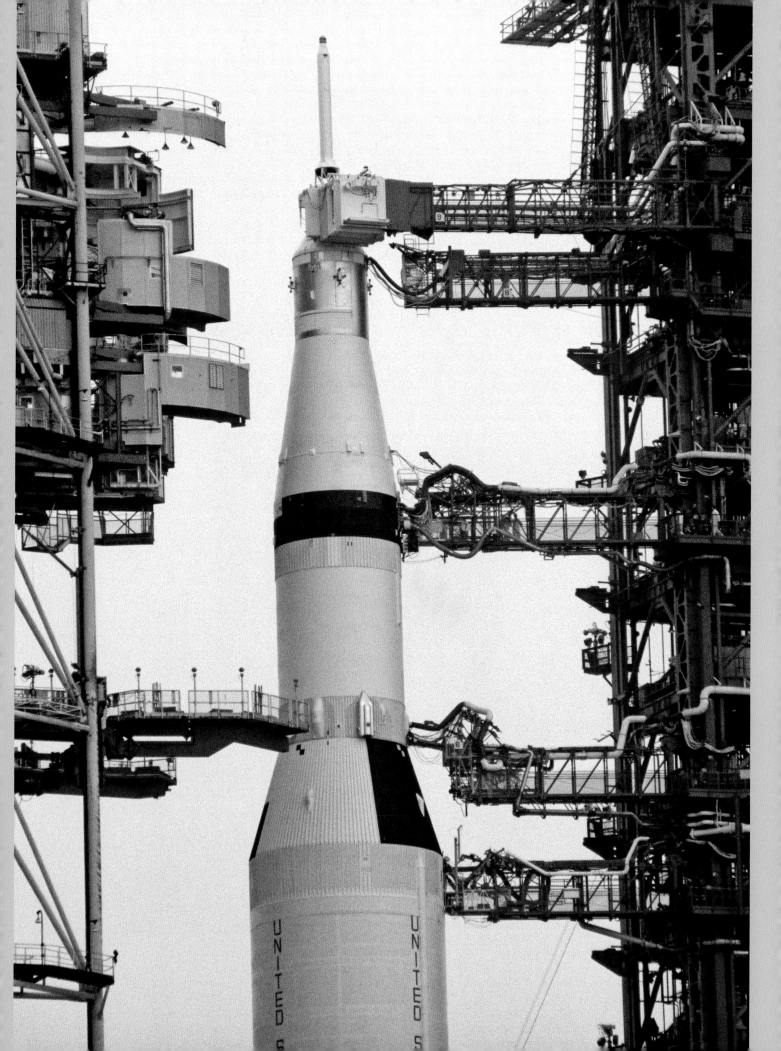

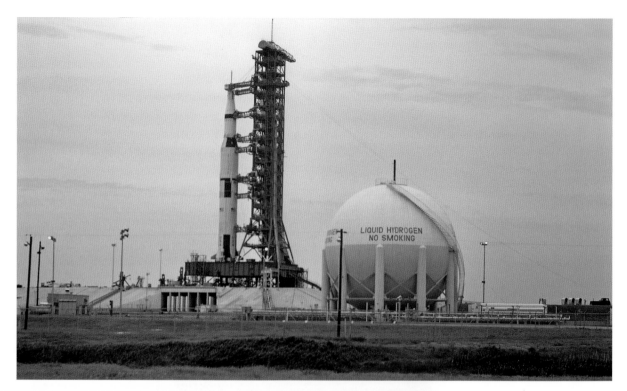

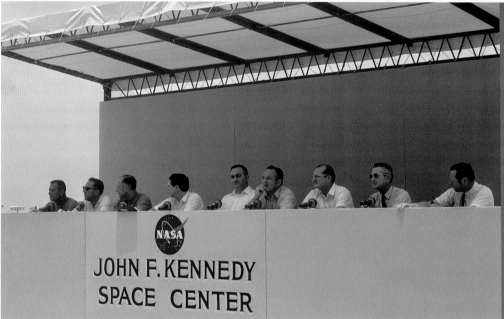

Above: Full view of the Saturn V looking west late in the afternoon of July 15, 1969. The MSS had just been moved away from the vehicle and is out of view to the left. The large liquid hydrogen tank to the right stored fuel for use on the Saturn V second and third stages. Large cryogenic tanks located near the pads stored the liquid hydrogen and liquid oxygen for the second and third stages of the Saturn V. (Photo by David Chudwin)

Above: NASA officials hold a final pre-launch briefing at the LC-39 Press Site grandstand. *Left to right*: Deke Slayton (MSC Flight Crew Operations), Dr. Charles Berry (MSC Medical Operations), George Low (Apollo Spacecraft Program Office), George Hage (Deputy Apollo Program Mgr), Rocco Petrone (Launch Director), Lee James (Saturn V Program Manager), Ozro Covington (Goddard Space Flight Center), Col. Royce Olson (Dept. of Defense), and Jack King (KSC Public Affairs and voice of launch control). (Photo by David Chudwin)

Right: Deke Slayton, director of Flight Crew Operations, speaks with reporters following the news conference. (Photo by David Chudwin)

Left: Head of the Southern Christian Leadership Conference Rev. Ralph Abernathy and his Poor People's Campaign staged a minor protest at the KSC Visitor Center on July 14 to try to raise awareness of poverty in the United States. The group also expressed admiration for the astronauts and prayed for their safety. To Abernathy's left is Walter Fauntroy, who had been appointed vice chairman of the District of Columbia City Council by President Johnson in 1967. (NASA)

Right: Rev. Abernathy inspects a Mercury capsule mockup at the KSC Visitor Center. (NASA)

Below: About 100 members of the Poor People's Campaign hold protest signs at the KSC Visitor Center. NASA Administrator Tom Paine met with the group and gave them VIP launch passes for ten families. (NASA)

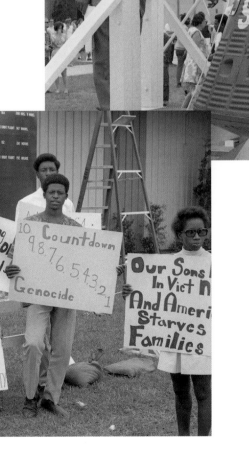

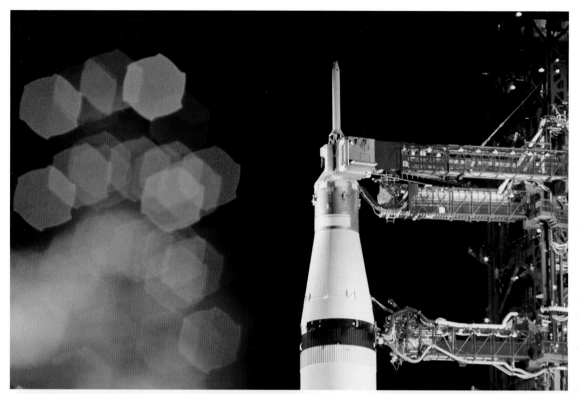

Artistic camera lighting plays in the dark next to the Apollo 11 spacecraft at LC-39A on the evening of July 15. Silver aluminum paint covers the service module. (Photo by Tiziou News Service)

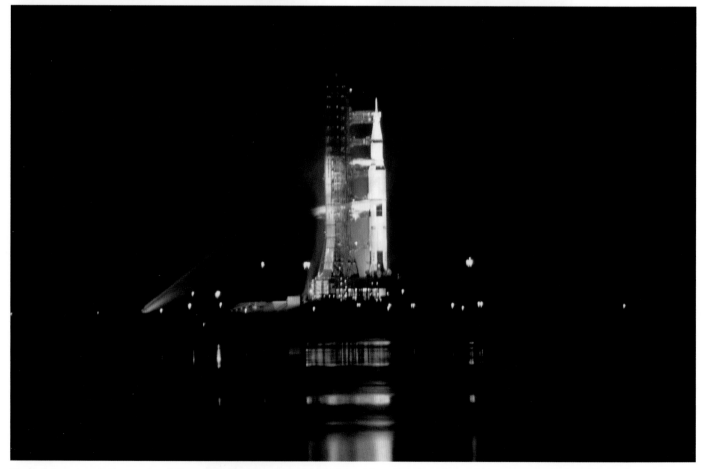

Technicians work throughout the night fueling the giant Saturn V rocket. Loading of the super cold liquid oxygen and liquid hydrogen would be finished around 4:00 a.m. (ET). Earlier that evening the astronauts had received a five-minute phone call from President Nixon; they ate an early dinner and went to bed around 8:30 p.m. (Photo by Jacques Tiziou)

7

Fire and Thunder

July 16, 1969: A beautiful sunrise provided the backdrop at LC-39A as the giant Saturn V and its Apollo spacecraft awaited their human cargo. The astronauts had awoken in the pre-dawn hours and ate the standard crew breakfast of choice: steak and eggs. They moved to the suit room, where they were helped into their pressure suits before proceeding to the astronaut transfer van. The roads at KSC were lined with people that morning, waving and sending best wishes as Armstrong, Aldrin, and Collins made their way to the pad.

Apollo 11 got under way right on time, at 9:32 a.m. (ET), in front of a crowd approaching a million spectators—the largest ever to witness a rocket launch. Dignitaries included former President Lyndon Johnson, Vice President Spiro Agnew, and Army Chief of Staff Gen. William Westmoreland, commander of U.S. forces in Vietnam until March 1968. Jan Armstrong was the only one of the three crewmen's wives to attend the liftoff. Post-launch traffic around the Space Coast was backed up for ten miles, but the enormous crowds proved to be well behaved.

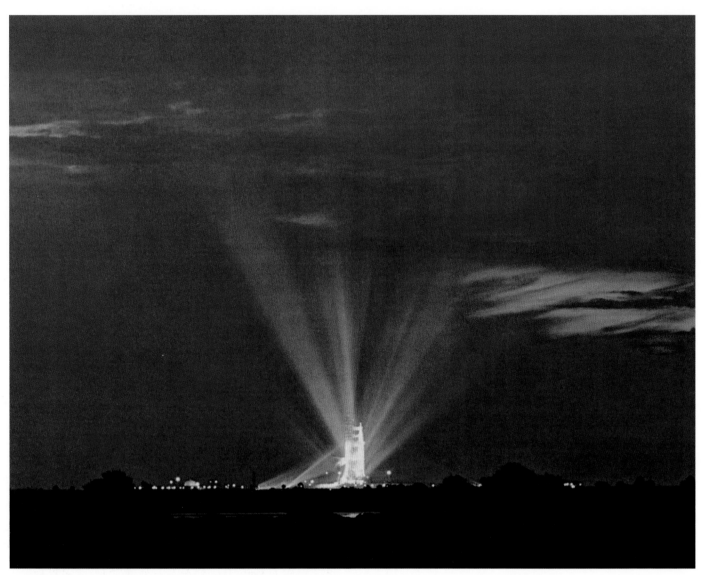

First signs of a new day are visible in the early morning sky over Launch Complex 39 and the Saturn V on July 16. More than 20,000 companies employing 350,000 people had been involved in building the Apollo equipment under government contracts, and the goal of astronauts landing and walking on the Moon was at hand. (NASA)

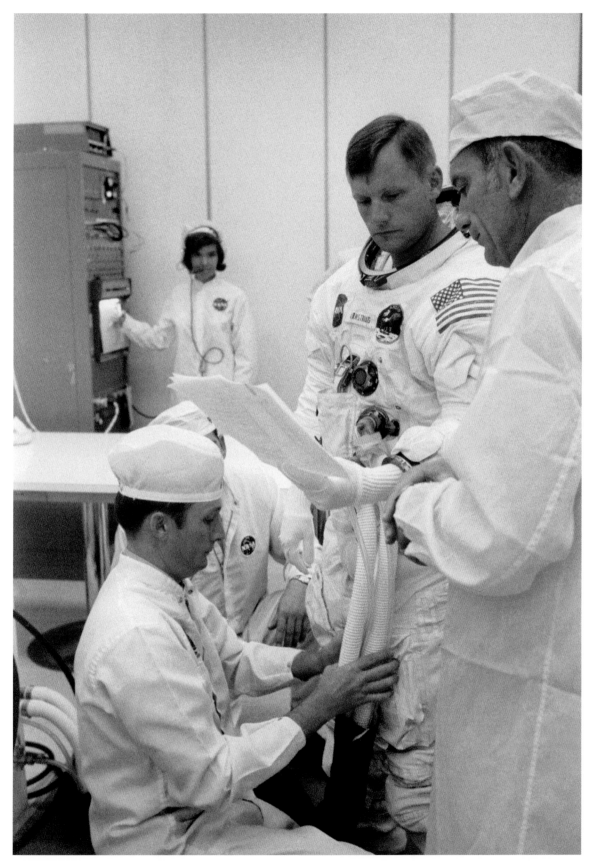

Deke Slayton goes over some final pre-flight notes with Armstrong as NASA technician Troy Stewart works with his pressure suit on launch morning. Judy Sullivan monitors biomedical instrumentation from the back of the room. (NASA)

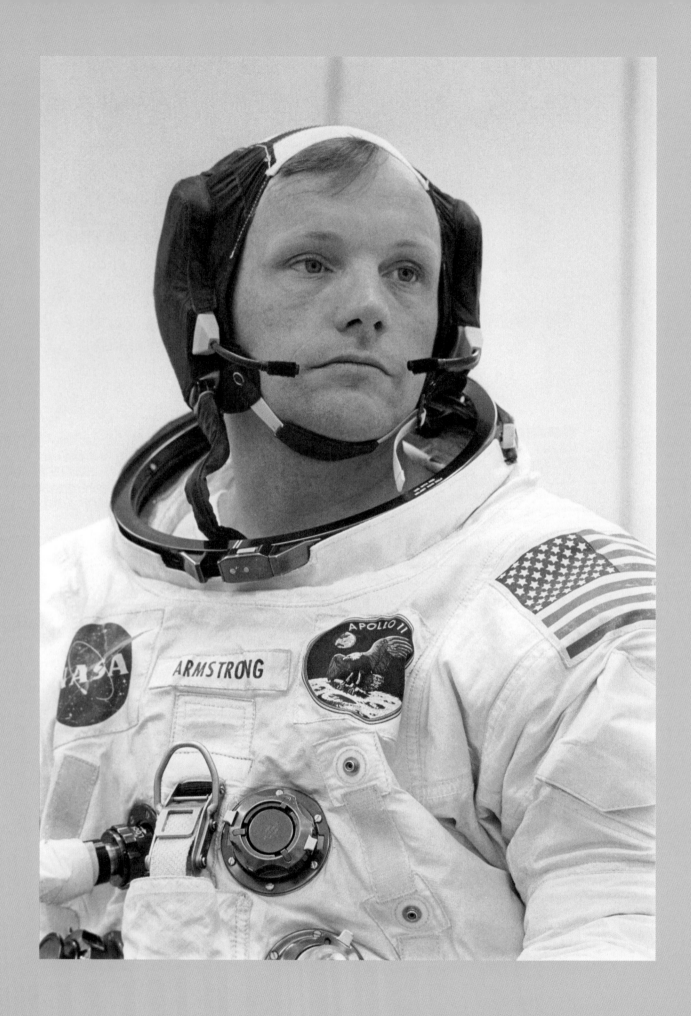

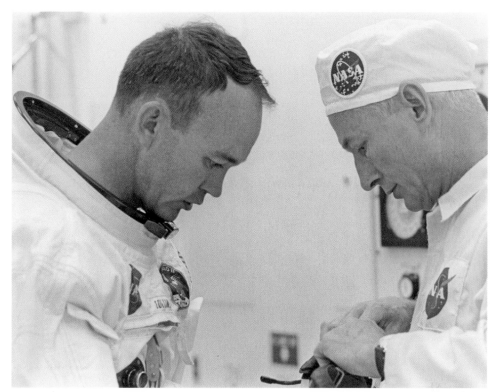

Facing page: A serious looking Armstrong in the suit room on launch day. The astronauts were awakened at 4:15 a.m. (ET) and had a breakfast of orange juice, scrambled eggs, tenderloin steak, toast, and coffee. Suiting activities began at 5:35 a.m. (NASA)

Above: NASA suit technician Joe Schmitt makes adjustments to the front of Collin's flight suit. Schmitt had been with NASA from the beginning, including suiting astronaut Alan Shepard, the first American in space, in 1961. (NASA)

Left: Sullivan and Dr. Jack Teegan in the suit room on launch morning, monitoring instrumentation that records biomedical data such as heartbeat and respiration rates of the astronauts. The twenty-six-year-old Sullivan was a biomedical engineer, the first hired by NASA for spacecraft testing. (NASA)

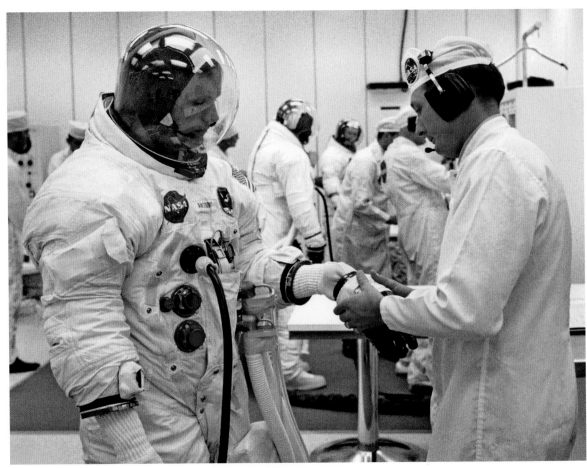

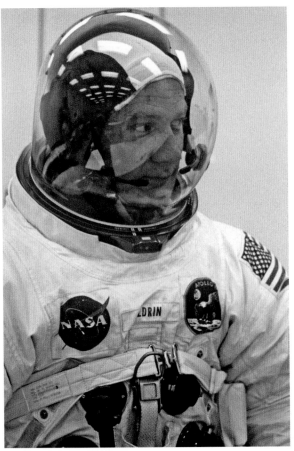

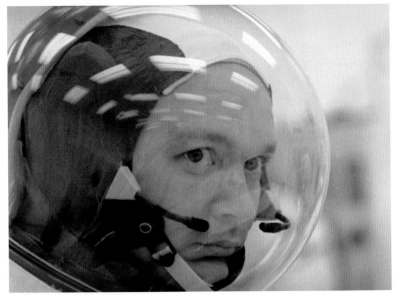

Top: Suit technician Troy Stewart helps Armstrong with his left glove. Collins and Aldrin are seen behind them. (NASA)

Left: Aldrin is fully suited as last-minute adjustments are completed prior to departure. (NASA)

Above: Collins soaks up the quiet sounds of his space suit as the time to depart for the launch pad approaches. (NASA)

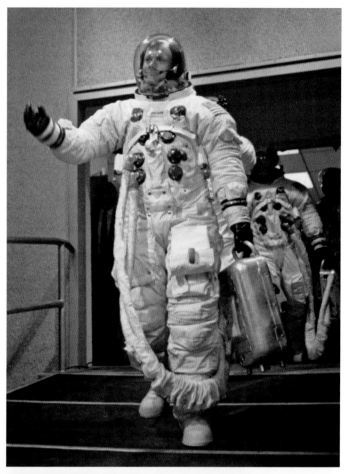

Right: Armstrong leads Collins and Aldrin down the ramp outside the MSOB at 6:27 a.m. on launch morning. The astronauts would board the air-conditioned transfer van for the eight-mile trip to LC-39A. (UPI)

Below: Armstrong waves to onlookers through the glare of spotlights illuminating the area around the crew transfer van. KSC Security Chief Charles Buckley (*far right*) holds open the van door. While the astronauts rode to the pad, technicians repaired two problems with ground equipment—a leaky valve and a faulty signal light. (Mondadori Portfolio via Getty Images)

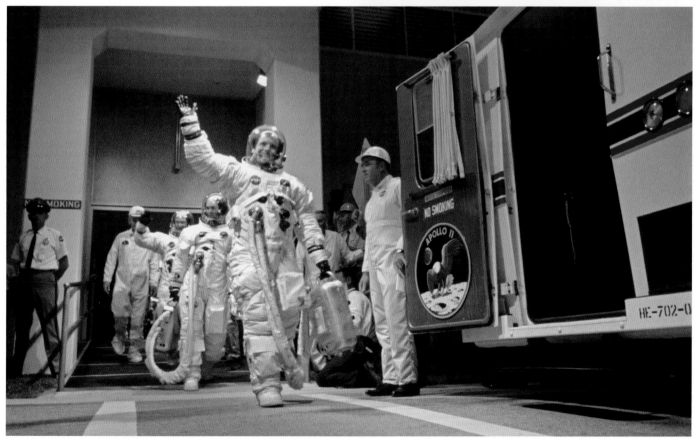

Left: The astronauts head for the elevator at the base of the pad following the trip from the MSOB crew quarters. Buckley, having accompanied the astronauts in the van, gives them a quick thumbs-up as they head into the elevator. (NASA)

Below: Pad Leader Wendt chats with Aldrin in the white room at Pad 39A as he prepares to take the center couch in the CM. Armstrong had climbed into the left couch at 6:54 a.m., followed soon by Collins in the right couch. (NASA)

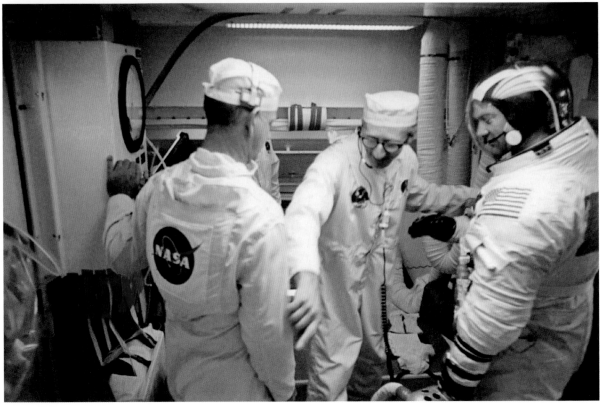

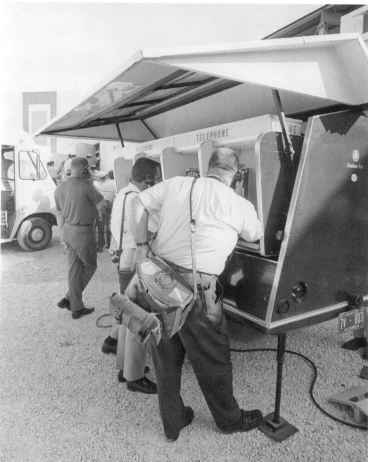

Above: Two media engineers hoping to record the launch sound in stereo catch up on sleep in this early morning view of the grandstand at the LC-39 Press Site. Most reporters arrived at the site after taking a two-hour, bumper-to-bumper bus trip in the middle of the night from the Cocoa Beach Apollo News Center. (NASA)

Left: Reporters take advantage of the pay phone banks set up behind the Press Site grandstand. The Vehicle Assembly Building is visible to the north. A NASA food truck is to the left. (NASA)

Photographers check their equipment near the Turning Basin as the Saturn V vents liquid oxygen in the distance. Photographers had staked out camera locations at the Press Site days in advance. (Photo by Tiziou News Service)

Sunrise at the Press Site grandstand on July 16. KSC issued 3,497 badges to members of the media representing 56 countries. Most heavily represented was the United States at 2,685, followed by Japan (118), England (82), Italy (81), France (53), Argentina (52), and Mexico (51). (Photo by Tiziou News Service)

Journalists, who had to reserve seats in the Press Site grandstand, could have phone lines, broadcast lines, and audio feeds of NASA transmissions installed. (NASA)

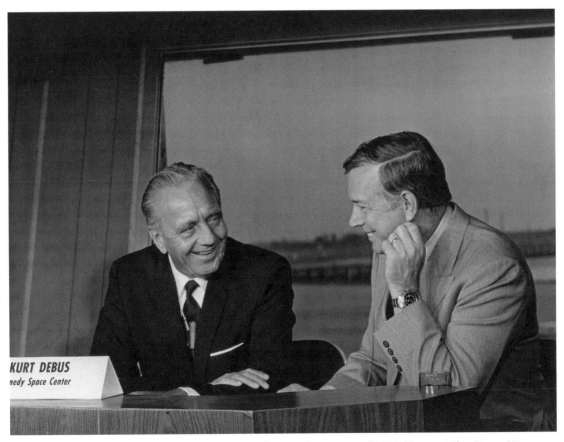

KSC Director Kurt Debus (*left*) is interviewed by Hugh Downs of NBC News at the Press Site. Downs was one of the more familiar faces on television in the 1960s and was a longtime supporter of the space program. (NASA)

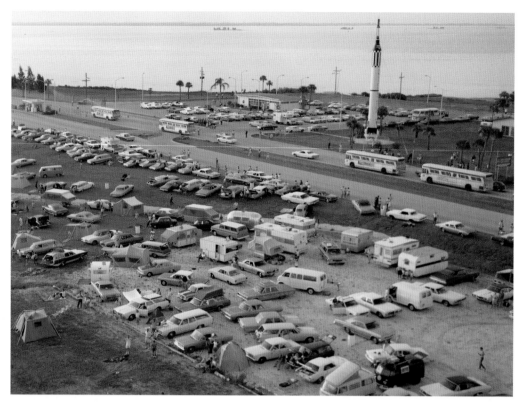

Buses carrying NASA guests approach KSC Gate 3 east of Titusville along the NASA Parkway West on launch morning. To the right is a full-scale mockup of the Mercury-Redstone that carried the first American into space. The cars and campers in the foreground occupy the closest spots to KSC property the public could be. (NASA)

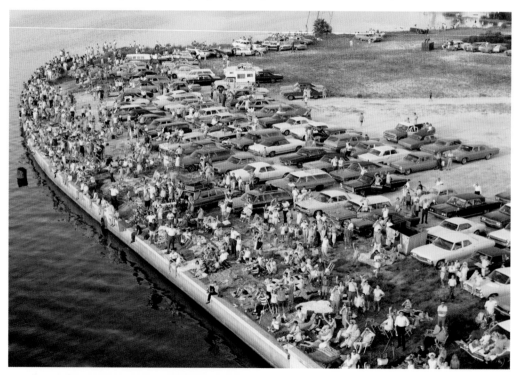

"Bird watchers" wave at a NASA photographer aboard a helicopter as he documents the crowds up and down the Space Coast on launch morning. This group gathered in Titusville near the Indian River, west of KSC. More than half a million people had already descended on the area by late in the day on July 15 seeking out viewing spots. (NASA)

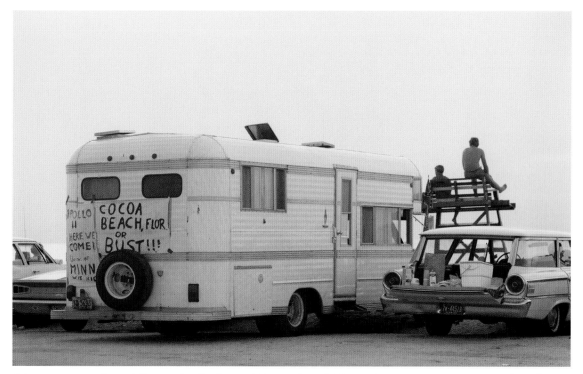

A large camper from Minnesota displays a "Cocoa Beach Flor or Bust!!!" sign at Jetty Park early on July 16. People from across the country converged on the Space Coast to witness history in the making. (NASA)

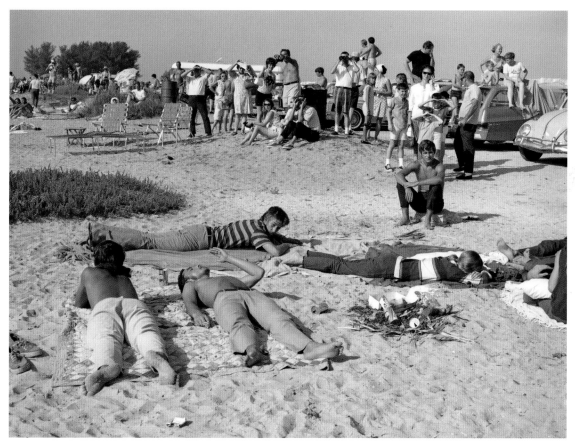

A group of young men who'd camped out on Cocoa Beach and built a fire overnight greet the day. (NASA)

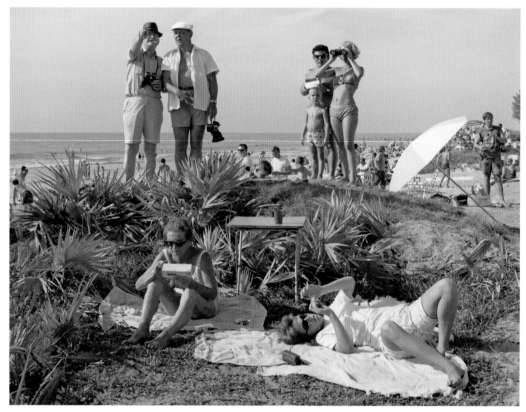

Others relax on blankets listening to the radio and waiting for the launch. Suntan lotion, binoculars, grills, blankets, beer, and cigarettes are among the essential provisions of "bird watchers" occupying Cocoa Beach. (NASA)

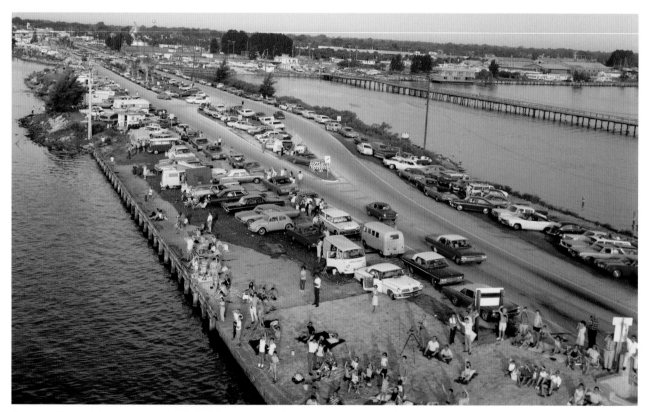

Cars and spectators crowd the Sand Point area of North Titusville on launch morning. This photo shows traffic along the Max Brewer Memorial Parkway. (NASA)

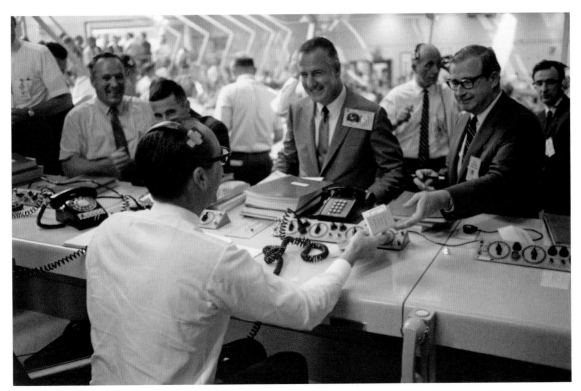

Dr. George Mueller, NASA associate administrator for Manned Space Flight (*with back to the camera*), celebrates his 51st birthday on July 16 in the Launch Control Center (LCC), accepting a greeting card from NASA Administrator Thomas Paine (*right*). Also on hand are (*left to right*) Lee James, astronaut William Anders, and Vice President Spiro Agnew (*center*). (NASA)

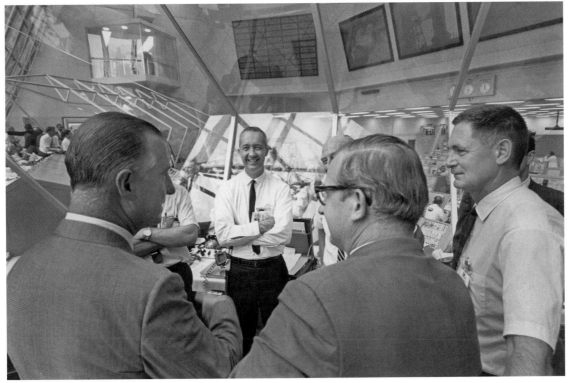

From left to right: Vice President Agnew chats with James McDivitt, manager of Apollo Lunar Landing Operations; Paine; and Miles Ross, deputy director of KSC, in the VIP room of LCC's firing room 1 on launch morning. (NASA)

Launch guests mill around near the VAB as the minutes tick away to launch. The atmospheric temperature was 85 degrees at launch time, but a comfortable 70 degrees inside the CM at liftoff. (NASA)

Former President Lyndon B. Johnson arrives at the VIP viewing site near the VAB at 8:25 a.m. LBJ and his wife Lady Bird had flown into Patrick AFB the day before and stayed in a penthouse apartment at the base. "I have ridden on every flight," Johnson remarked at a luncheon on July 15, adding that he doubted whether anyone could be as concerned or troubled as he was until a safe splashdown. (NASA)

Apollo 10 Commander Tom Stafford was on hand in the VIP section to help answer any questions that guests of Johnson or Vice President Agnew might have. (NASA)

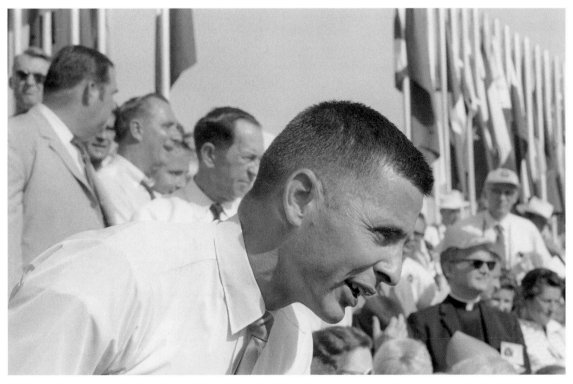

William Anders, Apollo 8 astronaut and Apollo 11 back-up crewmember, was also in the VIP stands. In 1975 he was appointed the first chairman of the new Nuclear Regulatory Commission, responsible for nuclear safety and environmental compatibility. (NASA)

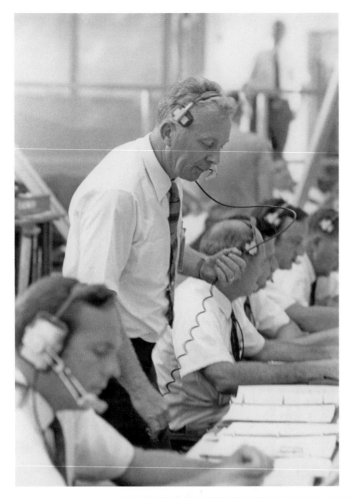

Left: KSC Launch Operations Manager Paul Donnelly (*standing*) monitors the countdown from his console in the firing room on launch morning. Donnelly was responsible for the checkout of all Apollo launch vehicles and spacecraft, and was also involved in every U.S. manned launch from Alan Shepard's Mercury flight in 1961 through the tenth space shuttle mission (STS-41B) in 1984. (NASA)

Below: Deputy Director of KSC Launch Operations Walter Kapryan, Kurt Debus, and Rocco Petrone (*left to right*) keep a close eye on activities in the LCC during the final minutes of the countdown. Petrone, the son of Italian immigrants, was known for his no-nonsense management style. (NASA)

Facing page: The Saturn V rocket moments after ignition. At nine seconds before liftoff, an automatic sequencer initiated ignition of the five F-1 engines, sending fuel in at a rate of 15 tons a second and lifting the 6,484,280-pound vehicle off the pad. (NASA)

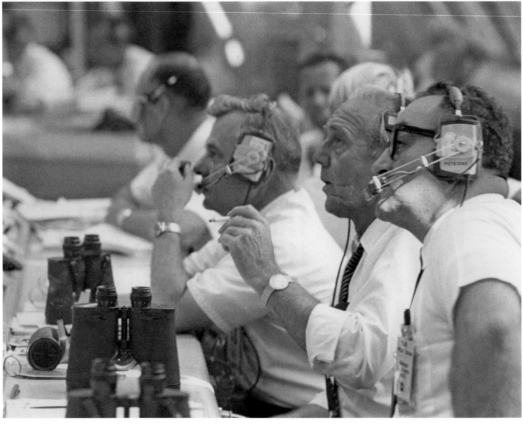

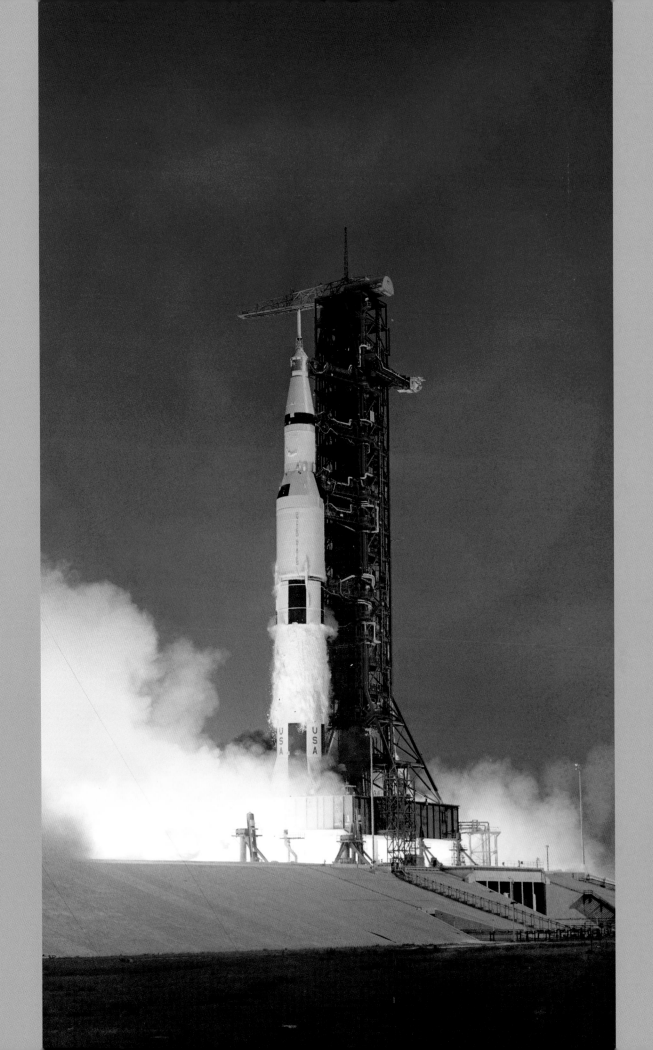

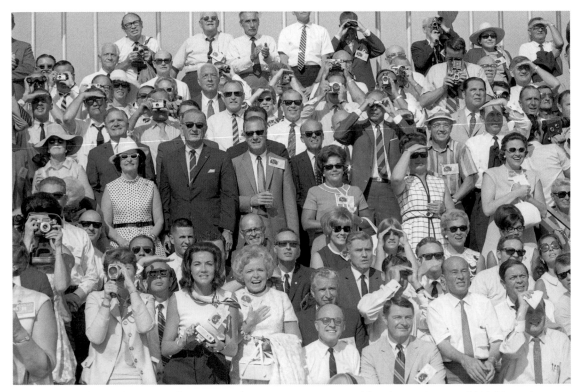

Former President Johnson and Vice President Agnew are joined by their wives and NASA and government officials in the VIP stands as Apollo 11 lifts off. Only two of the 5,000 seats in the stands had cushions: those for LBJ and Lady Bird. (NASA)

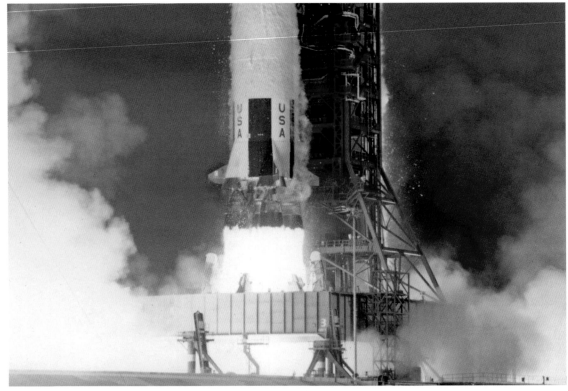

The combined power of the five F-1 engines of the Saturn V is evident as Apollo 11 moves off ML-1 on LC-39A. The F-1 is the most powerful single-nozzle liquid fueled rocket engine ever flown. The center engine of this Saturn V (SA-506) was eventually recovered from the Atlantic in March 2013 by a team sponsored by billionaire Jeff Bezos. (NASA)

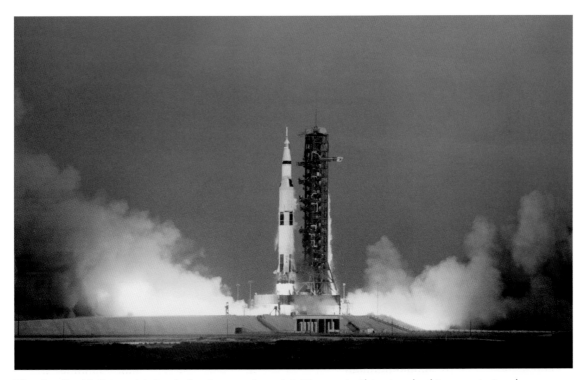

The Apollo 11 Saturn V slowly begins moving at 9:32 a.m. in this view looking west. A column of flame more than 30 feet in diameter shot down the 45-foot flame deflector under the massive rocket, splitting the flame in half. (NASA)

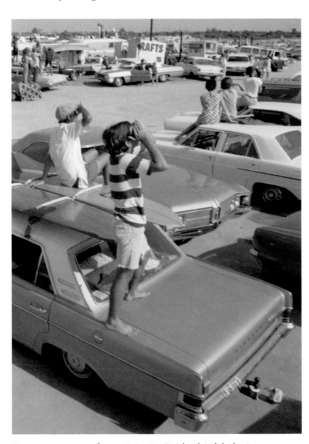

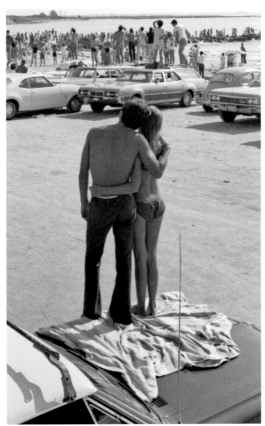

Two young surfers at Jetty Park shield their eyes as they follow the progress of Apollo 11 rising through the blue Florida sky. (NASA

A young couple are wrapped up in the moment as they watch the mission get under way from their vantage point at Jetty Park. (NASA)

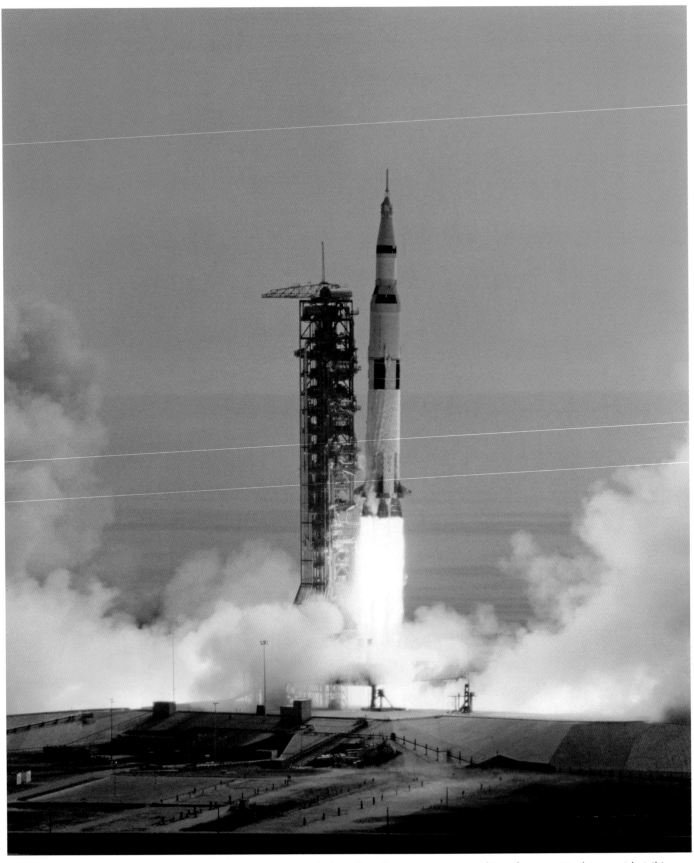

The Saturn V, seen looking east, is already executing a slight roll and yaw maneuver, tilting from vertical to avoid striking the Launch Umbilical Tower in case of a wind gust or other problem. It would take fifteen seconds for the rocket to clear the tower. (NASA)

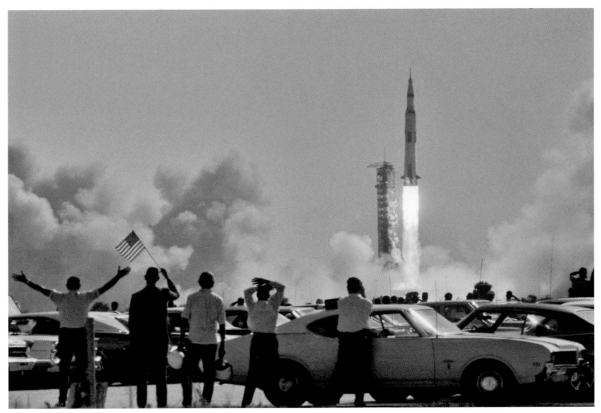

Spectators in a parking lot near the VAB wave an American flag as Apollo 11 begins its journey to the Moon. The Saturn's automatic engine shutdown function was inhibited during the first thirty seconds to prevent the vehicle from falling back onto the pad during a launch failure, seen as the least preferable option at that stage of the flight. (Photo by Tiziou News Service)

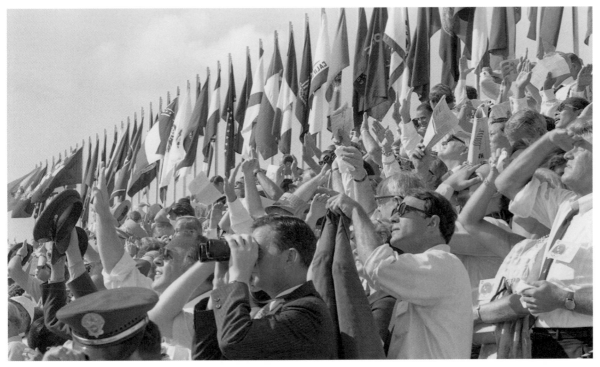

VIP guests from around the world use binoculars and cameras as they soak in the sights and sounds emanating from the Saturn V at launch. Among them were Gen. William Westmoreland, Army chief of staff; late-night TV host Johnny Carson; and a direct descendent of Napoleon Bonaparte. (NASA)

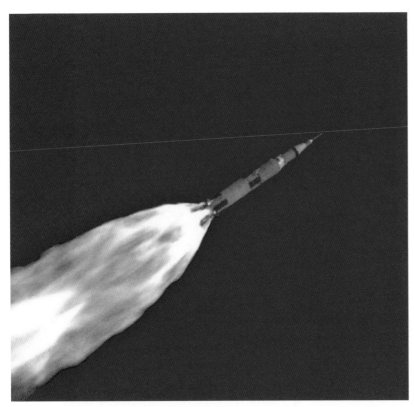

Left: An Air Force EC-135N plane photographs the Saturn V as it trails a 900-foot tongue of flame. The photo was taken using a long-range tracking camera mounted in a pod that was attached to the door of the aircraft. The Airborne Lightweight Tracking System is capable of automatic tracking and can photograph a rocket at distances exceeding 200 miles. (NASA)

Below: Tears, cheers, and shouts come from the overflowing crowd of media representatives at the Press Site as Apollo 11 begins its journey to the Moon. The small building at center is restroom facilities. (NASA)

Facing page top: The S-IC first stage shortly before burnout and separation. The center engine performed a planned shutdown at 2:17 into flight, followed by staging at 2:44. The astronauts experienced a 4g load at this time. This image was taken with a 70mm telescopic camera aboard a USAF EC-135N aircraft flying at 35,000–40,000 feet. (NASA)

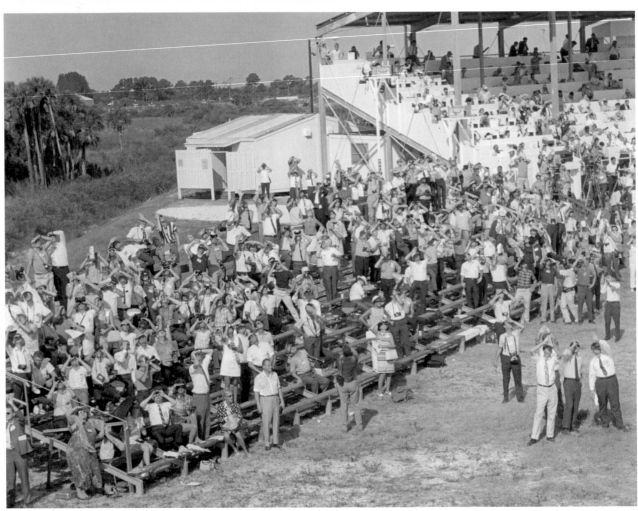

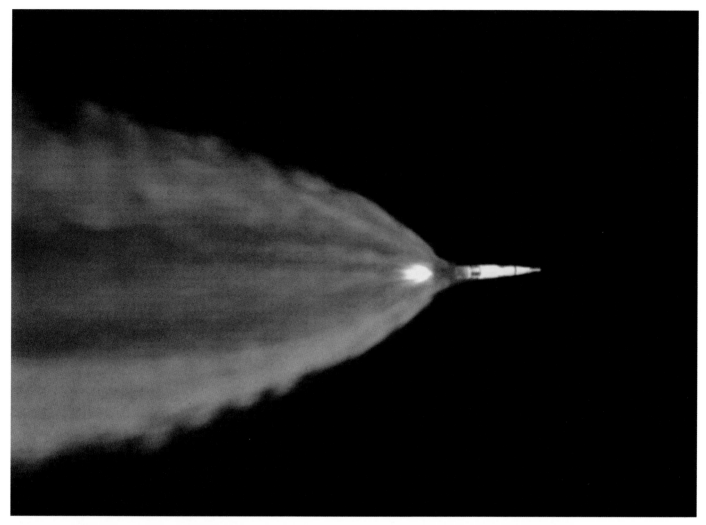

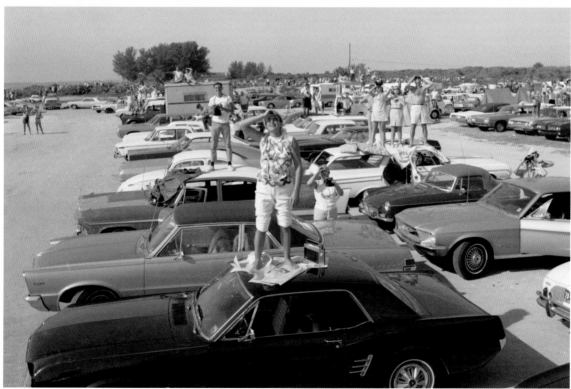

Left: Launch watchers at Jetty Park stand on cars as they follow the progress of Apollo 11. The rocket was visible for 30 miles before going out of sight. (NASA)

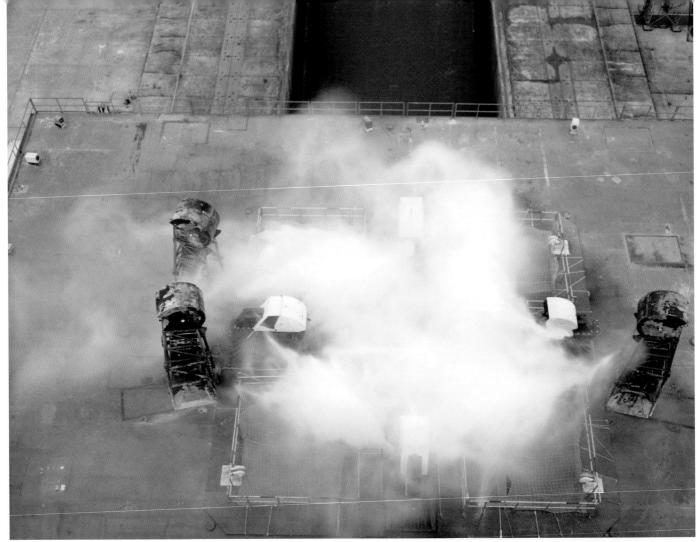

Above: The pad hardstand and LUT are doused with water shortly after launch from the Sound Suppression Water System (SSWS). The pad surface is flooded with water at approximately 50,000 gallons a minute during the first 30 seconds after liftoff. This is preceded by 8,000 gallons of water a minute pumped from nozzles in the flame trench below the Saturn's five F-1 engines. (NASA)

Right: Water continues to pour onto the base of the pad from the SSWS shortly after launch. The rate has slowed here to 20,000 gallons a minute. (NASA)

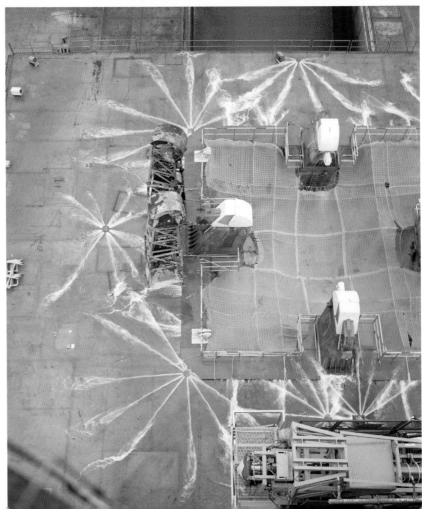

Above: Vice President Agnew (*foreground*) addresses the Apollo 11 launch team in the LCC following the liftoff. Seated to the left are launch commentator Jack King, George Low, and Walter Kapryan. Tom Stafford and Rocco Petrone stand behind Agnew, who used the occasion to propose a manned flight to Mars in the following decade. (NASA)

Left: Apollo Program Director Lt. Gen. Sam Phillips in the LCC reflecting on what would be his final launch before returning to the Air Force. (NASA)

President Johnson and NASA Administrator Paine attend a luncheon at KSC following the successful launch. Guests included General Westmoreland, members of Congress, and other dignitaries. (NASA)

Jan Armstrong with sons Rick and Mark encounter reporters at what is now the Space Coast Regional Airport (then called the Titusville-Cocoa or Ti-Co Airport) during the afternoon of July 16 before flying back to Houston. Jan described the launch as "terribly exciting," and son Rick added that "it was a very nice launch." The families of Aldrin and Collins stayed in Houston and watched the launch on television. (NASA)

8

Men to the Moon

After the standard Earth-orbit checkout, the Saturn's third-stage engine was re-started to send Apollo 11 toward the Moon. The astronauts beamed back live television broadcasts from the spacecraft so that the world could share in the adventure. The center of attention, however, had now shifted from KSC to the Manned Spacecraft Center (MSC) in Houston, and reporters moved into the ho-tels and motels surrounding the MSC campus.

On July 20 lunar module *Eagle* separated from command module *Columbia*, and the LM descent engine fired to put the craft into a lower orbit around the Moon. The engine fired again to drop *Eagle* toward the surface. The LM landed at 4:17 p.m. (ET) in the Sea of Tranquility, after Armstrong steered around a boulder field. He reported, "Houston, Tranquility Base here. The *Eagle* has landed."

Armstrong stepped onto the Moon's surface at 10:56 p.m., stating, "That's one small step for [a] man, one giant leap for mankind." His first task was collecting a contingency lunar sample. Aldrin joined him 19 minutes later, and they unveiled a plaque on the strut behind the ladder and read the inscription: "Here men from the planet Earth first set foot upon the Moon July 1969, A.D. We came in peace for all mankind." They put up an American flag and received a congratulatory call from President Richard Nixon.

The crewmen then deployed the Solar Wind Composition experiment, and Aldrin set up the two experiments that comprised the Early Apollo Surface Ex-periments Package (EASEP): a Laser-Ranging Retroreflector and a Passive Seis-mic Experiment Package. The seismometer began operating almost immediately and was sensitive enough to detect the men's movements on the surface. The astronauts also took panoramic photos and collected lunar rocks and soil, each venturing about 300 feet from *Eagle*. They also took two core tube soil samples

and packed them into sample boxes with the rocks, and the foil collector from the solar wind experiment.

Aldrin returned to the LM after an hour and 41 minutes outside. Armstrong followed about 12 minutes later, after transferring the sample boxes up to Aldrin with a cable. The two spent the next seven hours resting and checking out systems. *Eagle*'s subsequent ascent from the Moon, re-docking with *Columbia*, and the crew's return voyage to Earth were without incident.

Collins is photographed by Aldrin inside the command module 1 hour and 9 minutes into the mission. Collins would soon switch couches with Armstrong and prepare for docking with the lunar module. (NASA)

Close-up view of the top of *Eagle*, which is still attached to the S-IVB as Collins guides *Columbia* during final approach. The spacecraft were successfully docked 3 hours and 24 minutes into the mission. (NASA)

Earth view over Central and North America as seen from Apollo 11 during the translunar phase on July 17. (NASA)

Dr. George Mueller and Dr. Chris Kraft, director of flight operations at MSC, follow activity in Mission Control Room 2 at MSC in Houston, Texas. (NASA)

Jan Armstrong receives an AP wire photo showing her husband aboard the CM during a telecast to Earth on July 17. Son Mark, aged six, is in the back seat of the car. (AP)

Above: The Ramada Inn near MSC, like many Houston businesses, displays a message of support on its marquee. (Photo by Tiziou News Service)

Left: The Holiday Inn on NASA Road 1 near MSC displays good luck messages for Apollo 11. (Photo by Tiziou News Service)

Left: Main sign for the Nassau Bay Resort Motor Inn on NASA Road 1 and a special Moon mission message. (Photo by Tiziou News Service)

Below: The Nassau Bay Resort Motor Inn as seen from inside the main gate of MSC. The resort's proximity to MSC made it a popular destination for reporters covering the Apollo missions. NBC News operated a studio on the top floor, and a CBS microwave antenna is on the roof. The hotel's grand piano ended up in the pool during the Apollo 11 splashdown party. (Photo by Tiziou News Service)

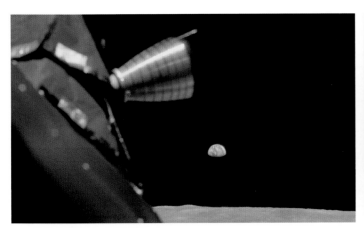 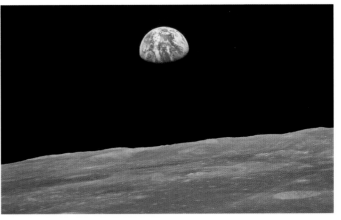

Above left: View of Earthrise during revolution 6 around the Moon. A reaction control system (RCS) quad is visible to the left out of Armstrong's window. The spacecraft was in sleep mode at the time, with the crew scheduled for a rest period shortly after this photo was taken. (NASA)

Above right: View of Earthrise on revolution 12 before separation of the LM and the CM. (NASA)

Below: View of the rugged lunar surface and craters Gutenberg E and Goclenius. The photo was taken from *Columbia* while on a near-circular lunar equatorial orbit. (NASA)

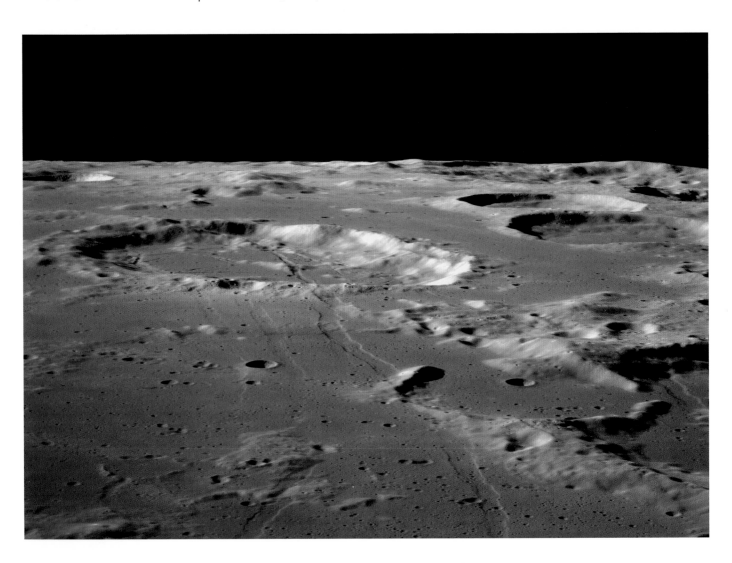

Right: View of photographic Target of Opportunity 67 showing partial coverage of the area south of Mare Crisium. Target 67 is the south rim of Crisium Basin. The LM is partially visible in lower half of the image. (NASA)

Below left: View of Messier and Messier A craters. Messier (*left*) is a relatively young impact crater located on the Mare Fecunditatis. (NASA)

Below right: Taruntius crater photographed from the CM. Taruntius is on the northwestern edge of Mare Fecunditatis and is named after the Roman philosopher Lucius Taruntius Firmanus. (NASA)

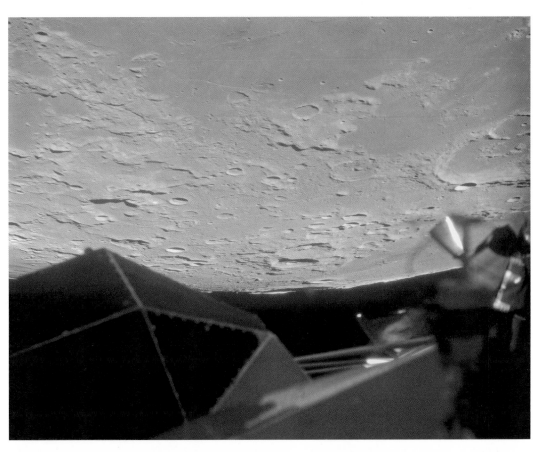

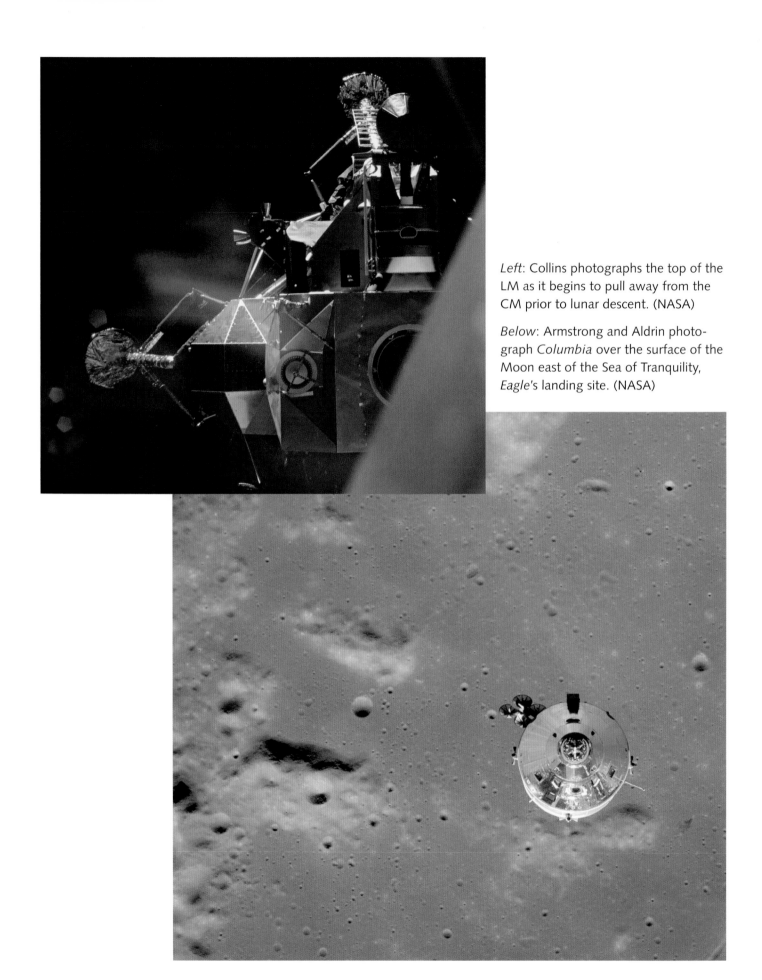

Left: Collins photographs the top of the LM as it begins to pull away from the CM prior to lunar descent. (NASA)

Below: Armstrong and Aldrin photograph *Columbia* over the surface of the Moon east of the Sea of Tranquility, *Eagle*'s landing site. (NASA)

Left: *Columbia* can barely be seen just to the left of crater Schmidt (*right*), which is just west of the Sea of Tranquility. This is the last photo taken from *Eagle* before it begins the descent to the lunar surface. (NASA)

Below: Guidance Officer Steve Bales was credited with playing a major role in saving the lunar landing from being aborted in the final minutes. A series of alarms from the LM guidance computer just prior to landing had threatened to spoil the day, but Bales analyzed the situation quickly and assured the flight director that all was well. (NASA)

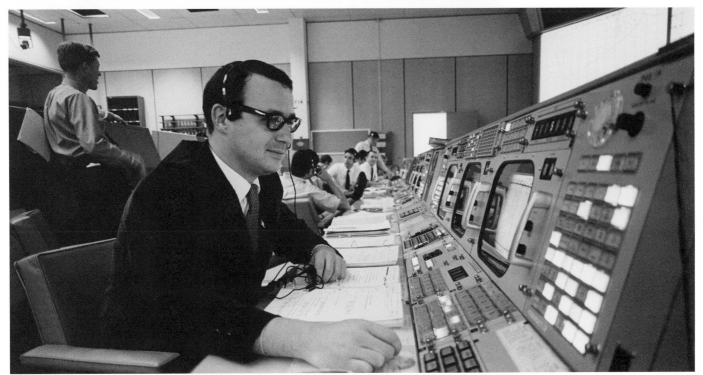

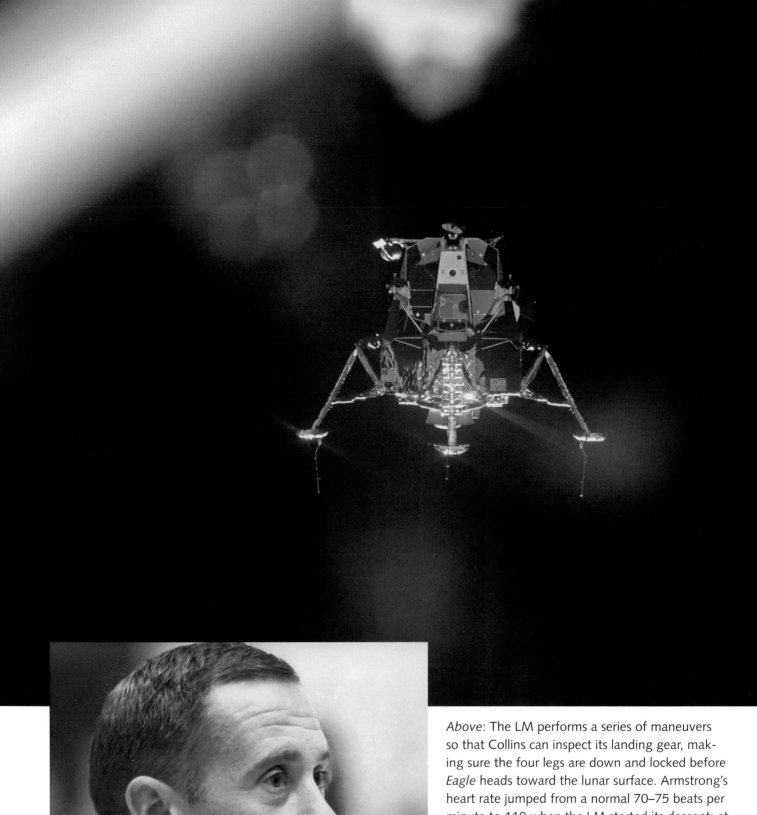

Above: The LM performs a series of maneuvers so that Collins can inspect its landing gear, making sure the four legs are down and locked before *Eagle* heads toward the lunar surface. Armstrong's heart rate jumped from a normal 70–75 beats per minute to 110 when the LM started its descent; at landing, it was 156 beats per minute. (NASA)

Left: Capsule communicator or "CAPCOM" Charles Duke at his console in Mission Operations Control Room 2 as *Eagle* prepares to land. Applause broke out in the Mission Control Center after the landing. Officials cheered, shook hands, and slapped one another on the back. (NASA)

Eagle's shadow photographed by Aldrin from his window in the LM after landing in the Sea of Tranquility. Armstrong and Aldrin took a series of photographs of the landing site soon after touchdown just in case a "no stay" decision was made. (NASA)

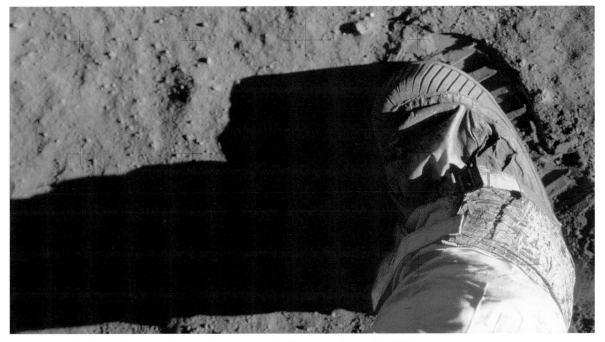

Close-up of Aldrin's boot and its indention on the lunar surface. (NASA)

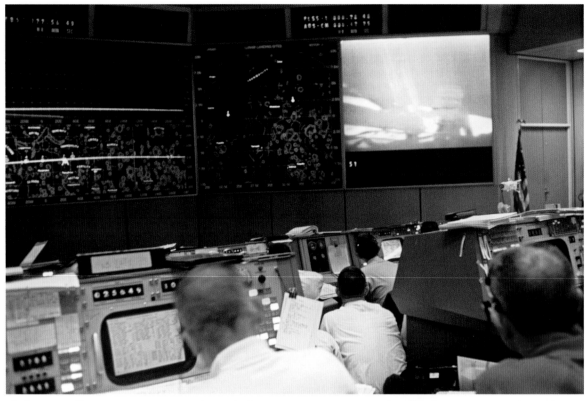

Flight controllers in Mission Control watch the projection TV screen shortly after Armstrong has taken his first steps on the Moon. Astronaut Bruce McCandless (*left*) and Deke Slayton are in the foreground; McCandless served as CAPCOM for the crews' first steps on the surface, and as a space shuttle astronaut would make the first untethered spacewalk in 1984. (NASA).

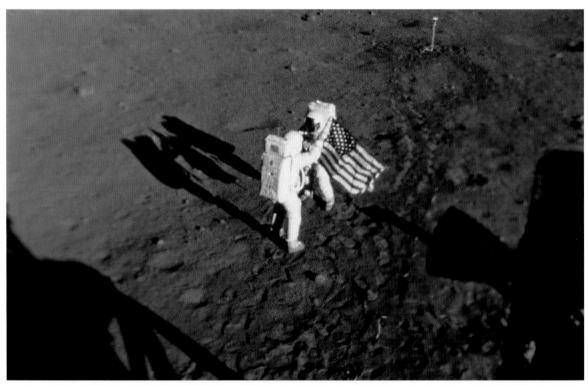

The astronauts set up the U.S. flag northwest of *Eagle*, with the TV camera at upper right, in this frame shot by the Maurer 16mm camera through Aldrin's window. The camera catches an RCS nozzle on cluster no. 4 at right, and the shadow of *Eagle*'s right leg is to the left. (NASA)

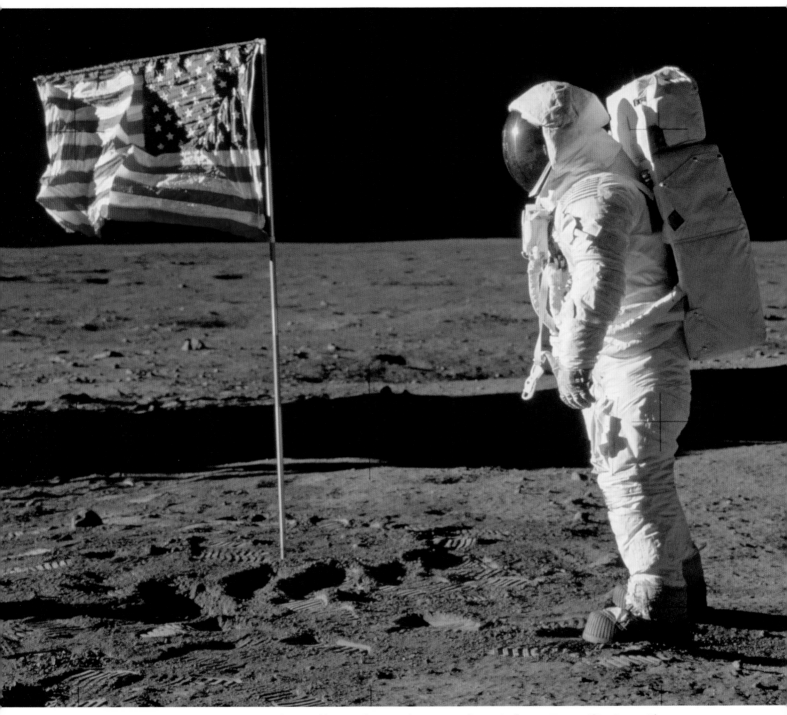

Aldrin with the Sun directly in front of him as he stands next to the U.S. flag at Tranquility Base. Aldrin's face is visible as he looks back at Armstrong taking the photo. The suit helmet had two visors, one covered with a thermal control coating and the other with a gold optical coating. It also had two side sunshields that could be raised and lowered independently. (NASA)

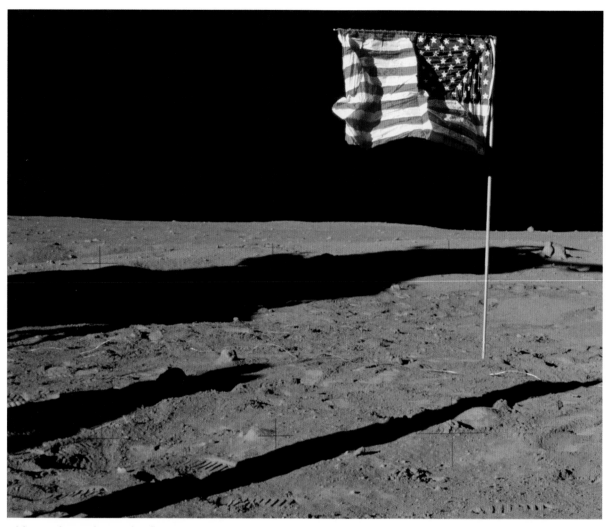

Aldrin's photo shows the flag, the camera video cable below it, and boulders on a ridge in the background. (NASA)

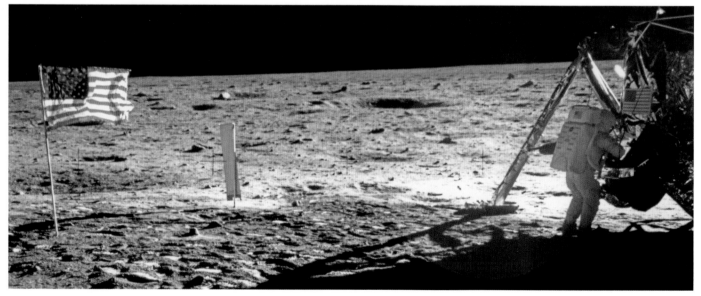

Armstrong took most of the photographs during the historic moonwalk; this is the only good picture of him on the lunar surface. He works in the shadow of the LM at the Modularized Equipment Stowage Assembly. The flag and Solar Wind Composition experiment (SWC) are to the left. (NASA)

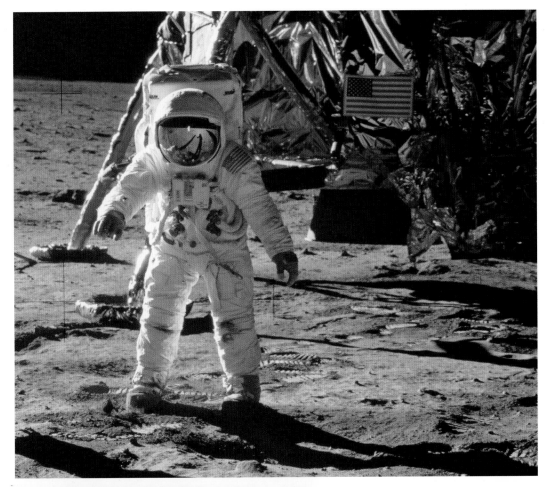

Above: Aldrin with the LM behind him shortly after he has deployed the SWC. If the photo is enlarged, Armstrong can be seen reflected in Aldrin's visor. Visible on the front of Aldrin's suit are his PLSS Remote Control Unit and camera bracket. (NASA)

Left: Close-up of the north footpad of *Eagle* taken while Aldrin was inspecting the vehicle. The half-buried landing contact probe is clearly visible. (NASA)

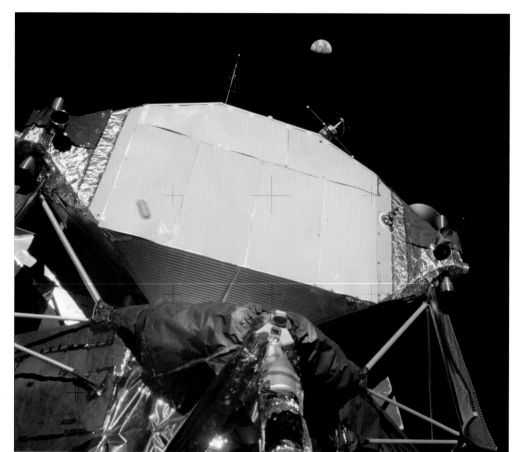

Right: The Earth is seen in the lunar sky above the ascent stage of the LM. (NASA)

Below: Armstrong took this photo during his return from the rim of little West Crater about 160 feet to the east, with the flag, SWC, and TV camera to the right of *Eagle*. Aldrin is behind the LM. (NASA)

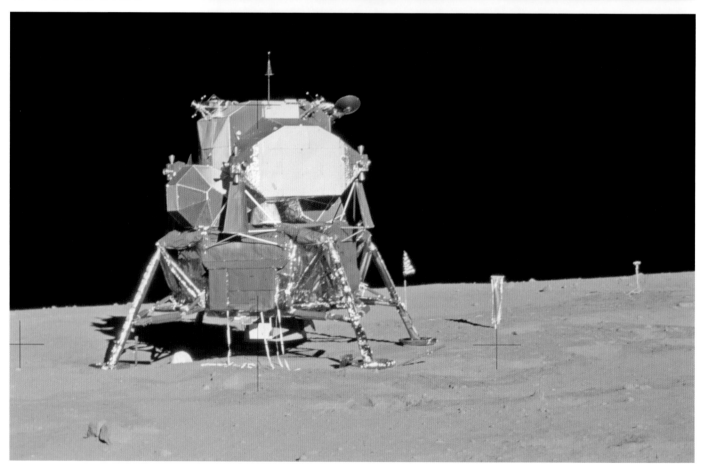

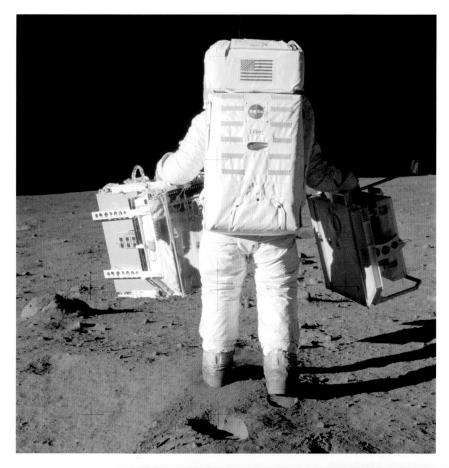

Left: Aldrin moves toward a position to deploy two components of the Early Apollo Surface Experiments Package. The Passive Seismic Experiment Package (PSEP) is in his left hand; he carries the Laser Ranging Retro-Reflector in his right. The PSEP was a 100-pound solar-powered seismic station with its own transmitter designed to detect very slight motions of the lunar crust. (NASA)

Below: Aldrin deploys the Passive Seismic Experiment Package. The PSEP, built by Bendix Aerospace, would fail after twenty-one days. (NASA)

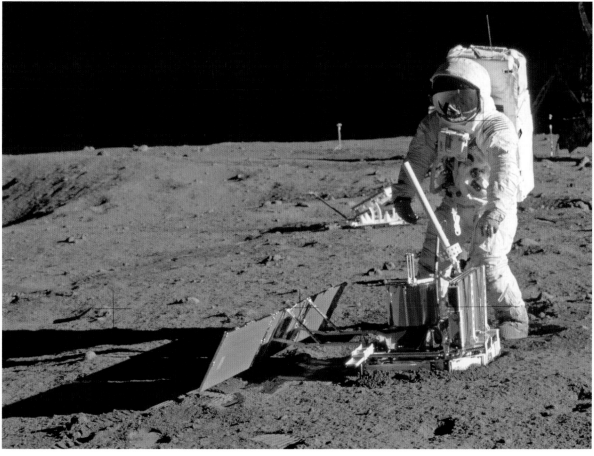

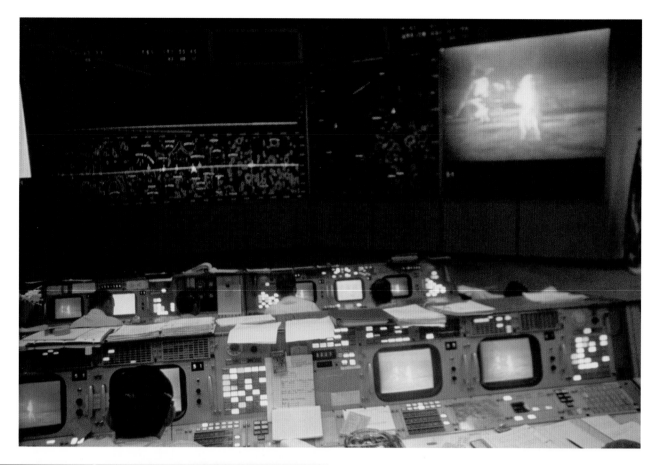

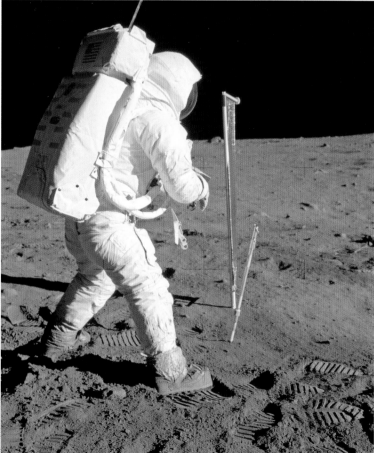

Above: Flight controllers monitor the mission's EVA, shown on the rear-projection TV screen. The activity lasted 2 hours and 36 minutes. The plot board at left depicts the landing site on a lunar chart. (NASA)

Left: Aldrin prepares to take a core-tube sample, with the SWC experiment in front of him. (NASA)

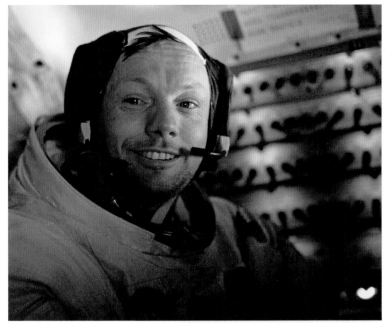

Left: Aldrin took this picture of his commander in the cabin after the completion of the EVA. Armstrong has his helmet off but has not yet doffed his "Snoopy cap." The circuit breaker panels are illuminated, and a small floodlight is on at lower right. A circuit breaker chart has been taped below the rendezvous window in the cabin roof. (NASA)

Below: *Eagle*'s shadow contrasts with the stark lunar surface in this photograph taken through Armstrong's window. Impressions in the lunar surface made by the boots of the two astronauts are clearly visible. (NASA)

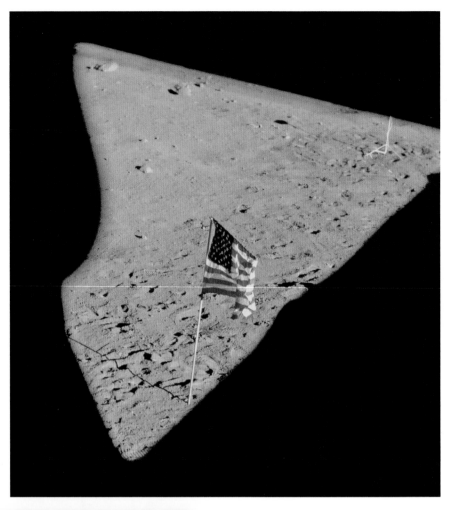

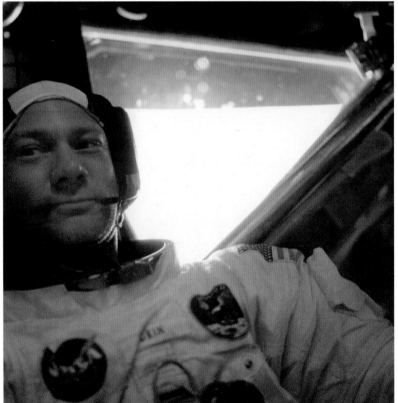

Above: View of lunar surface through a lunar module window, with the U.S. flag and part of the TV camera visible. Note that from Armstrong's side of the cabin, the horizon beyond the TV camera is cut off by the top of Aldrin's window. (NASA)

Left: Aldrin at his flight station aboard *Eagle* after the EVA has been completed. The bright lunar surface and horizon are visible through his front window. (NASA)

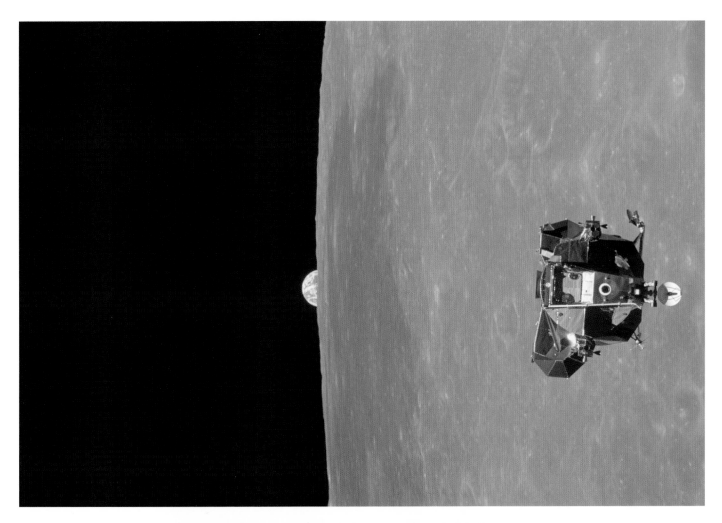

Above: Collins photographs the LM ascent stage as it approaches the CM. The Earth also appears on the horizon. Collins later remarked that everyone he knew was in this one photo. (NASA)

Right: The LM ascent stage station-keeping prior to rejoining the CM. Collins reported feeling a six- to eight-second gyration from the capture latches as the two spacecraft docked. No further problems were noted. (NASA)

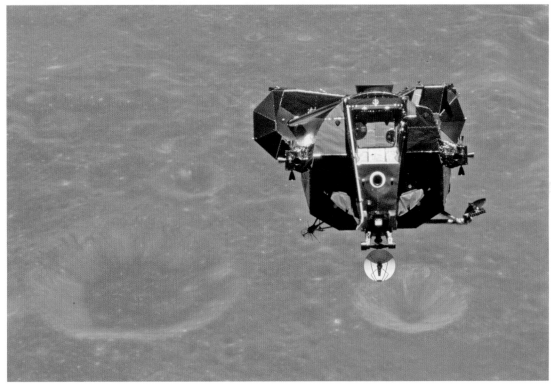

Jan Armstrong speaks with reporters in front of her home in El Lago on July 20 after the Moon landing. It was not an easy time for the wives back home during the two days their husbands were on the lunar surface. (AP)

Joan Aldrin speaks with reporters on July 21 after the LM had safely re-docked with the CM in lunar orbit. (Photo by Tiziou News Service)

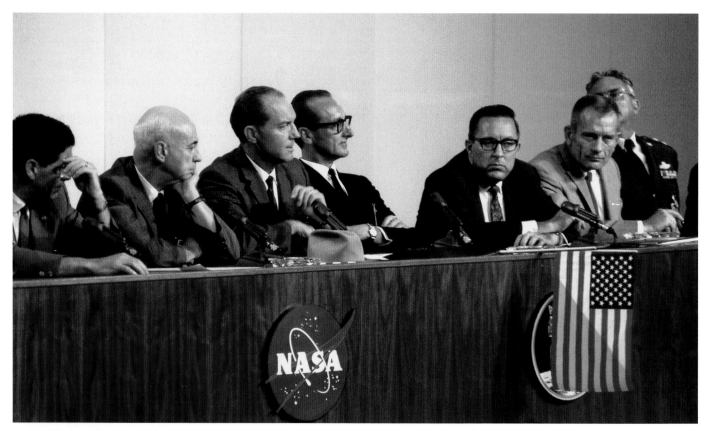

A U.S. flag is proudly displayed at a news conference at MSC's Building 2 after *Eagle* had lifted off from the lunar surface on July 21. *Left to right*: Apollo Program Deputy Director George Hage, Dr. Robert Gilruth, Lt. Gen. Sam Phillips, George Mueller, Dr. Charles Berry, Deke Slayton, and Gen. David M. Jones, Commander of the Air Force Eastern Test Range, Patrick AFB and Cape Kennedy AFS. (Photo by Tiziou News Service)

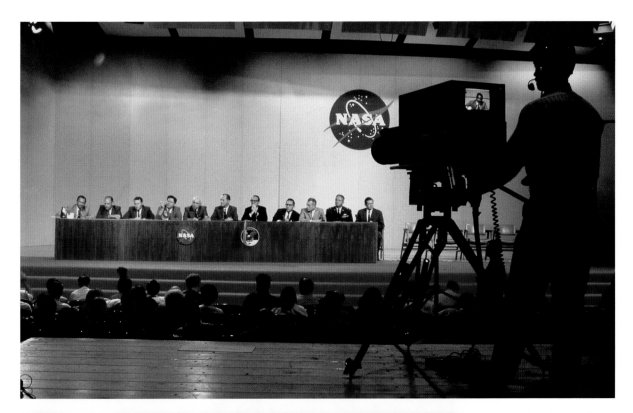

Above: The three television networks provided live coverage of the July 21 news conference at MSC with key Apollo program officials, which was delayed five minutes so that the color television cameras could warm up. (Photo by Tiziou News Service)

Left: Lt. Gen. Sam Phillips, Dr. Wernher von Braun, and Dr. Robert Gilruth (*left to right*) confer at MSC in Building 2 after the news conference on July 21. Von Braun retired from NASA in May 1972 after serving at NASA Headquarters as deputy associate administrator for planning following the Moon landing. (Photo by Tiziou News Service)

Right: "The men and equipment that are Apollo 11 have performed to perfection," Phillips said at the news conference. "Perfection is not too strong a word." He would return to the USAF in September as commander of the Space and Missile Systems Organization of the Air Force Systems Command in Los Angeles. (Photo by Tiziou News Service)

MSC Director Gilruth speaks with Voice of America anchor Barnwell Rhett Turnip-seed III (air name Rhett Turner) after the news conference. Gilruth was inducted into the International Space Hall of Fame in 1969 and served as MSC director until his retirement in 1972. Turnipseed was the primary VOA broadcaster from Mercury through Apollo; the Voice received a 1969 Peabody Award for radio promotion of international understanding, in part for its Apollo 11 coverage. (Photo by Tiziou News Service)

Above: Details of the flight were eagerly devoured; the *News Citizen* was a local Houston-area newspaper. (Photo by Tiziou News Service)

Left: The *Houston Post*, one of the city's two major daily papers, was a major source of information in "Space City" as the Apollo 11 crew headed home. (Photo by Tiziou News Service)

9

Safe Return

In the early morning of July 24, just more than eight days after launch, *Columbia* splashed down in the North Pacific Ocean, about 230 miles south of Johnston Island. Divers from the aircraft carrier USS *Hornet* arrived quickly and tossed three biological isolation garments into the spacecraft to guard against any space-borne pathogens. An hour after splashdown the astronauts were inside the Mobile Quarantine Facility (MQF) aboard USS *Hornet* and participated in a brief ceremony with President Nixon.

The nation—and the world—celebrated, as the goal of landing humans on the Moon had been accomplished. The astronauts, however, would not be personally feted for another three weeks, confined in quarantine until fears of Moon germs were extinguished.

The precious lunar rock and soil samples were rushed back to Houston on July 26 for analysis. The astronauts arrived a day later to be reunited with their families, albeit through a glass window and phone hookup. The next two weeks would be spent recounting their experiences for NASA debriefing teams.

The astronauts were able to breathe fresh air again on August 10 when they were released into the hot Houston evening and the arms of their families.

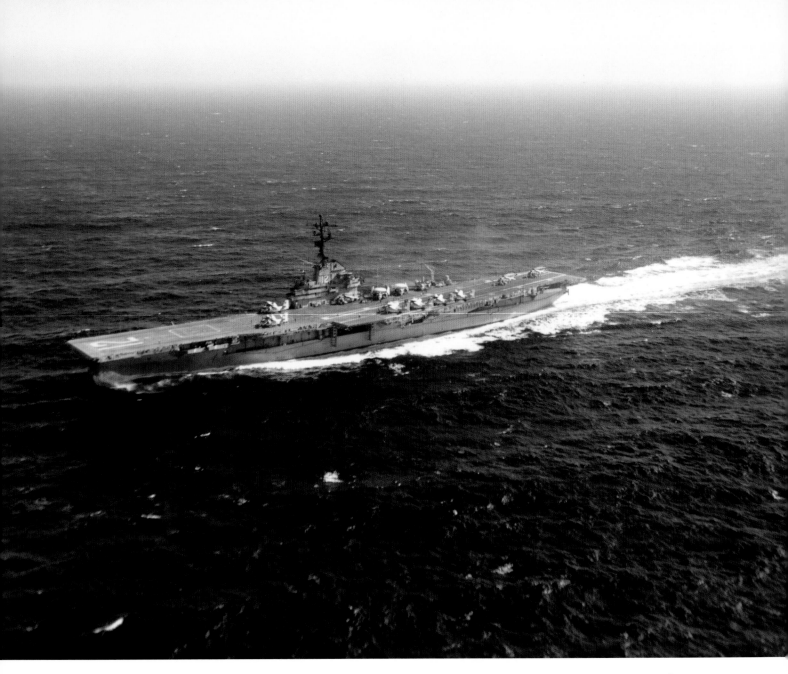

Above: Aerial view of USS *Hornet* on station for the Apollo 11 recovery. *Hornet* was commissioned in November 1943 and played a major part in the Pacific battles of World War II. It also served as the primary recovery ship for Apollo 12. The ship was decommissioned in 1970. (NASA)

Facing page top: The CM hurtles through the atmosphere while shedding flaming pieces of its protective ablative covering on July 24. The material on the aft heat shield is vaporizing and burning away, thus protecting the interior of the spacecraft from the searing heat. (NASA)

Facing page bottom: A helicopter hovers over *Columbia* after it splashed down in the North Pacific Ocean at 12:50 p.m. on July 24. The spacecraft landed right side up, then flipped upside down due to the ocean waves. Floatation bags returned the spacecraft right side up in under 8 seconds. (NASA)

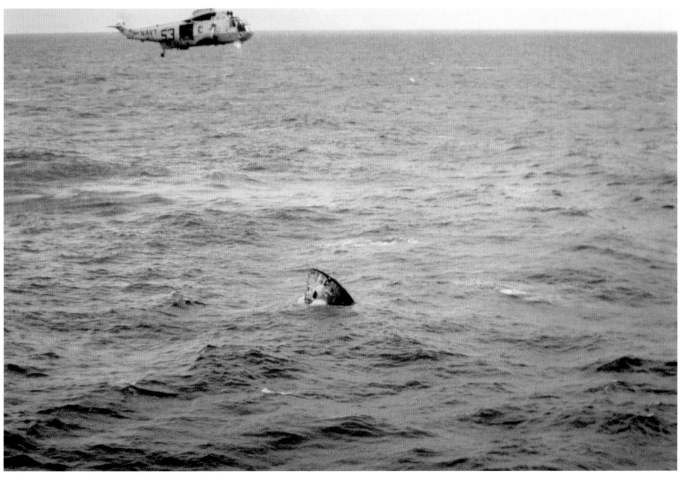

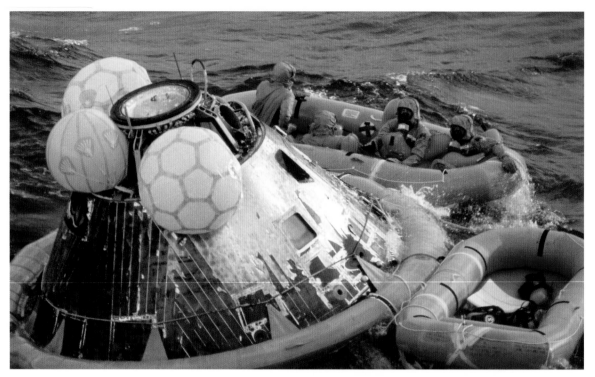

The astronauts donned their biological isolation garments inside *Columbia*, then crawled into a waiting raft. They and the spacecraft were then scrubbed down with disinfectant with the help of Navy Lt. Clancy Hatleberger, seen on the left. (NASA)

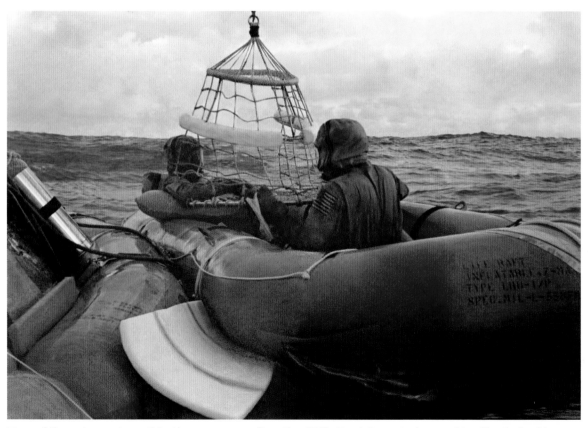

Two of the astronauts wait in the recovery raft as the "Billy Pugh" net is dropped in. Sharks had been a nuisance for swimmers the previous week during recovery training, but none were spotted during the actual recovery. (NASA)

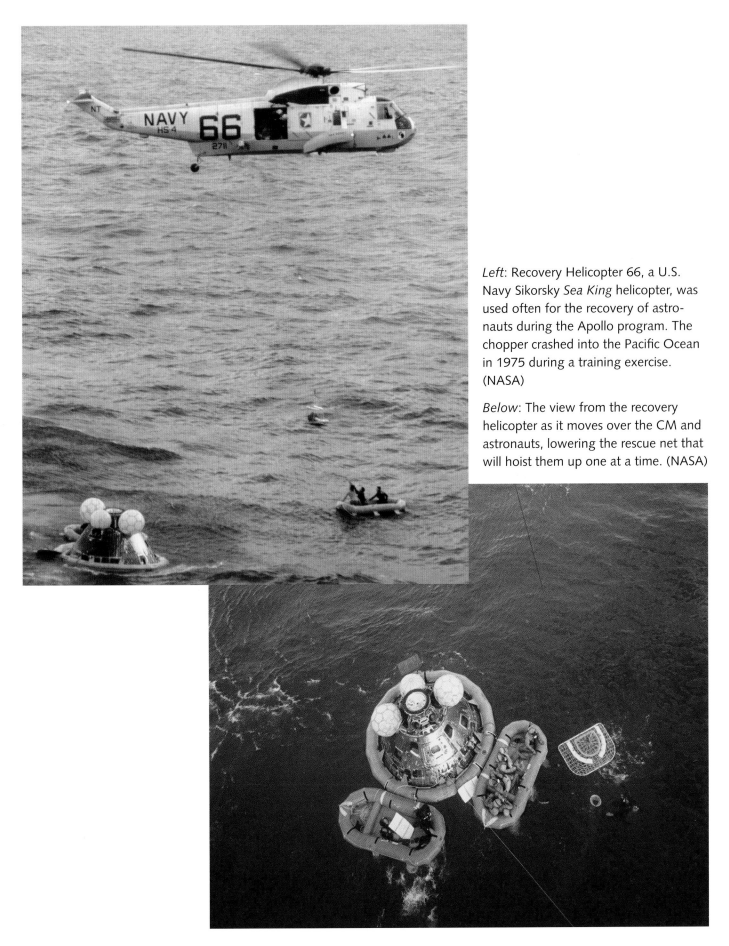

Left: Recovery Helicopter 66, a U.S. Navy Sikorsky *Sea King* helicopter, was used often for the recovery of astronauts during the Apollo program. The chopper crashed into the Pacific Ocean in 1975 during a training exercise. (NASA)

Below: The view from the recovery helicopter as it moves over the CM and astronauts, lowering the rescue net that will hoist them up one at a time. (NASA)

President Richard Nixon watches recovery operations aboard USS *Hornet*. He is accompanied by Henry Kissinger (*left*), secretary of state; Thomas Paine (*center*), NASA administrator; and Adm. John McCain, commander-in-chief, Pacific Command. (NASA)

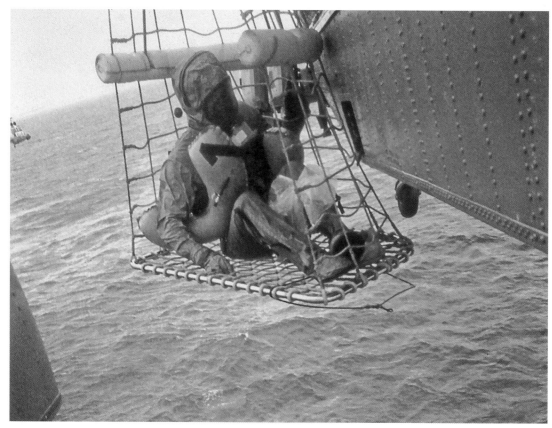

Front view of Armstrong in recovery net. All three astronauts were aboard the helicopter 1 hour and 5 minutes after splashdown. (NASA)

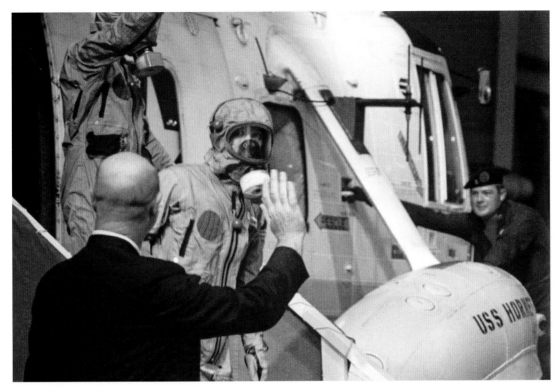

Left: The crewmen wave as they exit the recovery helicopter aboard *Hornet* after a two-minute ride from the splashdown point. The helicopter landed on the main deck of *Hornet* and then was lowered by elevator to the hangar deck, where the astronauts emerged. (NASA)

Below: Aldrin (*left*) and Armstrong wave after exiting the helicopter as Collins nears the door to the Mobile Quarantine Facility (MQF) (NASA)

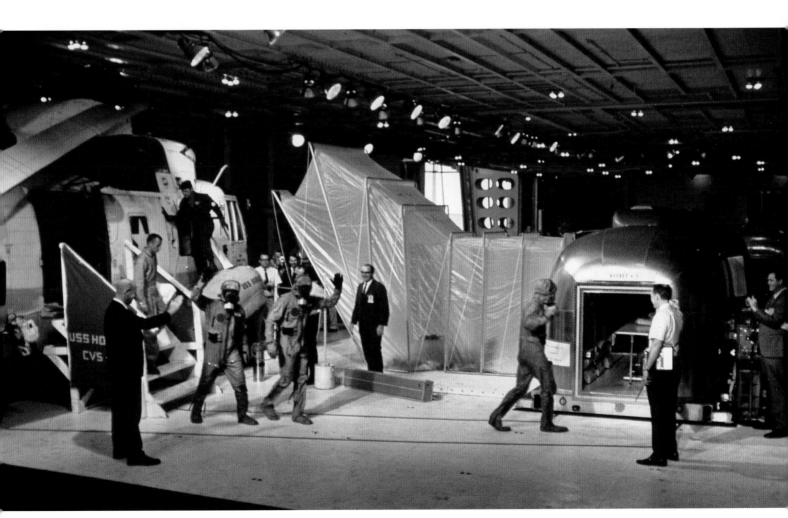

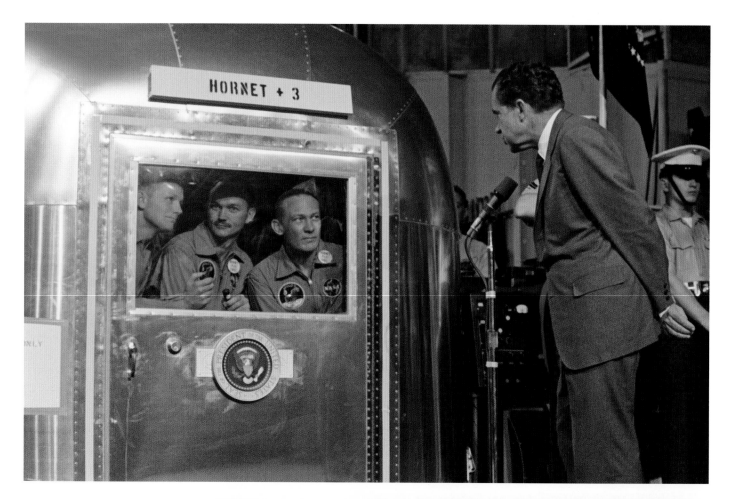

Above: Armstrong, Aldrin, and Collins listen to President Nixon aboard the *Hornet* on July 24. He told the astronauts that "this is the greatest week in the history of the world since creation." Navy regulations did not allow the first lady aboard; she stayed in Honolulu. The presidential seal covers the American Standard plate on the MQF door (American Standard supplied plumbing for the MQF). (NASA)

Right: Armstrong, Collins, and Aldrin (*left to right*) inside the MQF, which provided self-contained living accommodations for six people after recovery and during transportation by ship, aircraft, and truck to Houston, Texas. (NASA)

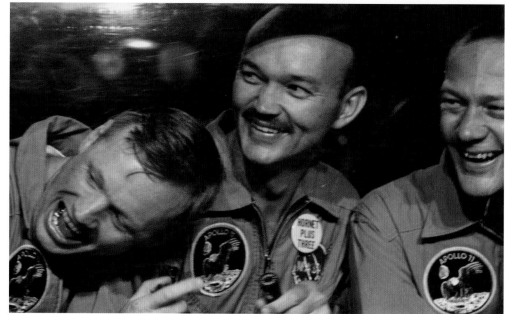

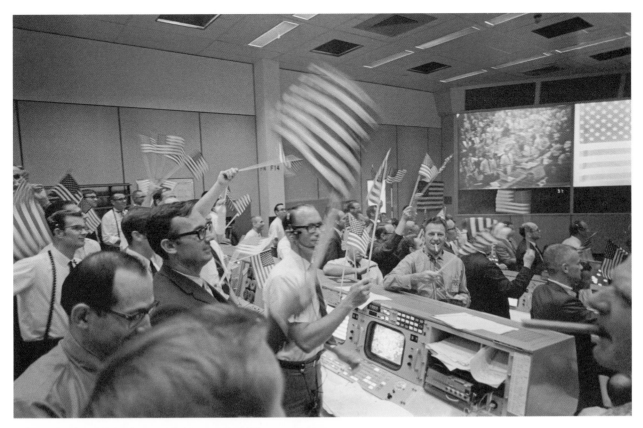

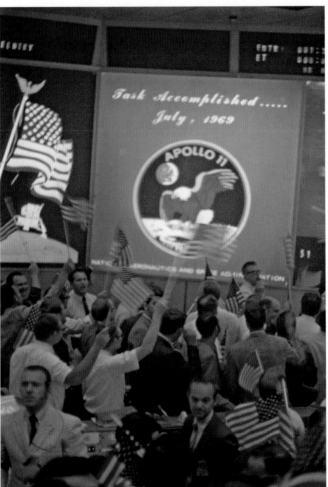

Above: Members of the flight control team at Mission Control in Houston wave U.S. flags and light up cigars at the successful conclusion of the mission on July 24. (NASA)

Left: The Mission Control Center is a scene of jubilation after the astronauts are safely recovered. A screen at the front of the room reads, "Task Accomplished . . . July, 1969," referencing President John Kennedy's pledge to put a man on the Moon by the end of the decade. MSC Director Robert Gilruth declared, "We here at the MSC have a feeling of elation and relief, and we are supremely happy." As the flight control room for the first manned Moon landing, Mission Operations Control Room 2 was designated a National Historic Landmark in 1985 and reconfigured to its July 1969 appearance. (NASA)

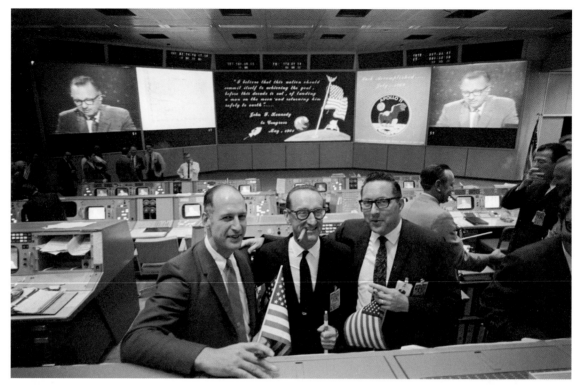

George Low, Dr. George Mueller, and Dr. Charles Berry (*left to right*) in the MCC after splashdown. CBS News coverage of Apollo 11 with anchor Walter Cronkite is on the screens at the front of the control room. (NASA)

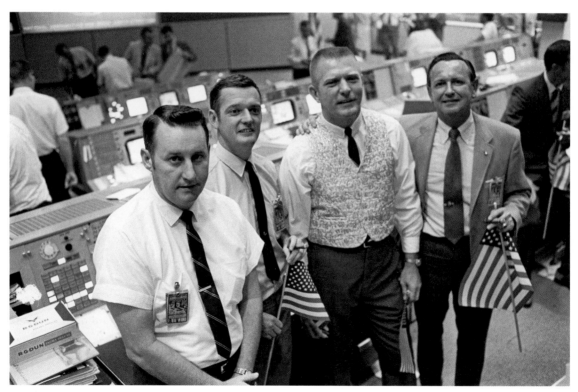

In Mission Operations Control Room 2 after recovery, NASA officials celebrate at the flight director's console. *Left to right*: The mission's three flight directors, Cliff Charlesworth (Green Team, launch and EVA), Glynn Lunney (Black Team, lunar ascent), and Gene Kranz (White Team, lunar landing), and MSC Director of Flight Operations Chris Kraft. (NASA)

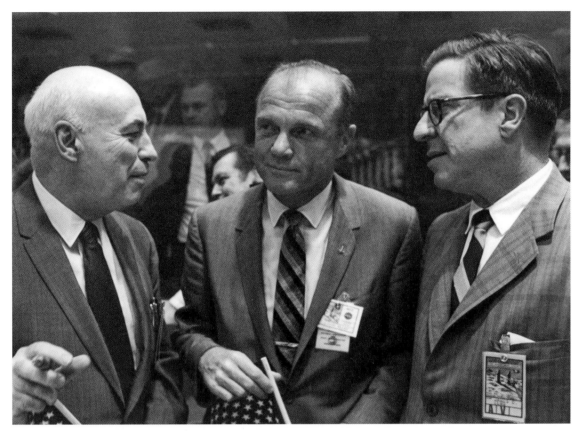

Gilruth, former astronaut John Glenn, and MSC Deputy Director James Elms (*left to right*) celebrate in Mission Control on July 24. (NASA)

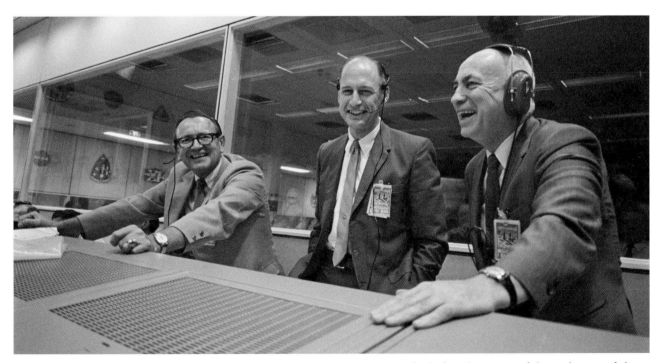

Dr. Chris Kraft, George Low, and Gilruth (*left to right*) are the picture of relief at the successful conclusion of the flight. (NASA)

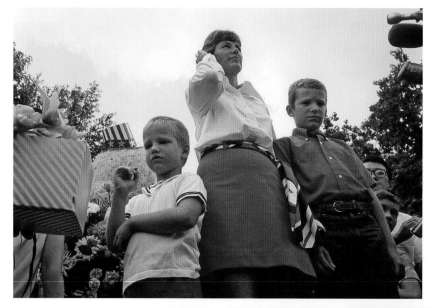

Jan Armstrong is joined by sons Mark (*right*) and Rick in front of their El Lago home following splashdown. The floral creation is a Moon made of yellow mums. Mrs. Armstrong described the mission as "out of this world." (Photo by Tiziou News Service)

Pat Collins with daughters Kathleen and Ann speak with reporters in front of their home in Nassau Bay following splashdown. (Photo by Tiziou News Service)

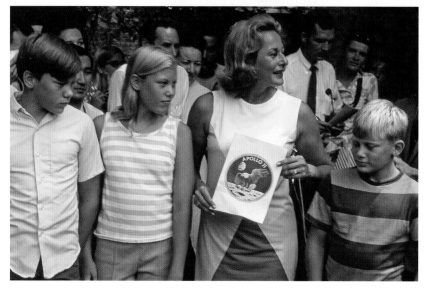

Joan Aldrin answers questions from reporters following safe recovery of the astronauts. She is joined by children Michael, Jan, and Andy. (Photo by Tiziou News Service)

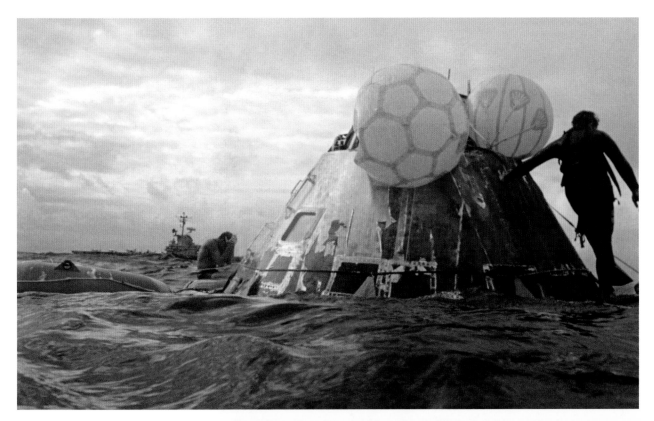

Above: The carrier *Hornet* is in the background as the CM is towed in for recovery. Two of the three flotation bags are clearly visible. (NASA)

Right: *Columbia* is brought aboard USS *Hornet*. The CM weight at splashdown was 10,873 pounds, about 1,300 pounds lighter than at liftoff. (NASA)

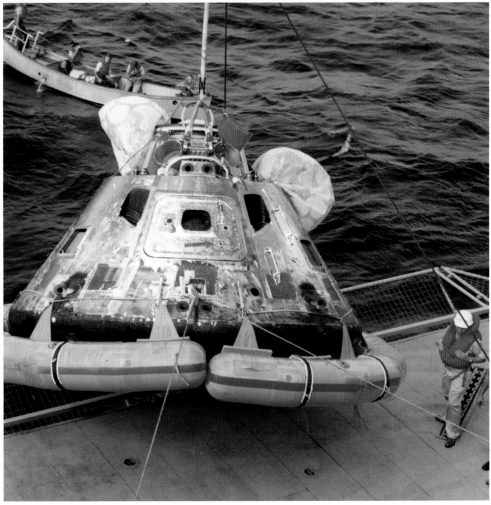

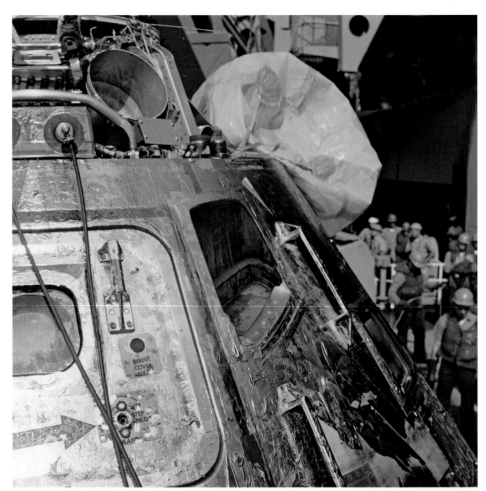

Top: The gold Mylar foil on *Columbia*'s hatch (aboard USS *Hornet*) is peeling, revealing the honeycomb structure of the heat protective ablative material covering the CM. An EVA handhold is at upper right. In an emergency, a large hex-key wrench opened the hatch, using the fitting at lower left. A deflated flotation bag is in upper center. (NASA)

Bottom: This image taken aboard USS *Hornet* provides a close-up view of the CM's Earth Landing System. The large canister-like structures are the two drogue mortar cans. Each one housed a drogue parachute that oriented and slowed the spacecraft when it was at 24,000 feet prior to splashdown. (NASA)

Facing page: *Columbia* is towed on a dolly from *Hornet*'s carrier deck before being lowered to the hangar deck. The spacecraft had just completed a voyage of 828,743 nautical miles. (NASA)

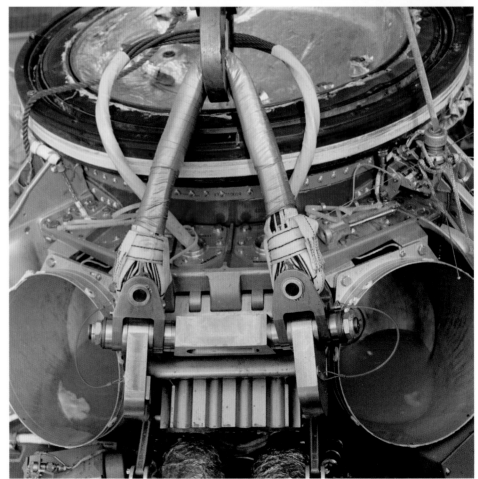

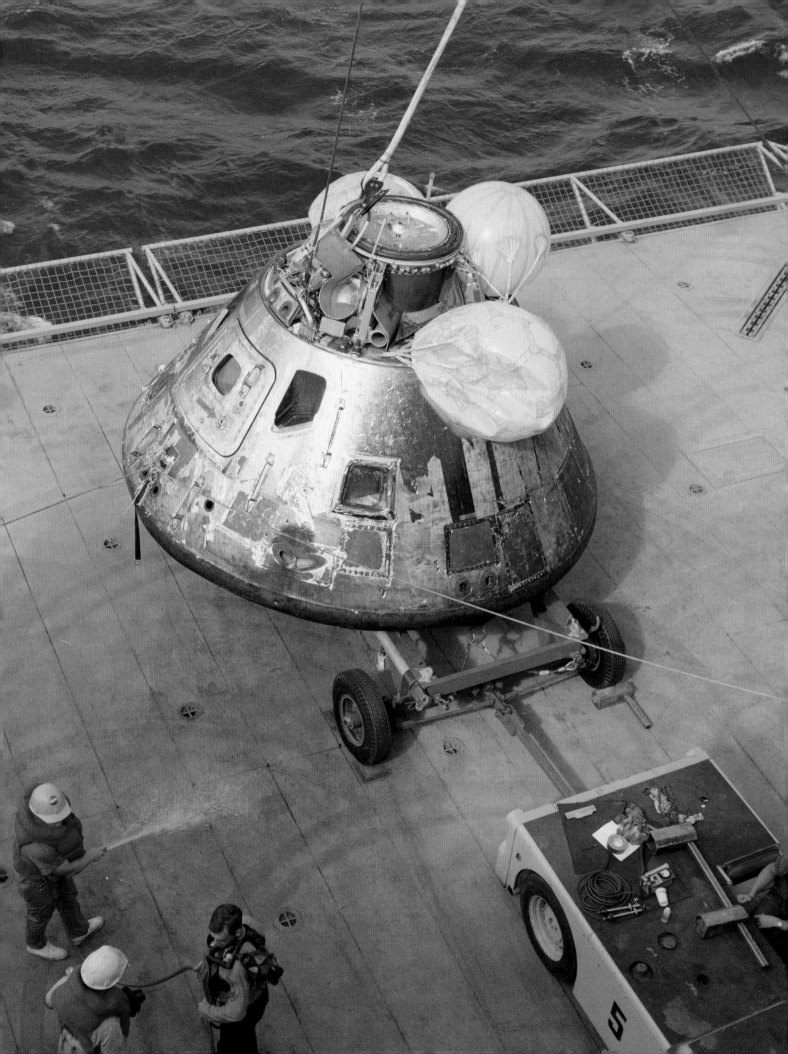

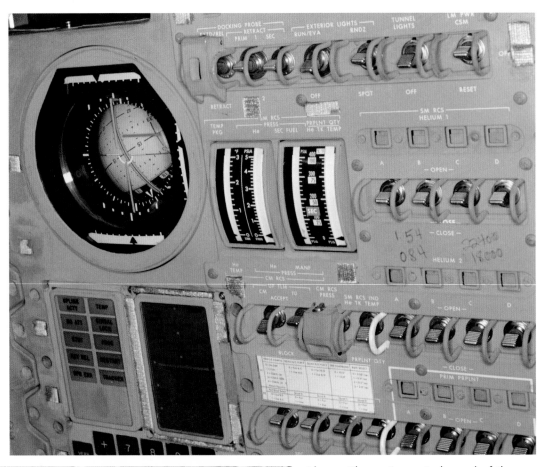

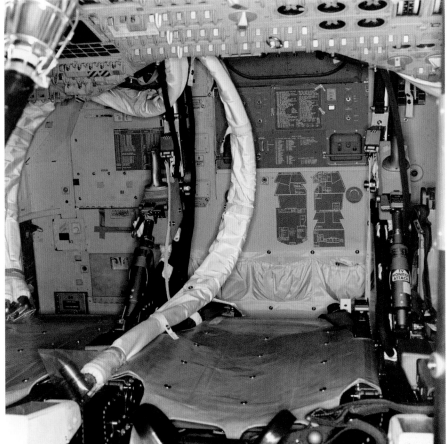

Above: The main control panel of the CM is photographed after being brought aboard USS *Hornet* on July 24. Some hand-written figures can be seen on the center-right portion of the panel. (NASA)

Left: View through the main hatch of the CM aboard *Hornet* on July 24. NASA recovery technician John Hirasaki reported that the interior had a "gunpowder"-like odor. He had not noticed this in the other CMs he had worked with at recovery, and he believed lunar dust in the cabin was the source. (NASA)

Right: Side view of *Columbia* aboard USS *Hornet*. A deflated flotation bag is on left. On the right, covering the hatch, is the transfer tunnel, which leads to the MQF. (NASA)

Below: Wide view of the Mobile Quarantine Facility and transfer tunnel to the CM on *Hornet*'s hangar deck late in the day on July 24. The MQF was equipped with a dining area, galley, bedrooms and shower. (NASA)

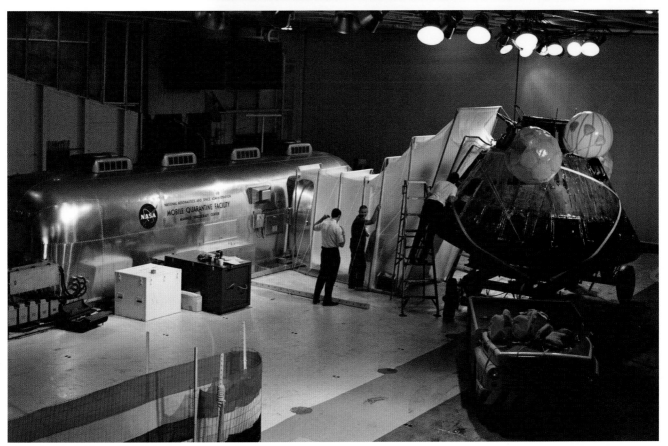

Above: A technician aboard USS *Hornet* holds an ID card for photo documentation purposes. Much of the Mylar covering on the outer skin of the CM has burned off during re-entry. Every inch of the CM was photographed after each Apollo mission as part of the post-flight activities. (NASA)

Left: A technician (in protective gear) deactivates *Columbia* on Ford Island, Hawaii. CM pyrotechnic devices were deactivated, and residual propellants were removed from the reaction control system (RCS). The CM was then flown to Ellington AFB on a C-133 *Cargomaster* aircraft. (NASA)

Armstrong relaxes by playing the ukulele inside the MQF on July 24. Each astronaut slept for eight or nine hours on their first night aboard the *Hornet*, and they reported awakening very relaxed. (NASA)

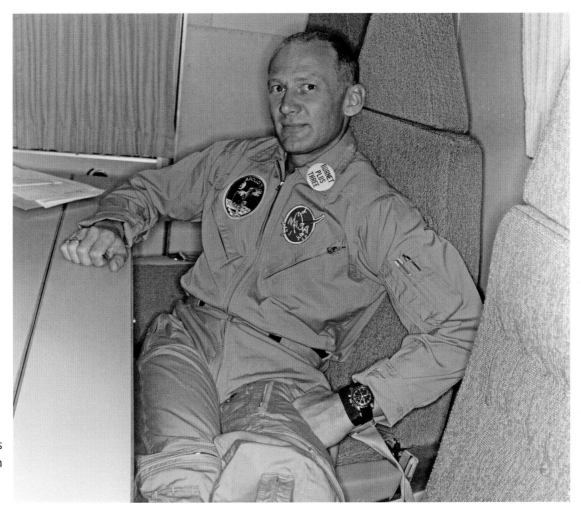

Aldrin takes it easy in one of the aircraft seats installed in the MQF, a converted thirty-two-foot Airstream trailer, one of four built for Apollo. This trailer is on display at the Smithsonian's National Air and Space Museum's Udvar-Hazy annex in suburban Washington, D.C. (NASA)

Above: Aldrin presides over a reenlistment ceremony from within the MQF for four sailors aboard USS *Hornet* on July 26. (NASA)

Right: The first box of lunar samples arrives at the Lunar Receiving Laboratory (LRL) at MSC at 7:50 a.m. (CT) on July 26, 1969, more than a day earlier than the returning astronauts. Dr. Charles Berry, Dr. Bill Kemerer, and Ben Wooley (*left to right*) watch over the just-delivered rock box (*on right*) as well as a box containing film exposed on the mission. The LRL was a facility at MSC (Building 37) that was built specifically to quarantine astronauts and material brought back from the Moon. (NASA)

The Apollo Lunar Sample Return Containers or "rock boxes" were designed and manufactured by the Union Carbide facility in Oak Ridge, Tennessee. Made of aluminum, they were equipped with a triple seal and weighed 13 pounds each. Their primary function was to preserve a lunar-like vacuum around the samples and protect them from any shocks during the return flight to Earth. Prior to flight, each box was loaded with sample container bags and stowed in the Modularized Equipment Stowage Assembly aboard *Eagle*. (NASA)

The first of the rock boxes weighed in at 33.35 pounds and was opened on July 26 inside a vacuum cabinet at the quarantined LRL laboratory. The elaborate procedures were intended to prevent any Moon microbes that might have been brought back from escaping. Most scientists did not expect to find any life in the samples, but the space agency was not taking any chances. The box also contained foil from the solar wind experiment and two lunar soil core samples. (NASA)

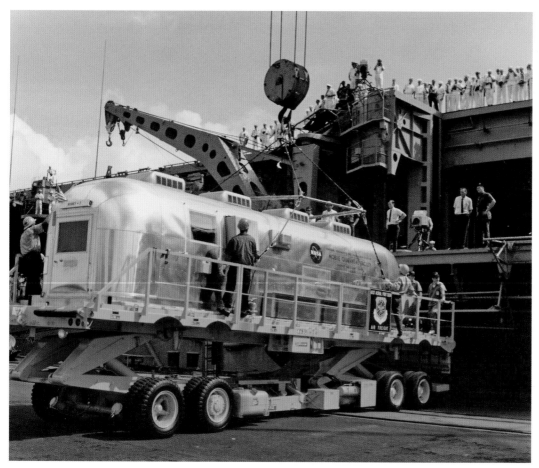

Left: The MQF with the crew aboard is off-loaded by crane from USS *Hornet* at Pearl Harbor, Hawaii, on July 26. The trailer was then trucked to Hawaii's Hickam Field and loaded aboard a C-141 *Star- lifter* cargo aircraft for the 3,800-mile trip to Hous- ton. (NASA)

Below: The MQF is moved ashore on July 26 in Hawaii, where the astro- nauts are greeted with a ceremony attended by an estimated 12,000 Hawai- ians. This was the first time the astronauts had been on land since leaving for the Moon. (NASA)

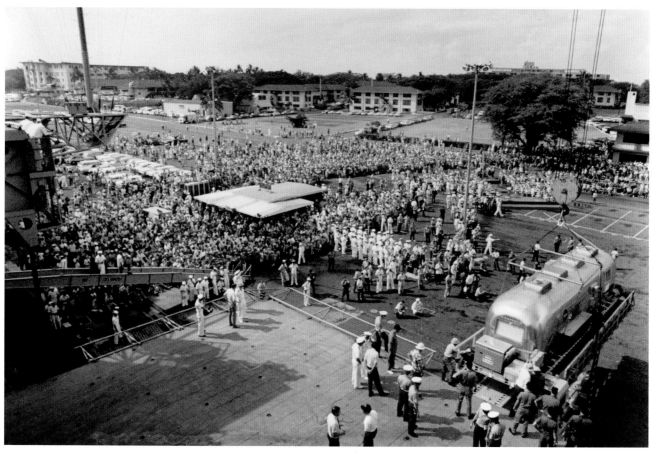

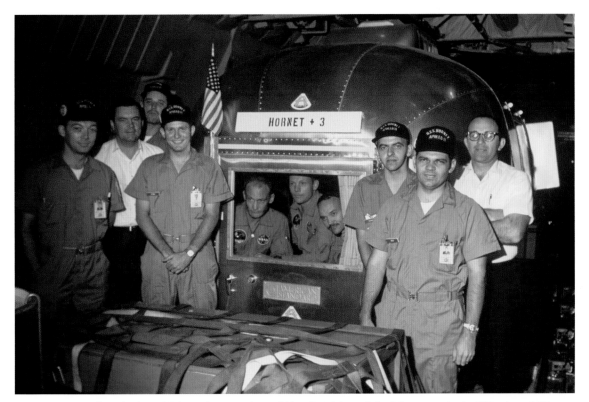

MSC personnel with the MQF and crew aboard the C-141 on July 26, en route to Ellington AFB in Houston. Both in white shirts, NASA Public Affairs Officer Ben James is second from left, and right of the MQF is John Stonesifer, chief of MSC's Landing and Recovery Division in the Recovery Systems Branch. (NASA)

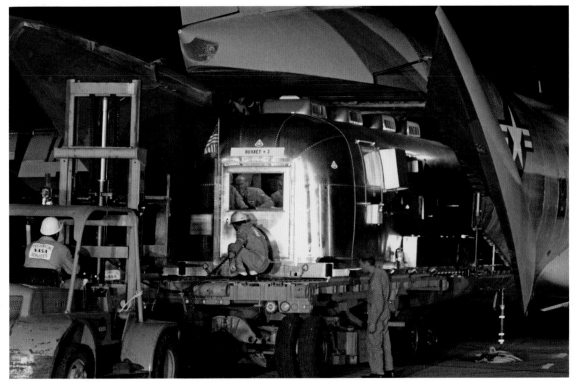

The MQF is unloaded from the C-141 plane at Ellington AFB early in the morning on July 27 and rolled to a stand where the astronauts' families await them. An enthusiastic flag-waving crowd of 6,000 people is on hand to welcome the astronauts home. (NASA)

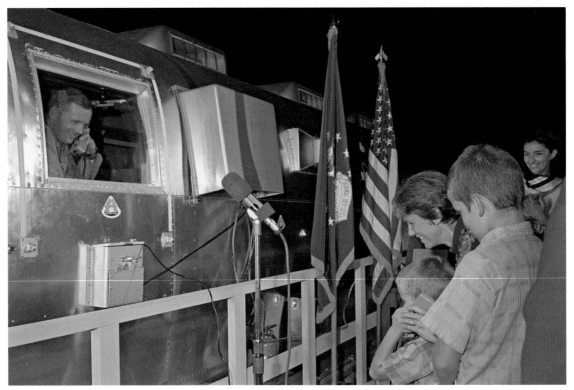

Armstrong speaks with his family on July 27 after arriving at Ellington AFB. Son Mark uses a red phone that allowed the families to converse. Armstrong's wife Jan and son Rick wait their turn to speak. (NASA)

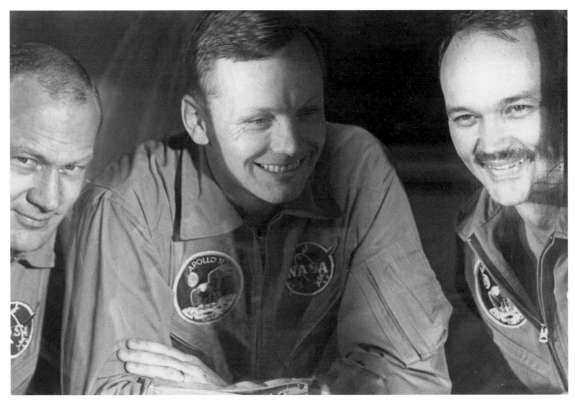

Aldrin, Armstrong, and Collins (*left to right*) look through the window of the MQF on July 27 at Ellington AFB. The MQF was soon trucked from Ellington to MSC, past small groups of people gathered on NASA Road 1 to wave and cheer along the route. (NASA)

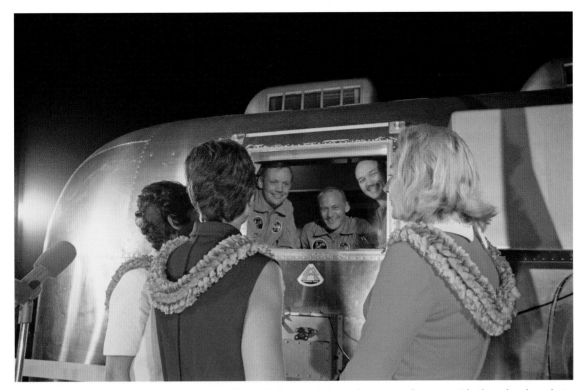

Pat Collins, Jan Armstrong, and Joan Aldrin (*left to right*) exchanging glances with their husbands in the MQF on July 27 before it was sent to the Lunar Receiving Laboratory at MSC. (NASA)

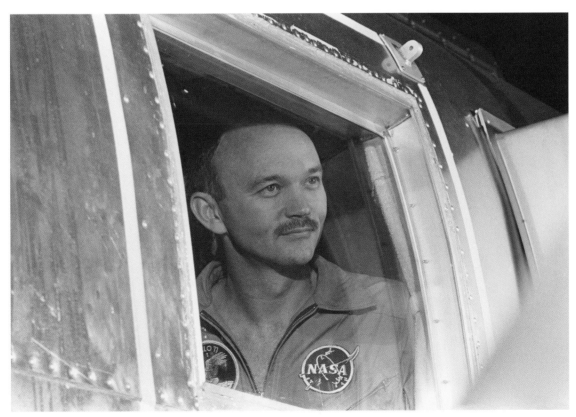

Collins peers through the MQF window on July 27, 1969, sporting his new "Moon moustache." After the exchanges with family and NASA officials at Ellington AFB, the MQF was eventually backed into the LRL in Building 37 at MSC. Arriving at the LRL, the astronauts were so exhausted that all three were asleep in their bedrooms within 30–40 minutes of arrival. (NASA)

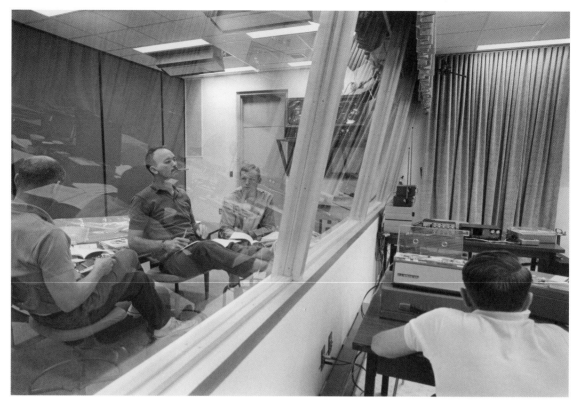

Aldrin, Collins, and Armstrong (*left to right*) in the LRL later on July 27, behind the biological barrier separating the crewmen from the non-quarantined debriefing team at MSC. Collins smokes a cigar. (NASA)

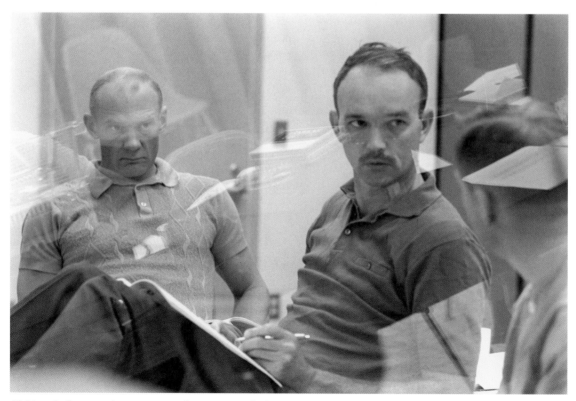

Aldrin, Collins, and Armstrong during post-flight debriefing sessions in LRL on July 27. Aldrin's father, Edwin Aldrin Sr., ridiculed the quarantine procedure, blaming it on "some medicos" and "the long-haired guys." (NASA)

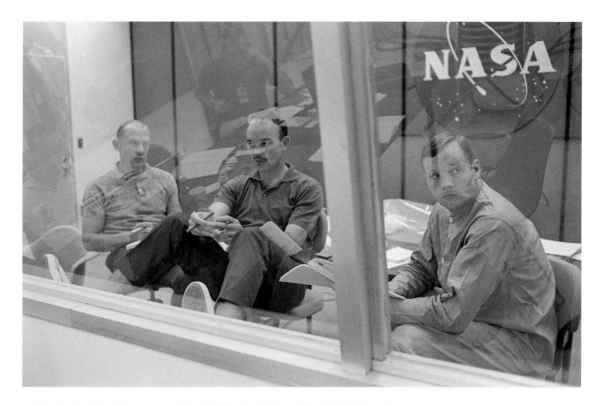

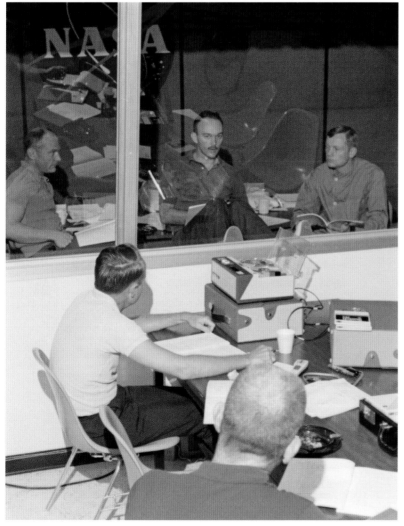

Above: Aldrin, Collins, and Armstrong behind the biological barrier, seen through window of the LRL debriefing area, on July 27. (NASA)

Left: The astronauts spent more than six hours on July 27 participating in debriefing sessions, recording their comments on reel-to-reel audio tapes. (NASA)

Armstrong, Collins, and Aldrin in the LRL mess hall. The LRL was equipped with two microwave ovens and two quartz-plate infrared ovens, cutting-edge cooking techniques at the time. (NASA)

Aldrin, Collins, and Armstrong (*left to right*) at the dining table in the LRL on July 30. (NASA)

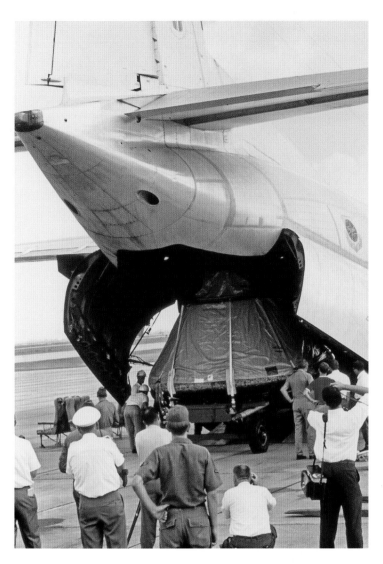

Left: The CM is offloaded from its transport plane after arriving at Ellington AFB in Houston on the afternoon of July 31. It was moved into a special bay inside the LRL that evening. The astronauts were then reunited with the spacecraft and allowed to retrieve personal gear. (Photo by Tiziou News Service)

Below: *Columbia* rolls into the LRL after being transported from Ellington AFB to the MSC on July 31. (Photo by Tiziou News Service)

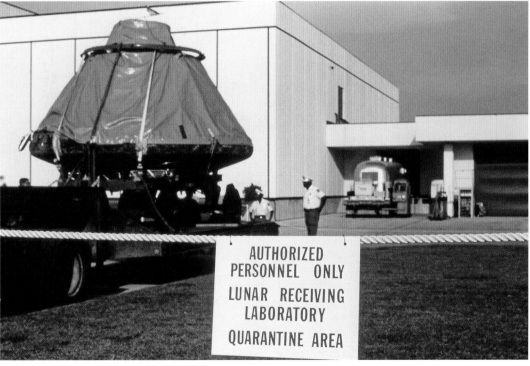

AUTHORIZED
PERSONNEL ONLY
LUNAR RECEIVING
LABORATORY
QUARANTINE AREA

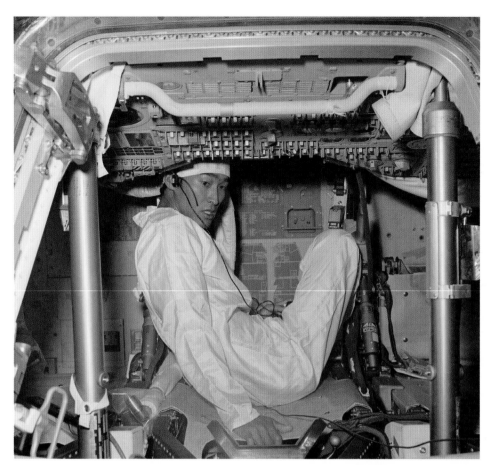

Left: NASA recovery technician John Hirasaki works inside the cramped CM cabin after it had arrived at the LRL. Hirasaki was the son of Japanese immigrants and joined the NASA recovery division in 1966. He was responsible for transferring mission-related equipment from the CM into the LRL. (NASA)

Below left: Collins's space suit photographed and inspected in the LRL. Special attention was paid to excessive fraying found on the left elbow area of the suit, and excessive wear below the U.S. flag on the left shoulder. (NASA)

Below right: Collins revisits his good friend *Columbia* in the LRL on August 5, 1969. At the end of the quarantine the spacecraft was shipped to the North American Rockwell plant in Downey, California, for post-flight evaluation. (NASA)

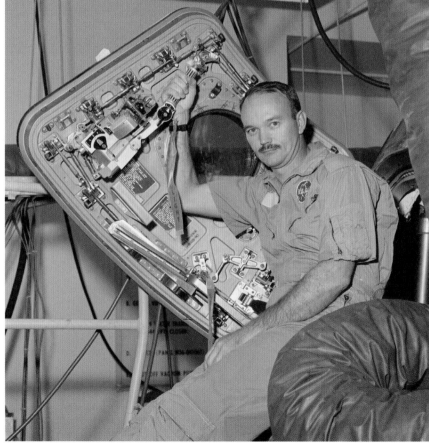

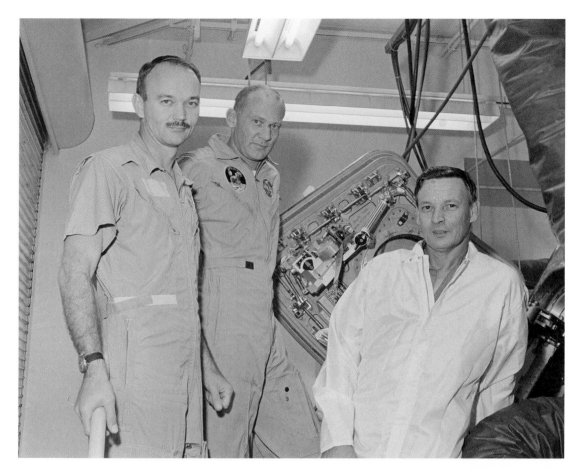

Above: Collins and Aldrin in the LRL next *Columbia*'s hatch with Brown & Root (MSC contractor) technician George Williams. (NASA)

Right: Armstrong, Collins, and Aldrin (*left to right*) review film from their mission while inside the LRL on August 5. The film had been processed at MSC while they were in quarantine. (NASA)

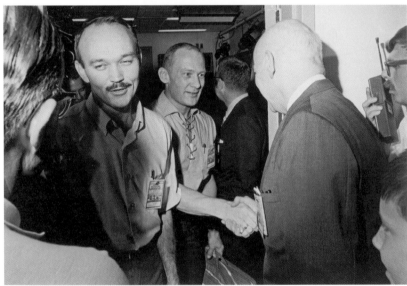

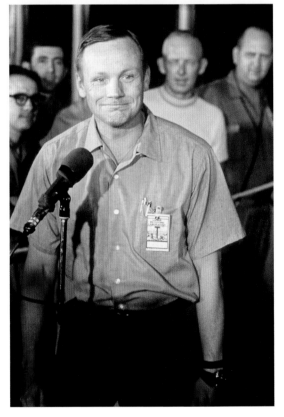

Top: Armstrong speaks to reporters and well-wishers at the end of the quarantine. The Apollo 11 astronauts were released on August 10, 1969, after twenty-one days. They walked out at 9:04 p.m. (CT) and were greeted by 1,500 cheering MSC workers before heading home with their families. (NASA)

Above: Collins and Aldrin (shaking hands with Gilruth) make their way out of the LRL and into a waiting crowd of well-wishers. (NASA)

Right: Armstrong speaks to well-wishers after leaving the LRL. He remarks, "I can't say I would choose to spend a couple of weeks like that, but I am very glad we got the opportunity to complete the mission." (Photo by Tiziou News Service)

Celebrating the Memories

The Apollo 11 mission had been a success, and a nation waited to show its appreciation. The astronauts were treated to a true heroes' welcome on August 13: New York City in the morning, Chicago in the afternoon, and a state dinner in Los Angeles in the evening. The astronauts and their families were getting a taste of their new lives.

President Nixon wanted to share the astronauts and their accomplishment with the world, so he sent them and their wives on a thirty-seven-day "Giant Leap" goodwill tour of twenty-four countries aboard a presidential jet. They were seen by an estimated 100 million people. The trip's logistics made it seem in some ways as difficult to accomplish as the lunar voyage.

The astronauts were reunited with their Apollo 11 spacecraft on July 20, 1970, the first anniversary of the Moon landing. This event would mark the beginning of a tradition that would see Armstrong, Aldrin, and Collins together at KSC or in Washington, D.C., every five years. The reporters' questions had become old hat, but seeing the first men to walk the Moon reunited on a regular basis was a satisfying sight.

Apollo 11's celebrated crew went on to take different paths in the following years.

Neil Armstrong was named deputy associate administrator for aeronautics at NASA Headquarters, but in 1971 he took up teaching aeronautics at the University of Cincinnati. The space program, however, was never far away. After the Space Shuttle *Challenger* accident in 1986, he was named vice chairman of the investigative panel, the Rogers Commission. He also spent time at numerous companies over the years, including Chrysler, Marathon Oil, and Learjet. Armstrong was a private man who tried to stay out of the spotlight; however, in his later years he began participating more in the milestone celebrations of all the Apollo missions.

He underwent bypass surgery in Cincinnati on August 7, 2012, to relieve blocked coronary arteries. He developed complications and died on August 25, 2012. The White House released a statement describing Armstrong as "among the greatest of American heroes—not just of his time, but of all time."

Buzz Aldrin retired from NASA in 1971 and was assigned as the commandant of the U.S. Air Force Test Pilot School at Edwards Air Force Base, California. He retired from active duty in 1972 after twenty-one years of service. The post-NASA world was not an easy one for Aldrin, as he suffered from clinical depression and alcoholism, for both of which he sought and received successful treatment. Aldrin has written several books on his experiences with the space program over the years. He has also become known as a tireless promoter of both human space exploration of Mars and of his own exploits in business and entertainment.

Mike Collins by most appearances led a quieter life than those of his fellow crewmen. He retired from NASA in 1970 and took a job in the Department of State as assistant secretary of state for public affairs. It is hard to keep an astronaut away from planes; Collins subsequently became director of the National Air and Space Museum in Washington, D.C., where he oversaw the construction and opening of its new facility in 1976. Collins held the position until 1978, when he stepped down to become undersecretary of the Smithsonian Institution. In 1980 he took the job as vice president of LTV Aerospace before resigning in 1985 to start his own business. He retired from the U.S. Air Force Reserves with the rank of major general. Today Collins spends time enjoying his love of painting and has become known for his original watercolors.

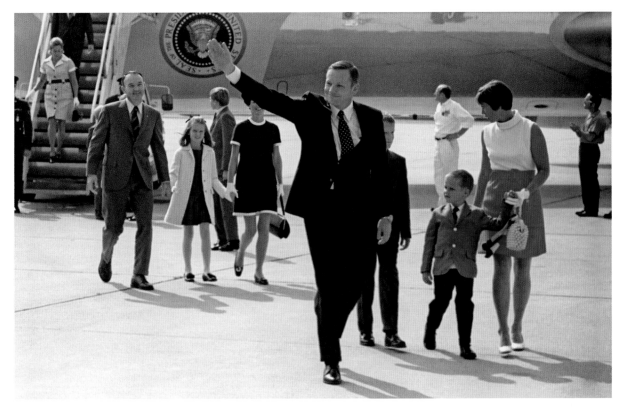

Above: Armstrong waves to onlookers as he and his family debark from Air Force One at Kennedy Airport shortly after arriving in New York City at 9:45 a.m. (ET) on August 13, 1969. The Collins family follows as the Aldrins descend the steps. The astronauts would be honored first in New York City before heading to Chicago for a second round of celebrations. (NASA)

Left: A large banner in New York City on August 13, 1969, welcomes the astronauts. Mayor John Lindsey presented the crewmen with medals of honor during a ceremony attended by 10,000 people outside City Hall. (Photo by Tiziou News Service)

Manhattan showers the Apollo 11 crew with confetti, shredded paper, and ticker tape during a parade up Broadway to Herald Square and then on to Times Square—said to be the largest parade in the city's history, though that is hard to verify. (NASA)

The astronauts made a stop at the United Nations, where they were praised by UN Secretary-General U Thant. Armstrong spoke, addressing the delegates as "distinguished representatives from the planet Earth."

An estimated 2 million people greet the Apollo 11 astronauts in Chicago on the afternoon of August 13. Chicago motor police cordoned off either side of the crew's car during the parade. (NASA)

Collins speaks at a ceremony at the Grant Park band shell in Chicago. Seated behind him are (*left to right*) Sen. Charles Percy (Ill.), Chicago Mayor Richard Daley, Armstrong, NASA Administrator Thomas Paine, and Aldrin. (NASA)

The astronauts and their wives are seated at the head table of a State Dinner on the evening of August 13, 1969, at the Century Plaza Hotel in Los Angeles. The 2.5-hour event was attended by an estimated 1,440 dignitaries, who saw the crewmen receive the Presidential Medal of Freedom after a seven-course dinner. *Left to right*: Joan Aldrin, Collins, Mrs. Agnew, Armstrong, Mrs. Nixon, President Nixon, Jan Armstrong, Vice President Agnew, Pat Collins, and Aldrin. (NASA)

Aldrin, Collins, President Nixon, Armstrong, and Vice President Agnew (*left to right*) at the dinner. Armstrong remarked: "We were very privileged to leave on the Moon a plaque endorsed by you, Mister President, saying it was for all mankind." (NASA)

August 16, 1969, was declared "Astronaut Day" by Houston as the city welcomed the Apollo 11 astronauts back to their homes, and the home of the Manned Spacecraft Center. Armstrong and family ride through downtown Houston in a mid-morning parade. (NASA)

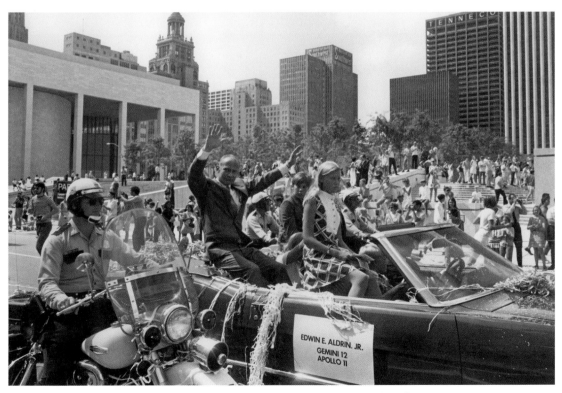

Buzz Aldrin and family ride in an open convertible during the parade. The "Astronaut Day" celebration ended that night with a party at the Astrodome for more than 30,000 space workers. Master of ceremonies was entertainer Frank Sinatra. (NASA)

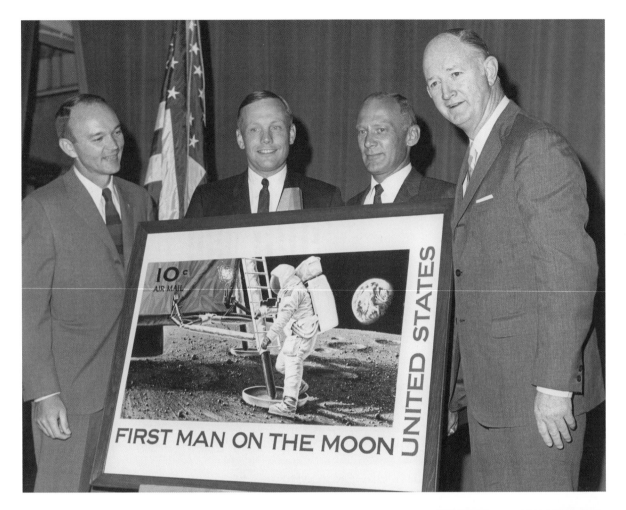

Above: Collins, Armstrong, and Aldrin (*left to right*) meet with U.S. Postmaster General Winton M. Blount Jr. in Washington, D.C., on September 9, 1969, at the issuance of the "First Man on the Moon" postage stamp at the National Postal Forum in Washington, D.C. The largest U.S. stamp released to that day, it was designed by noted space artist Paul Calle and produced using an engraved die that was carried to the Moon onboard *Eagle*. The astronauts were presented with albums containing thirty of the stamps, especially delighting Collins, who claimed to be an "old stamp collector." (NASA)

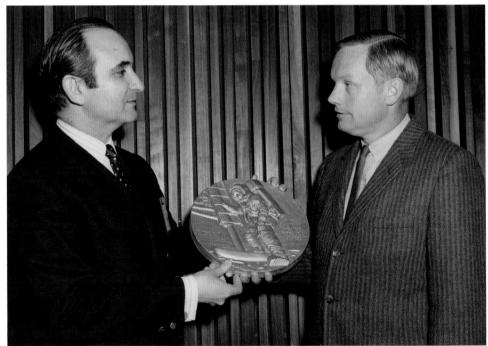

Calle would later show Armstrong a medal he designed after the mission. Elaborating on Calle's "First Man on the Moon" stamp design, with sculpting by Joseph DiLorenzo, the medal was photographed at MSC on January 21, 1970. (NASA)

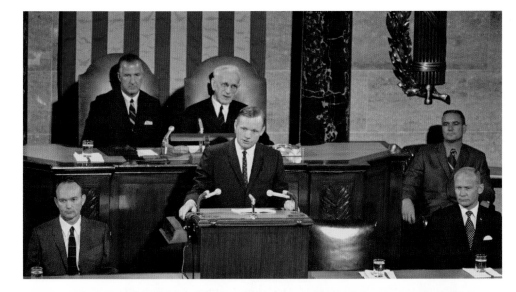

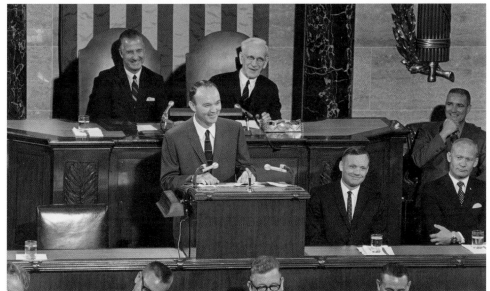

Top: Armstrong speaks to a joint meeting of Congress on September 16, 1969, in Washington, D.C. "A small step for a man was a statement of fact. A giant leap for mankind is the hope for the future," he told the assembly. Seated behind the lectern are Vice President Agnew *(left)* and House Speaker John McCormick (Mass.). (NASA)

Middle: Collins shared a favorite quotation of his father's when speaking before Congress: "He who would bring back the wealth of the Indies, must first take wealth to the Indies." (NASA)

Bottom: Aldrin takes his turn on September 16, observing, "The Apollo lesson is that national goals can be met where there is a strong enough will to do so."

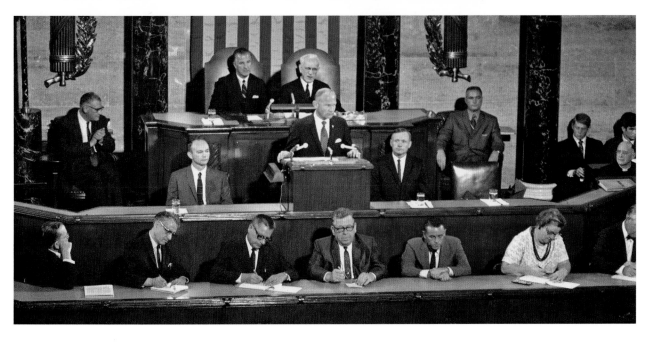

Above: Joan Aldrin, Pat Collins, and Jan Armstrong stand in the House Visitors Gallery during the joint meeting of Congress. Afterward the three couples viewed a two-pound Moon rock from the flight at the Smithsonian Institution's Arts and Industries Building. (NASA)

Left: Joan Aldrin, Pat Collins, and Jan Armstrong (*left to right*) on September 16, 1969, in Washington, D.C., as they proudly display a greeting with over 1,000 signatures from the Chilean Woman's Organization. (NASA)

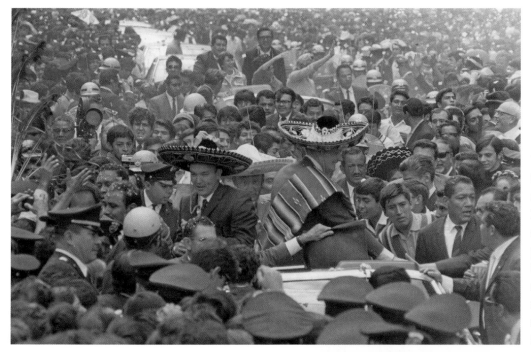

The astronauts' Presidential Goodwill Tour begins in Mexico City on September 29, 1969. The Apollo 11 crewmen in sombreros and ponchos are swarmed by thousands of people during a parade in the city's main square. They traveled aboard a presidential aircraft during the world tour. (NASA)

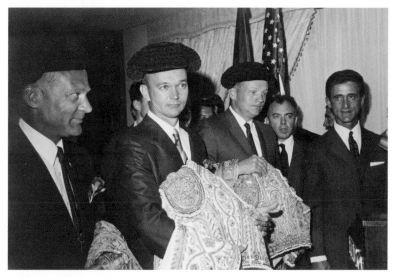

Aldrin, Collins, and Armstrong (*left to right*) are presented with bullfighting outfits during a stop in Madrid, Spain, on October 7, 1969. The presentation was made by well-known bullfighters Bienvenida, El Viti, and Pasco Camino. The astronauts had earlier placed a wreath on a monument in Madrid dedicated to explorer Christopher Columbus. (NASA)

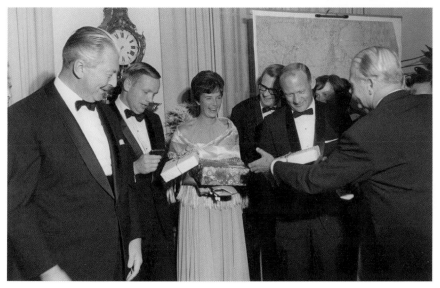

Apollo 11 astronauts and their wives receive gifts from the chancellor of the Federal Republic of Germany, Kurt Georg Kiesinger *(left)*, at the Palais Schaumberg in Bonn on October 13, 1969, after arriving from Norway. Collins and his wife then flew to Genoa, Italy, where Collins received gold medals for the three astronauts from the Christopher Columbus Scientific Society. He rejoined Armstrong and Aldrin in West Berlin the next day, where they spoke to a crowd of 20,000 people in John F. Kennedy Square and were cheered by 200,000 during a parade. It was the midpoint of their "Giant Leap" tour. (NASA)

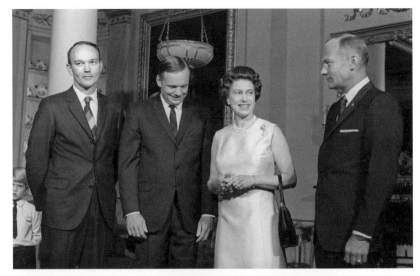

Top: The astronauts are received by Her Majesty Queen Elizabeth II at London's Buckingham Palace on October 14, 1969, during a one-day visit to Britain. The astronauts gave the royal family a full report on the mission. The crew had to postpone some television interviews because Armstrong was beginning to suffer from early signs of laryngitis. (NASA)

Middle: Armstrong holds the young grandson of Japanese Prime Minister Eisaku Sato at a reception at the prime minister's residence on November 4, 1969, the final stop on their tour. Satu also awarded them the Order of Culture medal, making them the first foreigners so honored. They earlier met with Emperor Hirohito. (NASA)

Bottom left: The Apollo 11 astronauts and their wives are welcomed at the White House on November 5, 1969, at the conclusion of the Presidential Goodwill Tour. The whirlwind trip consisted of stops in 24 cities in 20 countries over 37 days. (NASA)

Bottom right: Enthusiastic crowds greet the crew in Sydney, Australia, after their arrival from Perth on the morning of November 1. The tracking station at Honeysuckle Creek received the first video of the lunar EVA, and tracking stations at Carnarvon and Tidbinbilla, as well as a radio telescope at Parkes Observatory, also supported the mission.

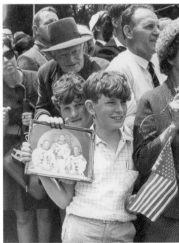

Armstrong in his office as head of NASA's aeronautics branch in July 1970 with an X-15 model. It was Professor Armstrong a little more than a year later, in September 1971, when he accepted a full-time position in the College of Engineering at the University of Cincinnati. Armstrong did not sever his ties with NASA, however, and served as a special consultant. (NASA)

KSC Director Dr. Kurt Debus unveils a plaque at the Launch Control Center at 9:32 a.m. (ET) on July 16, 1970, exactly one year after the launch of Apollo 11. A replay of the countdown was played over the public address system prior to the unveiling. (NASA)

The astronauts are reunited with their CM *Columbia* on July 20, 1970, in Jefferson City, Missouri. The astronauts are accompanied by Missouri Governor Warren Hearnes. The spacecraft was in the middle of a tour of all fifty U.S. states celebrating the first anniversary of the Apollo 11 mission. (NASA)

Armstrong, Aldrin, and Collins (*left to right*) during an Apollo 11 anniversary ceremony on the Missouri State Capitol lawn in Jefferson City on July 20, 1970. Missouri Attorney General John Danforth is to Aldrin's right, behind him. Armstrong spoke to the crowd of 7,000, telling them he "saw the historic trip as a symbol of peace to unite mankind." (NASA)

Armstrong, Collins, and Aldrin are presented with large framed photos of the Apollo 11 launch at a ceremony at LC-39 on July 16, 1974, marking the fifth anniversary of the launch. MSC Apollo Program Manager George Low is to the left of Armstrong, and Joan Aldrin sits behind Buzz Aldrin. It was a longstanding tradition at KSC to present each returning Apollo astronaut with a launch photo. (NASA)

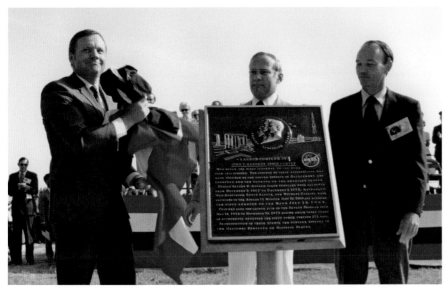

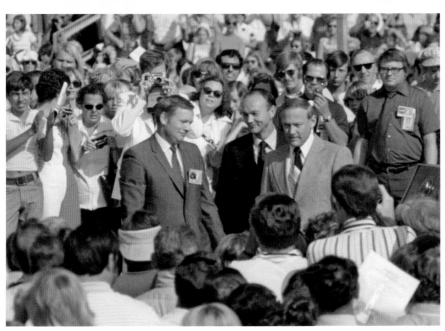

Top left: Aldrin speaks to the crowd on July 16, 1974, telling them, "Chills run up and down my spine when I hear that countdown. The footprints of the Apollo 11 crew are forever on the Moon." (NASA)

Top middle: "Apollo 11's trip to the Moon was a realization of the dreams of people who broke the shackles of gravity," Armstrong tells the crowd. (NASA)

Top right: "Today we stand at the halfway point," Collins says. "We are between the Apollo Program and the Space Shuttle. I look back with nostalgia and ahead with hope." (NASA)

Middle: Armstrong, Aldrin, and Collins (*left to right*) unveil a plaque on July 16, 1974, dedicating their launch site as a National Historic Landmark. A crowd of more than 6,000 people began cheering as a tape recording of the countdown was played leading up to the plaque's unveiling. (NASA)

Bottom: Armstrong, Collins, and Aldrin are surrounded by a sea of KSC workers, their family members and well-wishers as they view the LC-39 commemorative plaque. The astronauts had reluctantly grown accustomed to crowds and autograph seekers. (NASA)

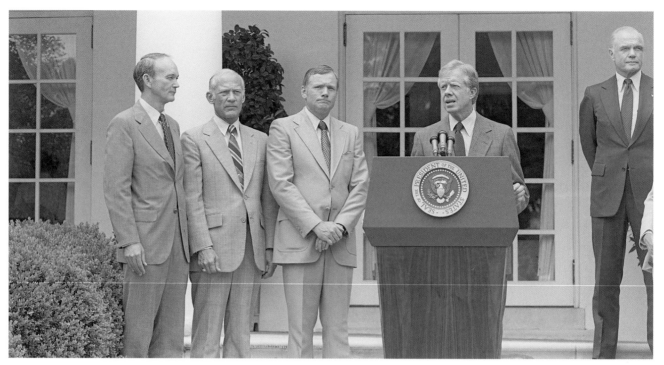

The tenth anniversary of Apollo 11 finds Collins, Aldrin, and Armstrong (*left to right*) at the White House with President Jimmy Carter on July 20, 1979. Carter used the occasion to compare the goal of energy independence with the goal of landing men on the Moon. The astronauts presented Carter with a flag they had carried to the Moon. (Photo by Jacques Tiziou)

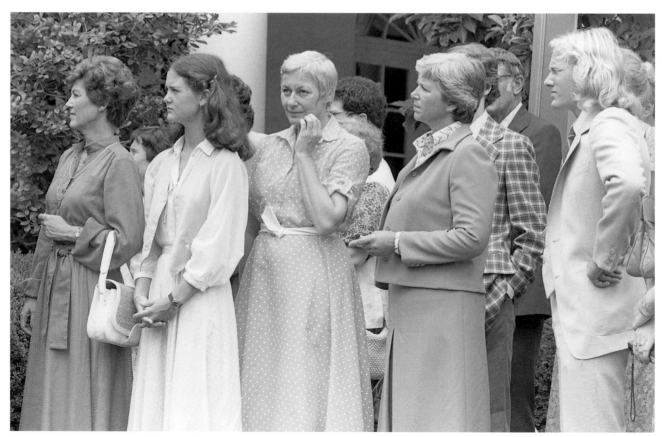

Wives and children of the Apollo 11 astronauts in the Rose Garden on July 20, 1979. *Left to right*: Pat Collins, Ann Collins, Joan Aldrin, Jan Armstrong, and Andy Aldrin. (Photo by Jacques Tiziou)

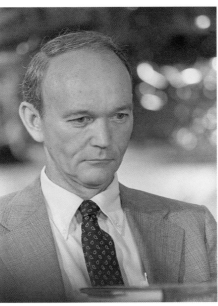

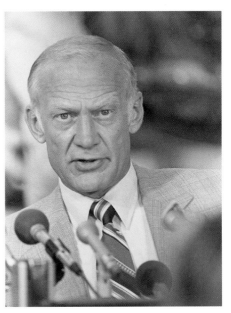

Armstrong speaks to the media at National Air and Space Museum (NASM) on July 20, 1979, saying he would be willing to return to the Moon "in a minute." (Photo by Jacques Tiziou)

Collins followed up on Armstrong's return to the Moon comment by saying, "It would take more than a minute for us to get ready." (Photo by Jacques Tiziou)

Aldrin took the opportunity to reference his battle with alcoholism. "Apollo 11 may have been a small step for Neil, but it was the beginning of a tremendous hurdle for me." (Photo by Jacques Tiziou)

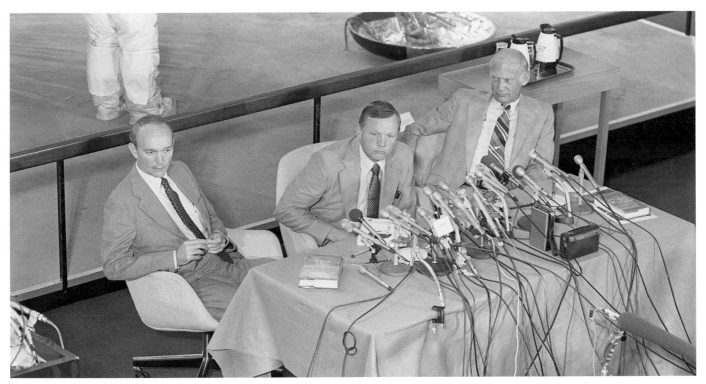

Collins, Armstrong, and Aldrin hold a news conference at the NASM on July 20, 1979. LM-2, behind the astronauts, was built for a second unmanned Earth-orbit test flight in 1968. Because the flight of LM-1 was so successful, however, a second test mission was deemed unnecessary and LM-2 was instead used for ground testing. (Photo by Jacques Tiziou)

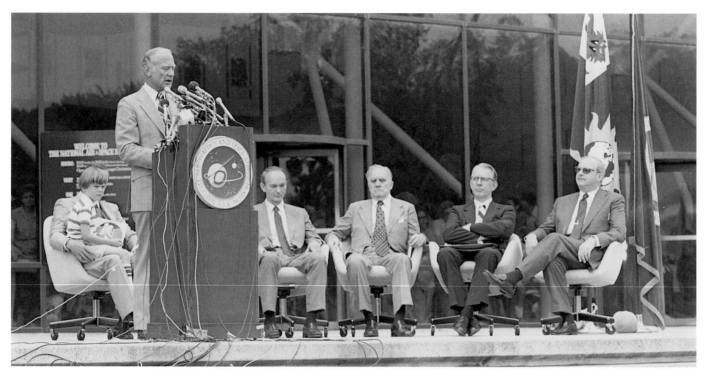

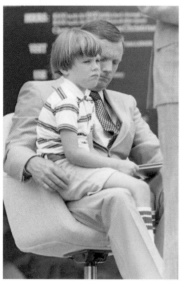

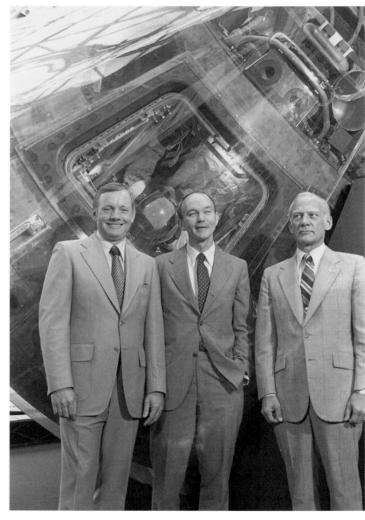

Top: Aldrin speaks to a crowd of 2,000 outside the NASM on July 20, 1979. Seated right of the lectern are (*left to right*) Collins and former NASA administrators James Webb, James Fletcher, and Thomas Paine. (Photo by Jacques Tiziou)

Center: While Aldrin was speaking, a young boy wandered up on stage, and Armstrong spoke to him for a moment before placing the child on his lap. The young man is holding the National Geographic book *Let's Go to the Moon.* (Photo by Jacques Tiziou)

Right: Armstrong, Collins, and Aldrin (*left to right*) endure the spotlight one more time as they pose with *Columbia* at the National Air and Space Museum on July 20, 1979. (Photo by Jacques Tiziou)

Top: Twenty years after they walked on the Moon, Collins, Aldrin, and Armstrong (*left to right*) pose with the Apollo 11 emblem during the KSC ceremony on July 16, 1989. The astronauts later rode in convertible Corvettes in a parade through Merritt Island and Cocoa Beach. (NASA)

Bottom: Aldrin, Collins, and Armstrong at KSC for an open house for space workers on the morning of July 16, 1989, for the twentieth anniversary of the launch. Armstrong recounted: "On July 16, 1969, the three of us left on a summer vacation, seeing new sights, and taking lots of pictures. We could not have done it without the help of thousands of people." (NASA)

Top left: Armstrong addresses the crowd outside the NASM in Washington, D.C., on July 20, 1989, saying, "The Apollo Program enjoyed a certain nobility of purpose, a program not to exploit, but to explore." (Photo by Tom Usciak)

Top middle: "We have rested on our Apollo laurels long enough," Collins tells the crowd. (Photo by Tom Usciak)

Top right: Aldrin comments, "The time for seizing the initiative in space is upon us." (Photo by Tom Usciak)

Middle: NASA Administrator and Vice Adm. Richard Truly, Vice President Dan Quayle, President George H. Bush, Postmaster General Anthony Frank, and the Apollo 11 astronauts (*left to right*) admire a new stamp celebrating the twentieth anniversary of the first Moon landing. (NASA)

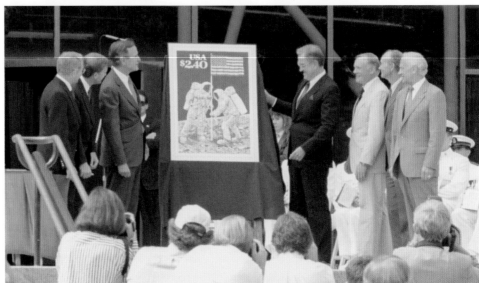

Bottom: Aldrin, Armstrong, and Collins (*left to right*) inspect an Apollo command and service module on display inside the NASM on July 20, 1989, during the twentieth anniversary celebration in Washington, D.C. This CSM (CSM 105) was used early in the Apollo Program for acoustic and vibration testing. (NASA)

Right: Apollo 7 Commander Wally Schirra (*left*) and Armstrong pause in the Saturn V Center at KSC on April 4, 1997. The unflown CSM behind them (CSM 119) served as the back-up for the Apollo-Soyuz Test Project mission in 1975. (NASA)

Above left: Armstrong and wife Carol at KSC on April 4, 1997, watching Space Shuttle *Columbia* launch on the STS-83 mission from LC-39A, the same pad where he left for the Moon twenty-eight years earlier. (NASA)

Above right: Armstrong answers media questions on July 16, 1999. When asked again if he would like to return to the Moon, he answered, "Yes, I left a few things up there." (Photo by Tom Usciak)

Left: Armstrong (*left*) and Aldrin answer questions for approximately one hundred members of the news media at KSC's Saturn V Center on July 16, 1999. A special dinner was held at the facility that evening marking the thirtieth anniversary of the first Moon landing. (Photo by Tom Usciak)

Top left: Armstrong, here 68, and Aldrin, 69, recall their accomplishments during the news conference. Collins had declined an invitation to attend the event. (Photo by Tom Usciak)

Top right: The first and last men on the Moon, Armstrong and Apollo 17 Commander Gene Cernan, at KSC's Saturn V Center on July 16, 1999. After a dinner celebration, Armstrong said, "I can never say thanks enough" to the people who made the Apollo 11 flight possible. (NASA)

Middle: Aldrin recounts some of the highlights of the Apollo 11 mission on July 16, 1999. (Photo by Tom Usciak)

Bottom: Collins, Armstrong, and Aldrin (*left to right*) are reunited again with *Columbia* at the National Air and Space Museum on July 20, 1999, to share memories of Apollo 11. Each of the astronauts was presented with the Smithsonian Institution's Samuel P. Langley Gold Medal. (NASA)

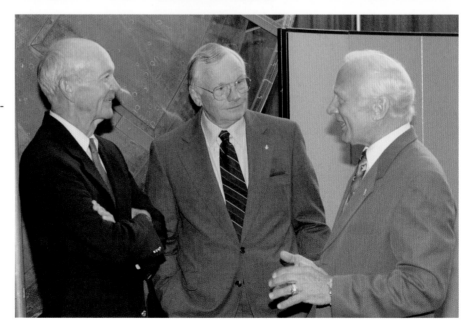

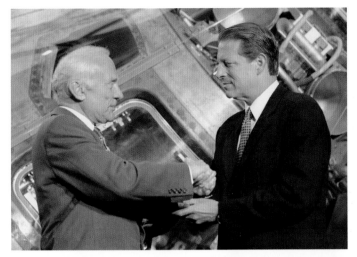

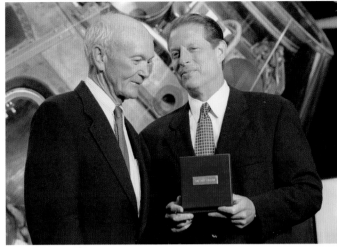

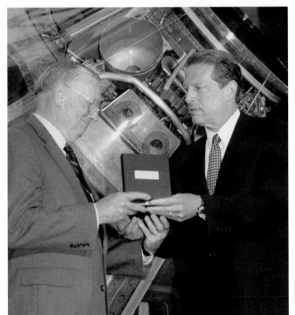

Top left: Aldrin accepts his Langley Gold Medal from Vice President Al Gore. Aldrin told the crowd that "competition got us to the Moon in a hurry, but it left us without a clear vision for future space activities." (NASA)

Top right: The vice president chats with Collins before presenting him with the Langley Gold Medal on July 20, 1999. Collins was asked if the Moon voyage had changed his personal concept of God. Collins replied that "traveling to the Moon confirmed to him that there is some order in the universe." (NASA)

Left: Vice President Gore presents Armstrong with his Langley Gold Medal. Gore told Armstrong that he had been at the 1969 launch, just after graduating from Harvard University. (NASA)

Right: Collins, Armstrong, and Aldrin meet with President George W. Bush in the Oval Office on July 20, 2004. Earlier that day, Bush had challenged the nation to send astronauts back to the Moon and on to Mars. The same day, however the U.S. House of Representatives Appropriations Committee voted to cut NASA's 2005 budget request. (NASA-Ingalls)

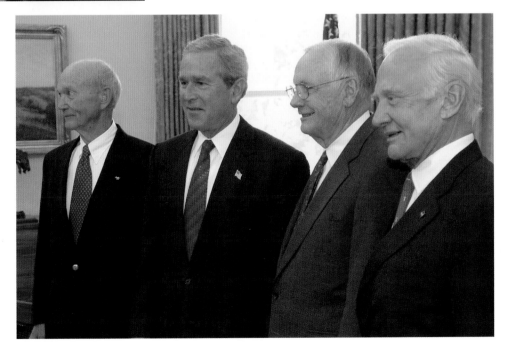

Above: Armstrong is honored as a NASA ambassador of exploration on April 18, 2006, in a ceremony at the Cincinnati (Ohio) Museum Center. NASA Administrator Michael Griffin presented Armstrong with the award, which contains a lunar rock sample and is now on permanent display at the museum. (NASA)

Right: Armstrong is shown casting his astronaut boot print during a July 19, 2007, visit to NASA's Marshall Space Flight Center. Armstrong is assisted by Daniel McFall. This print is on display at the U.S. Space and Rocket Center in Huntsville, Alabama. (NASA)

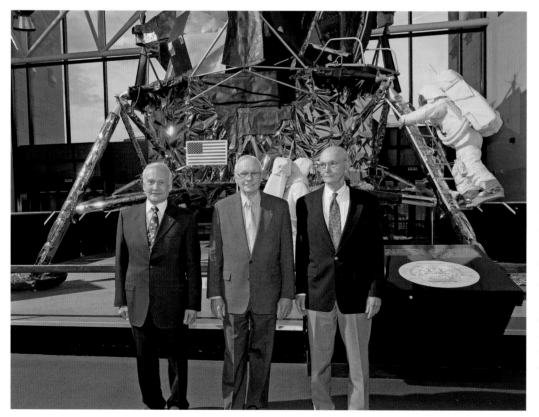

Left: Aldrin, Armstrong, and Collins (*left to right*) pose in front of LM-2 on display at the National Air and Space Museum in Washington, D.C., on July 20, 2009, the fortieth anniversary of mission. It would prove to be the final time the Apollo 11 astronauts would reunite at the museum. (NASA)

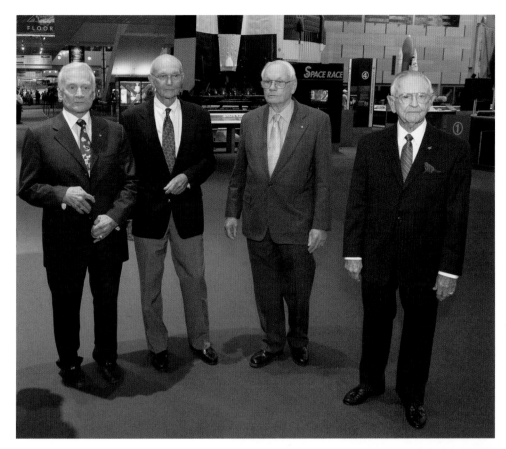

Above: Aldrin, Collins, and Armstrong are accompanied by Dr. Chris Kraft (*right*) during the July 2009 event at the National Air and Space Museum. Kraft, a former director of the Johnson Space Center, was instrumental in setting up Mission Control operations, first at Cape Canaveral and later in Houston. (NASA)

Right: Aldrin, Collins, and Armstrong meet with President Barack Obama in the Oval Office on July 20, 2009. Obama praised the trio and thanked them for inspiring a generation of Americans. Obama was seven years old at the time of the Apollo 11 mission in 1969. (NASA-Ingalls)

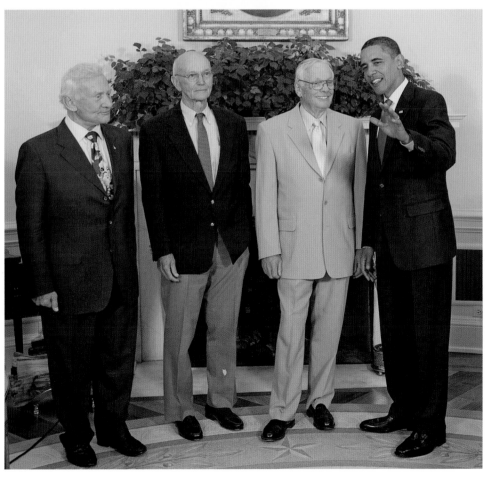

Above left: Armstrong is shown at the helm of USS *Dwight Eisenhower* on March 10, 2010. He was presented with honorary Naval Astronaut Wings by Capt. Dee Mewbourne, commanding officer of the aircraft carrier. (NAVY photo)

Above right: Armstrong sits in the commander's seat of space shuttle *Atlantis* in Orbiter Processing Facility 1 at KSC on April 26, 2012. *Atlantis* was being prepared for public display at the KSC Visitors Center. (NASA / Dimitri Gerondidakis)

Armstrong speaks in the Capitol Rotunda on November 16, 2011, as he, Aldrin, Collins, and John Glenn are presented the prestigious Congressional Gold Medal. Armstrong accepted on behalf of his compatriots: "The Apollo 11 crew is honored to receive the Congressional Gold Medal, and accept on behalf of our fellow Apollo teammates and all those who played a role in expanding the human presence outward from Earth." Armstrong would pass away a little more than nine months later. (NASA-Alers)

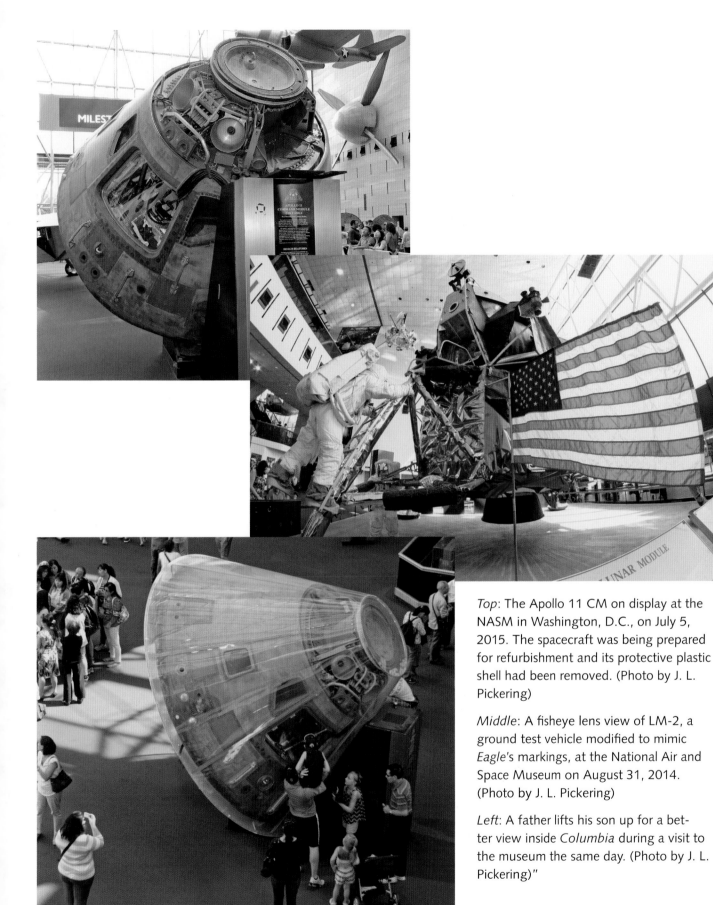

Top: The Apollo 11 CM on display at the NASM in Washington, D.C., on July 5, 2015. The spacecraft was being prepared for refurbishment and its protective plastic shell had been removed. (Photo by J. L. Pickering)

Middle: A fisheye lens view of LM-2, a ground test vehicle modified to mimic *Eagle*'s markings, at the National Air and Space Museum on August 31, 2014. (Photo by J. L. Pickering)

Left: A father lifts his son up for a better view inside *Columbia* during a visit to the museum the same day. (Photo by J. L. Pickering)"

ACKNOWLEDGMENTS

Rick Armstrong	Ed Hengeveld	Jim Ragusa
Alan Bean	Rick Houston	Dan Schaiewitz
Shane Bell	John Johnson	Robert Sieck
Chris Calle	J. Steven Jordan	Dionne Stafford
John Charles	Christopher C. Kraft	Thomas Stafford
David Chudwin	Sy Liebergot	Jacques Tiziou
Walt Cunningham	Dan O'Brien	Jerry Trachtman
Paul Fjeld	Robert Pearlman	Mark Usciak
Mike Gentry	Margaret Persinger	Tom Usciak
Ken Havekotte	Don Phillips	Jonathan Ward
Jim Hawk	Susan Stroink Pickering	Ron Woods

Reference Material

Alton, Judith Haley. "Catalog of Apollo Lunar Surface Geological Sampling Tools and Containers." Prepared for NASA/JSC by Lockheed Engineering and Sciences Company, Houston, TX. March 1989.

J. L. PICKERING has been archiving rare space images for some forty years. Drawing from NASA archives, retired NASA personnel, news photographers, and other sources, his collection numbers more than 120,000 high-resolution prints and images. He covered the final Apollo/Saturn launch in 1975 and attended numerous Space Shuttle launches. Today he serves as a resource and expert for authors, documentary filmmakers, museums, former astronauts and even NASA. He lives in Bloomington, Illinois.

JOHN BISNEY is an author and journalist who covered the space program for more than thirty years for CNN Radio, the Discovery Science Channel, RKO, and SiriusXM Radio. He witnessed more than forty Space Shuttle launches and was one of the few broadcasters at the 1986 *Challenger* disaster. Growing up in Florida, he saw his first rocket launch on Cocoa Beach in 1965. He attended the launches of Apollo 11–13, met President Nixon at the Apollo 12 launch, and covered Apollo 16–17, Skylab 1–4, and the Apollo-Soyuz Test Project from the Launch Complex 39 Press Site. He also covered the Apollo 11 crew reunion news conferences on each ten-year anniversary of the mission. He lives in Seminole, Florida.